FROGS

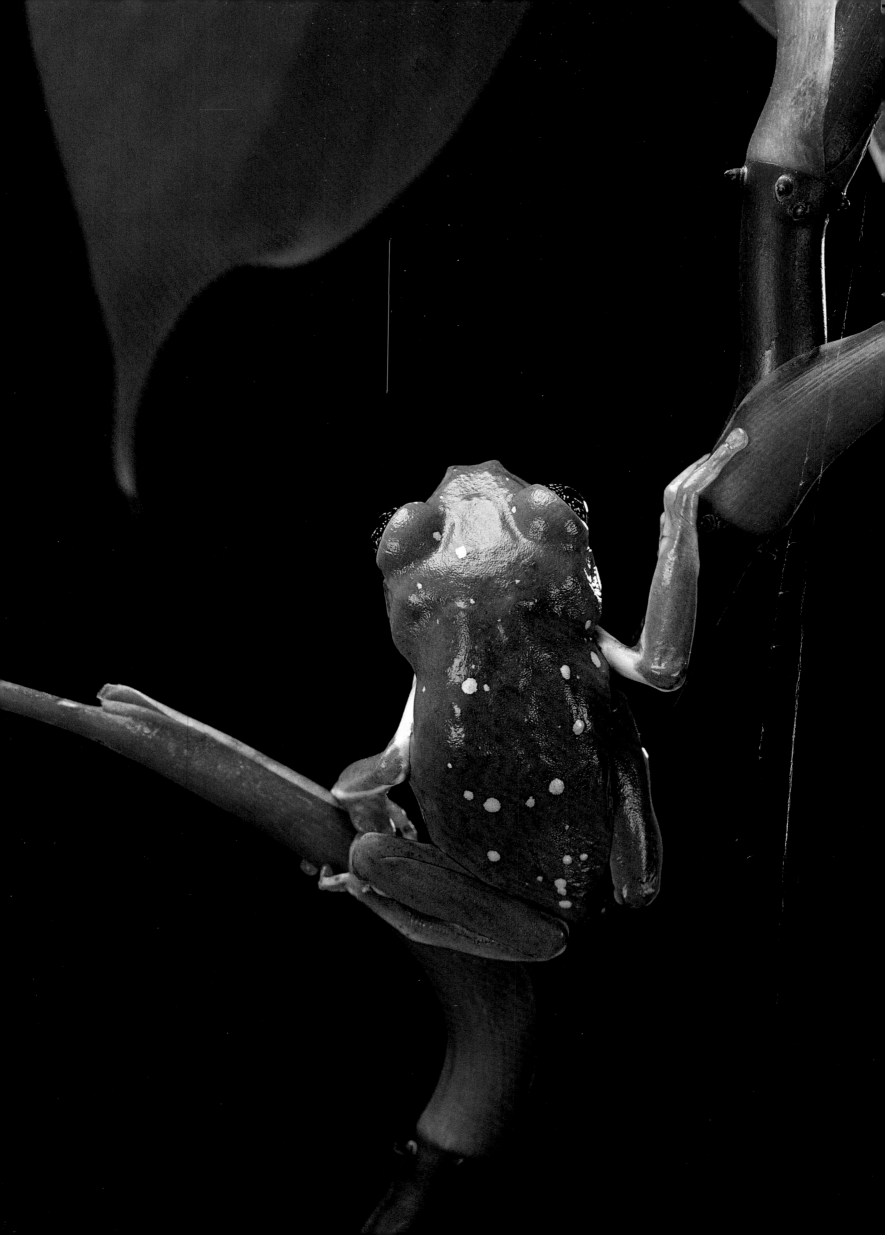

PAUL STAROSTA | TEDDY MONCUIT

FROGS
AND OTHER AMPHIBIANS

NATURAL WONDERS PRESS

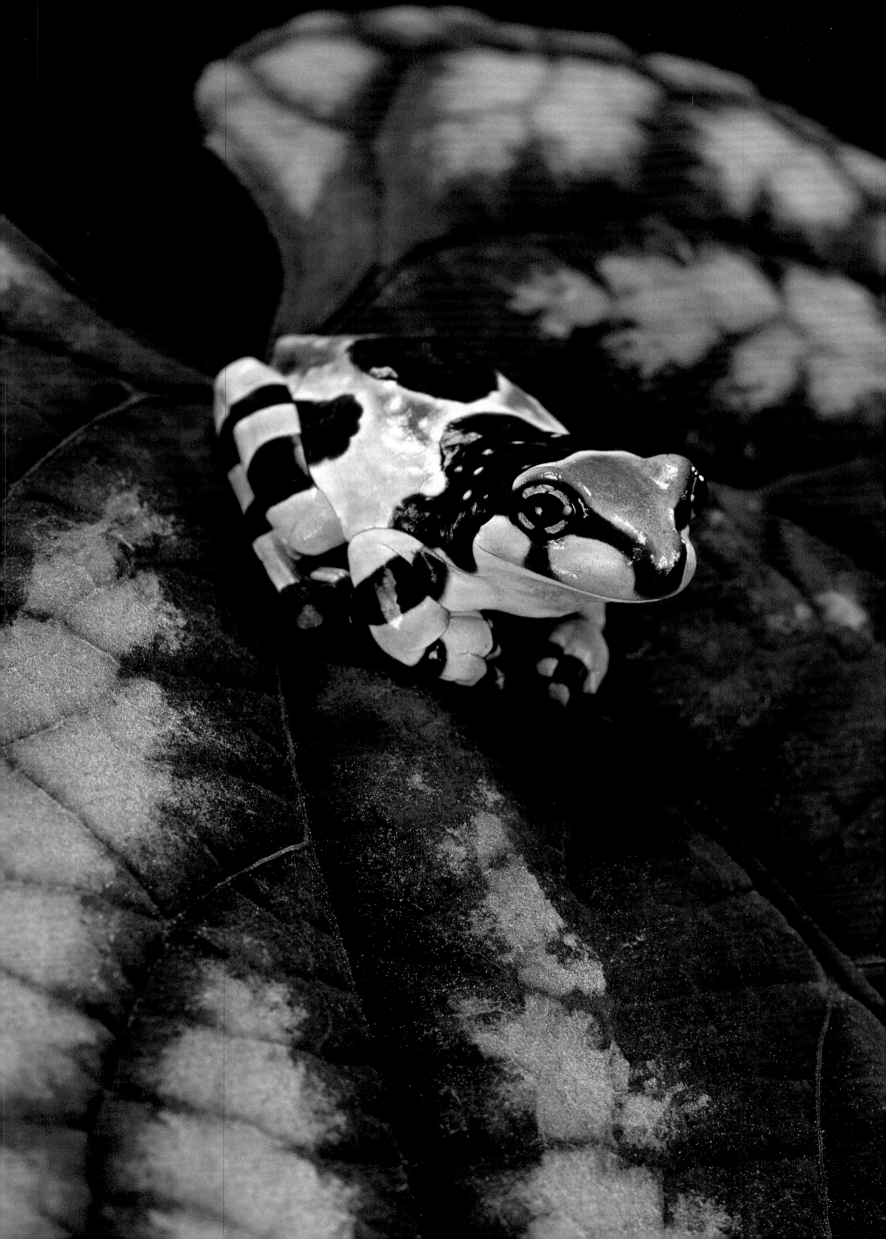

CONTENTS

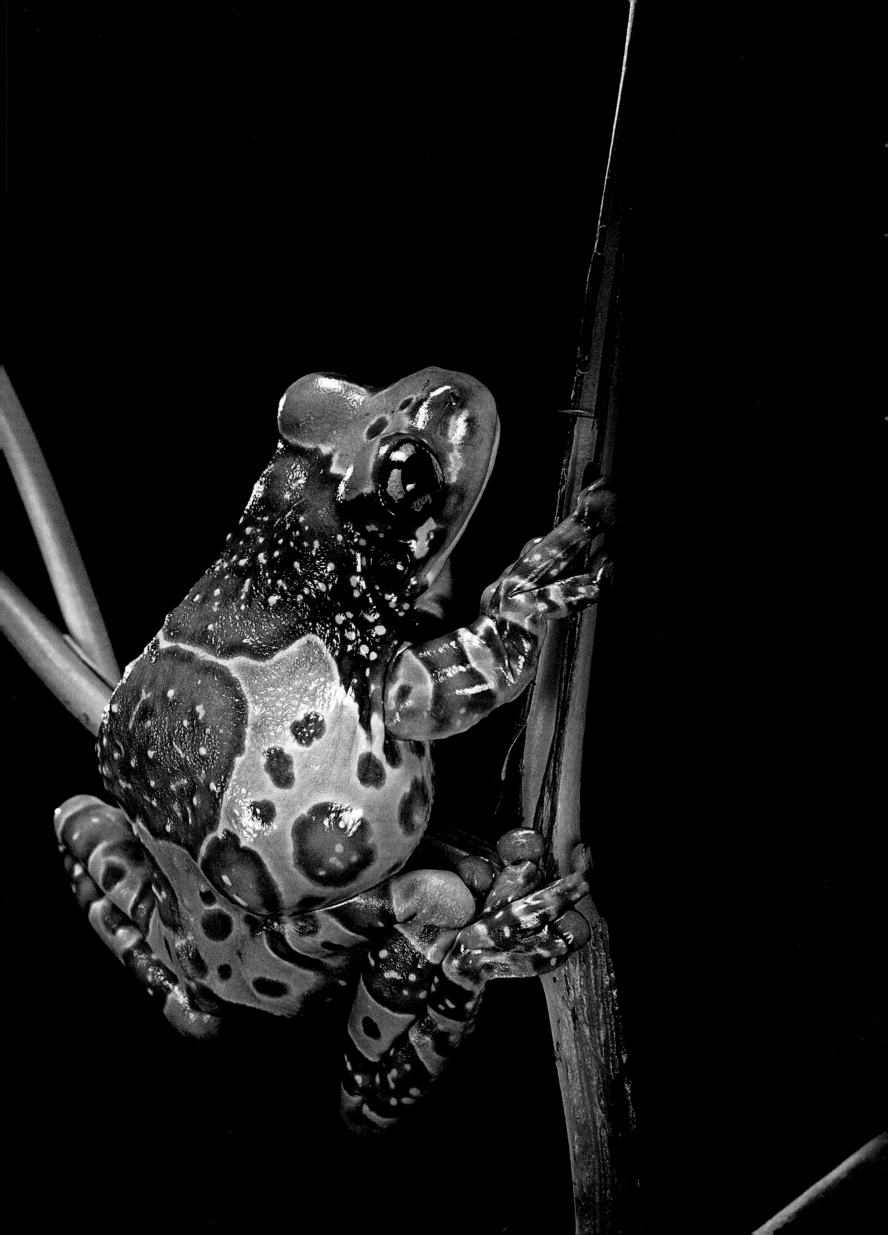

PREFACE

Fascinating yet often considered repulsive, amphibians are without a doubt ambiguous creatures. We affiliate them with murky and dismal environments, while never appreciating the true beauty of these animals, whose incredible diversity in shapes and colours is matched only by the extraordinary evolutionary adventure that has enabled them to adapt to environments of infinite variety.

Long viewed as lesser animals, amphibians are today slowly emerging from the shadows. Their story is the story of life, of evolution: with its small miracles of adaptation, its perpetual cycles, its secrets hidden in the hollow of a bromeliad leaf or at the bottom of a pond. When we enter the world of the amphibian, we open the door on a universe both captivating and unfamiliar, and return to the very beginning of the great story of the emergence of vertibrate life hundreds of millions of years ago. Still with the same admiring fascination, we relive the incredible metamorphosis that recounts their passage from the aquatic to the terrestrial world.

Their story is certainly far from over: amphibians have not yet revealed all their secrets, far from it, in fact new species are identified every year. Sadly the interest they arouse today has come a little late – perhaps too late – and the exploration of their world is increasingly becoming a race against time, as they fall victim to extinction on every continent. Uncontrolled deforestation, pollution, global warming and disease may be doing away with one of the oldest animal families in the world, one whose role is still vital to nature's equilibrium.

After several millennia of living side by side with humankind, the disappearance of these fragile inhabitants of our gardens, ponds and imaginations would leave a great void and have immeasurable consequences for the environment at large.

Phrynohyas résinifictrix (Hylidae)
Distribution: all of the Brazilian and Peruvian Amazon, as well as Surinam and French Guyana
Average length: 7 to 10cm (2¾ - 4in)

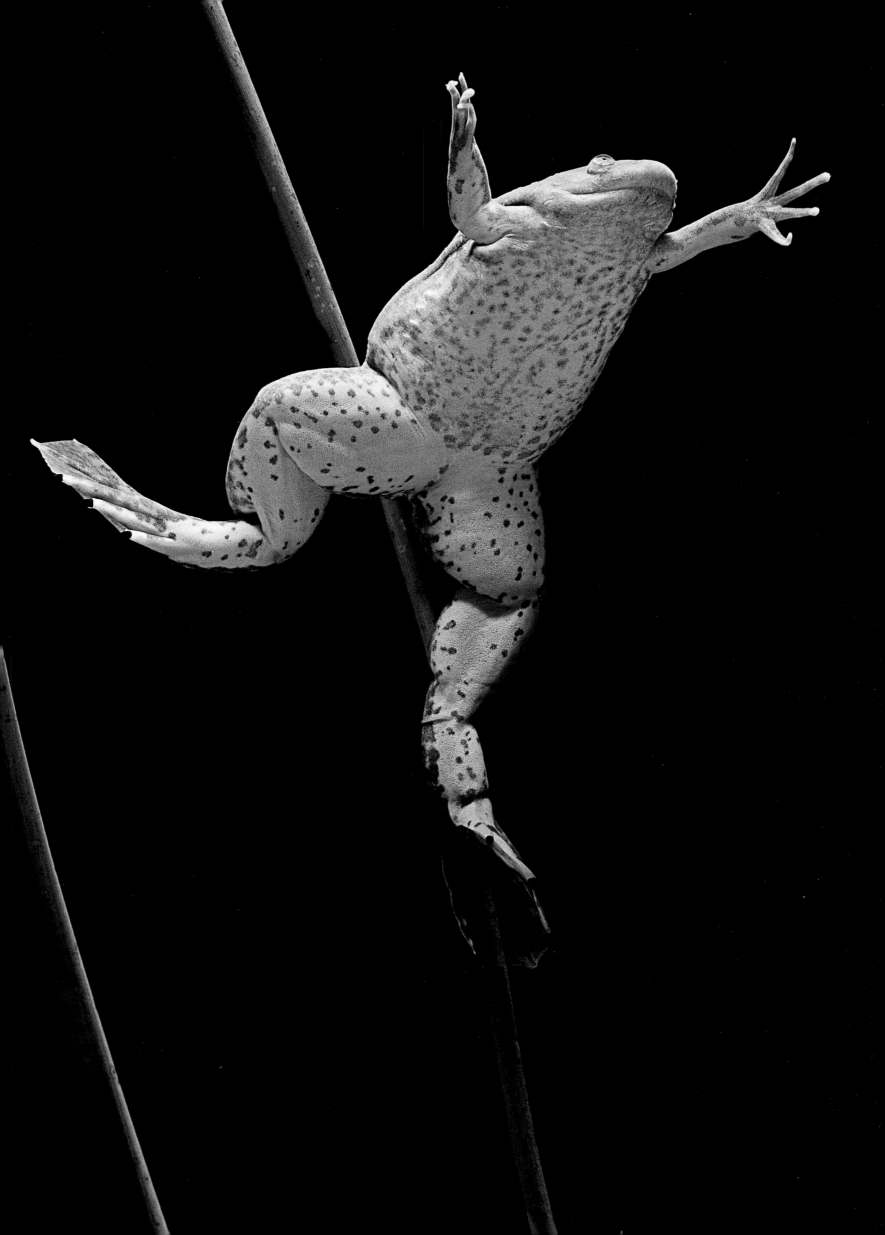

FROGS AND OTHER AMPHIBIANS

WHAT IS AN AMPHIBIAN?

The name 'amphibian' comes from the Greek, meaning 'double life' and perfectly illustrates the duality of their existence: one aquatic, the other terrestrial. Most amphibians live on land once they are adults, but generally in moist environments, as they cannot tolerate dryness. Most of them return to water to mate and lay eggs. Like reptiles, to which they are often associated, all amphibians are 'cold blooded' animals, that is to say they are unable to generate enough internal metabolic heat to properly maintain their physiological function: their body temperature varies with their environment. There are today around 6,000 species of amphibians, divided into three orders: Anura (frogs, toads and tree frogs), Urodela (salamanders and newts) and Gymnophiona (or caecilians, worm-like amphibians that lack feet).

ONCE UPON A TIME THERE WERE AMPHIBIANS...

The descendants of fleshy-finned fishes, primitive amphibians were the first vertebrates to colonise dry land. Like true pioneers they paved the way for all later vertebrates and formed a crucial bridge between fish and reptiles.

The first amphibians appeared around 360 million years ago, during the Devonian period, a time when reptiles, mammals and birds did not yet exist. The origin of primitive tetrapods is still under debate, yet it is likely that the first forms evolved from lobe-finned lungfishes such as Rhipidistians or the genus Protopterus, which were able to breathe air. They probably came out of the water because there were few enemies on dry land and food was abundant.

For millions of years, these animals, equipped with lungs, scaly skin and a fin-shaped tail, pursued their evolution, gradually defining, through the inevitable forces of natural

Xenopus laevis (Pipidae)
Distribution: South Africa, introduced into many countries
Average length: 5 to 12cm (2 - 4¾in)

selection, the structures vital to life on dry land: a skeleton adapted to terrestrial gravity and walking, eyelids to keep eyes moist when exposed to air, a developed sense of smell, and a tongue able to moisten food before swallowing it.

While it may be impossible to piece together a perfect jigsaw of their incredible evolutionary epic, we do know that the first amphibians to colonise dry land were similar to salamanders and newts. Much larger than amphibians of today, these were enormous animals that moved slowly and clumsily. They were, nevertheless, super predators with fearful jaws, ready to capture anything within reach. The proliferation of insects on dry land, where a warm and humid climate reigned, was favourable to their development and the colonisation of these new territories.

The domination of land amphibians reached its climax during the Permian period (260 to 225 million years ago) and gave rise to a great diversity in shapes and sizes, as is evident in the few fossil relics we have today. *Doleserpeton*, for instance, a land amphibian from the early Permian period was very small; *Eryops* lived in the marshes of Texas between 290 and 225 million years ago and reached two metres (6½ft) in length; while *Maontodonsaurus*, a giant urodelan discovered in Australia was almost four metres (13ft) long! Most of these great conquerors died out in the Triassic period (245 to 205 million years ago) and only a few evolved to modern day forms. These survivors attest to the fabulous evolutionary adventure inherited by the amphibians of today.

HABITATS AND ADAPTATIONS

Absent only from polar and mountainous regions, areas of very high altitude and most oceanic islands, amphibians are present on a major part of the globe. Owing to their inability to produce their own internal heat and their necessity to remain in a moist environment to avoid dehydration, they can be found in huge numbers in humid tropical rainforests, as well as in temperate environments, although fewer in number and in less diversity. Their living areas vary greatly: they may be found as much in marshes, lakes and rivers as on the ground, underground, in rocky crevasses, under litter, at the top of trees or even in caves.

Despite the severe constraints that regulate the lives of amphibians (temperature and water), some species have succeeded in adapting to highly improbable environments: high-altitude biotopes, arid environments (and sometimes desert) and even in one particular case (*Rana cancrivora*), the brackish waters of mangroves.

When conditions become unfavourable, for example during a heat wave or an intense cold snap, some species are able to aestivate or hibernate, that is to slow their metabolism down to save their energy. They go into a torpor, sheltered in a burrow or in the silt bed of a pond, for several days or months while waiting for more favourable conditions to return. Some anurans such as the African Bullfrog or the South American Horned Frog even produce a waterproof outer layer during the dry season to prevent any risk of drying out. Once buried, they shed the superficial layer of their skin and secrete a mucus that hardens along with the shed skin to form a protective cocoon.

The diversity of their habitats and environments, at times inhospitable, has led to great feats of adaptation in response to the specific constraints of their ecological niche. Anurans living

Litoria aurea (Hylidae)
Distribution: South East Australia,
introduced into New Zealand,
Tasmania and New Caledonia
Average length: 7 to 8.5cm (2¾ - 3⅜in)

in torrents, for instance, are equipped with fingers designed to attach to rocks and resist the forces of the current. Their tadpoles have sucker-like mouths to adhere to roots and rock faces. Another example can be observed in the heart of the tropical rainforest, where a few species of tree-dwelling urodelans have developed a prehensile tail.

Anatomy is a goldmine of information for those seeking to understand the lifestyle of amphibians. Their feet in particular are like identity cards to instantly determine the type of species: aquatic, terrestrial, tree-dwelling or burrowing.

Most aquatic anurans have a smooth and slimy skin, a streamlined body and long powerful legs ending in fully webbed feet, allowing them to make great leaps and to excel in water. In the same way, aquatic urodelans have gills, a hydrodynamic body, short legs and a flat tail designed to optimise propulsion in water. Tree frogs generally have a slender body, long thin legs and fingers with sucker-like adhesive discs. Some South East Asian species not only have webbed feet but also fringes of skin allowing them to glide when they spread out their fingers and toes. Terrestrial species, on the other hand, have dry and warty skin, with little or no webbing.

Most amphibians are difficult to detect in their biotope, having learnt that discretion and camouflage is the first rule of their survival. Shaped by their environment, their lifestyles reveal remarkable capacities for adaptation and innovation imposed by the immutable laws of nature.

ALL-PURPOSE SKIN

Lacking in hair, feathers and scales, the bare, smooth or bumpy skin of amphibians is vital for a variety of reasons and has many different functions. In amphibians, skin is not merely a protective coating but a partner in its own right. It is covered with glands and secretes

mucus to maintain moisture and keep it from drying out. It is also highly permeable, enabling the animals to 'drink' by directly drawing water contained in the humid air. Finally, its structure is very fine, allowing the oxygen dissolved in the water to pass through and be absorbed directly into the blood system. In this way, most adult amphibians breathe through the skin as well as through the lungs. In some species, particularly in urodelans, skin respiration is the only respiratory system it has (with mucous membranes of the mouth). The skin is also vital as a survival mechanism: as they are easy prey and have no means of defence, most amphibians have poisonous glands under the skin. These secretions are most often invisible and vary in the degree of danger they present to the predator. In some species the secretions are exuded in the form of an unpleasant tasting milky white substance capable of killing a predator. While the venoms have varying levels of toxicity depending on the species, they are generally harmless to humans on direct contact and only lead to a slight burning sensation or itching. Since amphibians have no inoculation system, the venom remains purely defensive. Among the most efficient is toad venom, mostly concentrated in the two prominent glands located behind the eyes: the parotids. If a lizard should bite one of these clusters of glands it will die within moments. Some amphibians employ a dissuasion strategy that consists of rendering themselves unfit or dangerous for consumption by secreting poison, or projecting a few droplets onto their assailant as a warning.

Whether used to become invisible or visible, to seduce or to frighten, amphibians have a secret weapon: chromatophores, pigment cells that modify their appearance according to circumstance or their environment. In many species, changing colour serves to attract mates or to regulate body temperature. Some behave like chameleons and have a whole palette of colours at their disposal to blend with their environment. Still others may exhibit a very bright or flashy appearance to warn predators of their toxicity or display intimidating patterns to fool attackers. To prevent this precious skin covering from wearing off, amphibians moult several times a year – in strips for anurans and in a single piece for urodelans.

A VOICE TO BE HEARD

Having the means to communicate is a great asset in an amphibian's world of many dangers. Whether it be an alarm call, identifying a member of its species, finding a partner or claiming its territory, being able to be heard loud and clear is sometimes a question of survival.

However, amphibians are not all equal in this field: frogs and toads have a reputation for being loud; newts and salamanders (except the Pacific Giant Salamander), on the other hand, are mute, or almost mute, having no larynx, only a rudimentary organ without the vocal chords. Anurans were the first vertebrates to develop a structure for vocalisation and a hearing apparatus. Over time their croaking diversified to respond to specific situations so that overall two types of calls can be distinguished: the first is the mating call to lure females, and the second is the territorial call to keep other males at bay. Some species have just one type of call for the two objectives, whilst others have a larger repertoire and produce a whole range of territorial calls.

Croaking is a privilege essentially reserved for the males. There is a morphological reason for this: females lack vocal sacs. These external sacs of extendable skin may be located on either side of the head or under the floor of the mouth (depending on the species). To

emit a call, the male forces air from its lungs through the larynx, causing the vocal chords to vibrate. The sound produced is amplified by the vocal sac (or sacs), which acts as a resonance box and gives it its characteristic tone. In this way, each species has its own specific call recognised by other individuals of the same species. Bellowing, clanging, clicking, barking and shrieking all merge into a deafening cacophony; and while the males compete in decibels, the females need only compare and make their choice.

MATING AND METAMORPHOSIS

In most amphibians mating takes place in or around water. The climate (temperature and humidity) being a determining factor, the breeding period generally starts in the spring in temperate zones and coincides with the rainy season in tropical areas. This period gives rise to vast migrations of amphibians converging towards lakes, ponds, rivers and streams to reproduce. They may even journey several kilometres or miles to reach their destination.

THE SERENADE OF ANURANS

For most anurans the great mating migration is announced and orchestrated by the calls of males. This mating call, designed to attract a partner, also serves to define a territory and drive away a potential rival. Despite this, sometimes two males will compete for the same female and it may end up in a brawl. In dendrobates, particularly, it is not unheard of for

two suitors to confront each other in one-to-one combat. The first to bring the other to the ground is considered the winner and takes away the 'prize'.

With a few exceptions, anurans mate in water. The male approaches the female from behind, holds her in an embrace under the armpits with his forelegs and grips himself onto her back with his nuptial pads (rough, thickened skin at the base of the thumbs that stops him from sliding off), in a clasping reflex known as amplexus.

Fertilisation is external: eggs are fertilised by the sperm the instant the female expels them. On contact with water, the surrounding gelatinous envelope swells up and encloses each egg in a transparent membrane, protecting the embryos from predators and from drying out. The spawn (fertilised eggs) can be deposited in different ways. Frogspawn floats in clumps on the surface of the water whilst toad spawn forms long strings in the aquatic vegetation. As soon as they are laid, eggs are left to fend for themselves. There are, however, exceptions and some species, particularly those who lay their eggs on land, actively care for their clutch, taking care to keep them moist and away from predators. The male Midwife Toad goes a step further: he carries the eggs on his back, wrapped in a string around his hind legs. When they are ready to hatch, he deposits them in a body of water. More astonishing still, a Chilean frog actually incubates the eggs, using his vocal sacs as an incubator and nursery until the tadpoles are metamorphosed into little frogs. However, the award for originality probably goes to the female of an Australian frog who incubates her young inside her stomach and gives birth to them through her mouth!

LIFE CYCLE OF A FROG

Whether they are lain directly in water or let themselves drop from the nest into a rescuing pond, fertilised eggs hatch after a few days, releasing larva with a bulbous head

Hildebrandtia ornata (Ranidae)
Distribution: all of the southern Sahara (savanna regions), west and east Africa, up to South Africa
Average length: 5 to 6cm (2 - 2⅜in)

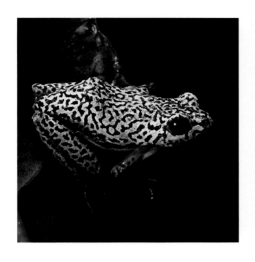

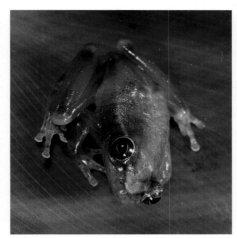

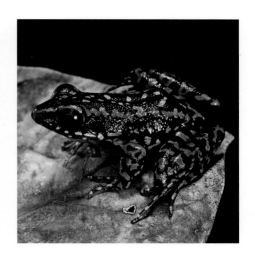

Hyperolius marmoratus (Hyperoliidae)
Distribution: Tanzania
Average length: 3cm (1⅛in)

Hyperolius sp. (Hyperoliidae)
Distribution: Tanzania
Average length: 2 to 3cm (¾ - 1⅛in)

Rana signata (Ranidae)
Distribution: Indonesia, Sumatra, Thailand,
Malaysia, Borneo and the Philippines
Average length: 4 to 6cm (1½ - 2⅜in)

and a flattened tail: a tadpole. Incompletely formed and incapable of swimming, it first clings to the debris of the nourishing envelope and then to algae. Gradually its tail develops and its eyes and mouth are formed. It breathes thanks to external gills, which resorb in a few weeks to become internal. Initially it is a herbivore (feeding on algae and aquatic plants), but later becomes a carnivore, capturing small aquatic invertebrates, various dead animals and even amphibian eggs. Its hind legs are the first to appear, followed by the forelegs and then the tail starts to resorb. The gills develop into lungs and the aquatic gill-breathing tadpole becomes a terrestrial lung-breathing frog. The metamorphosis is complete: the little anuran leaves the water to conquer dry land.

THE MATING DANCE OF URODELANS

The reproductive pattern of newts and salamanders is significantly different as for most of them fertilisation is internal. Mating is generally preceded by a complex and ritualised mating dance during which the male must understand the female's response before proceeding to the next step.

Some terrestrial species, such as newts, temporarily return to aquatic life to reproduce, showing off a highly spectacular ceremonial attire for the occasion. The Crested Newt in particular, is lavish in his means to seduce his mate: he is adorned with an impressive caudal crest and engages in a full courtship ritual, pushing his partner with his snout, shaking his silver tail to disperse pheromones and initiate mating – or its equivalent, as urodelans have no copulatory organ. Once the ritual is over, the male releases a spermatophore (a gelatinous mass containing spermatozoa), which settles on the silt bottom. The female then positions herself on top and grasps the spermatic receptacles with her cloacal lips, using her hind legs to help her self-fertilise.

Mating on land is less spectacular, yet just as complex in its courtship rituals. In many terrestrial salamanders the male stimulate reception in their mate by rubbing and caressing, then he encloses the female in an amplexus reflex. Other species such as *Euproctus* (essentially aquatic) embrace tightly and perform a kind of acrobatics to bring together

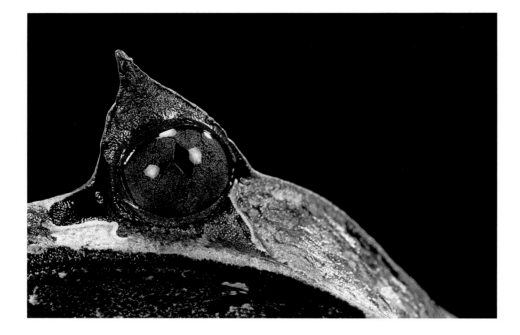

Megophrys nasuta (Megophryidae)
Distribution: Indonesia and Malaysia
Average length: 6 to 15cm (2⅜ - 6in)

their two urogenital orifices and as such the male transfers his spermatozoa directly to the cloacal lips of the female. Some urodelans have specialised organs to stimulate their partner: male *Plethodons*, for example have a chin gland and large teeth that they use to scarify the female's skin and 'vaccinate' her with an aphrodisiac secretion.

Contrary to anurans, urodelans lay their eggs one by one. Some newts can lay up to 300, which they wrap individually in the leaves of aquatic plants. Other species prefer to lay eggs on land, near a body of water, leaving the rain to wash the larvae into the liquid element where they will continue their metamorphosis.

LIFE CYCLE OF A URODELAN AMPHIBIAN

On hatching, urodelan larvae are equipped with external gills that develop very rapidly, a long tail and four buds that will develop into their fore and hind limbs. Contrary to anurans their forelegs develop first. After just a few weeks these larvae already resemble miniature adults. Their long gills, having fully blossomed, are gradually absorbed and replaced with breathing by lungs and through the skin. The transformation process lasts a few months, but young urodelans will have to wait another three or four years before reaching sexual maturity.

BIG BABIES

Some aquatic urodelans such as the axolotl (*Ambystoma mexicanum*) retain several of their larval characteristics their entire lives (gills, lateral line) despite having reached sexual maturation and being capable of reproduction. This phenomenon, known as neoteny, is

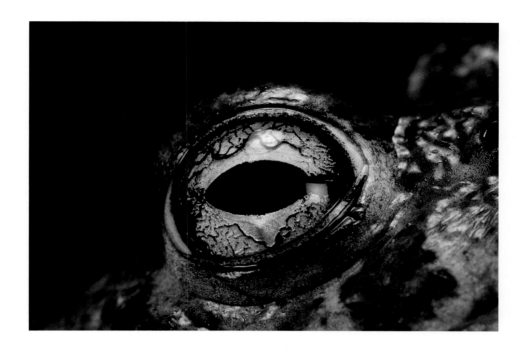

quite common in amphibians and particularly in aquatic salamanders. The explanation can be genetic or environmental (low iodine content or low water temperature). If a thyroid hormone is injected into a neotenic axolotl or iodine added to the water in its environment, it loses its gills and becomes terrestrial.

OVOVIVIPAROUS AND VIVIPAROUS

Although most amphibians are oviparous (producing eggs that hatch outside the female's body), some species, such as the common salamander (*Salamandra salamandra*), are ovoviviparous (producing eggs that hatch within the body of the mother). After mating, the fertilised eggs develop in the body of the female for around eight months. She can give birth to 60 young, which resemble miniature adults but with gills. After three months, the larvae develop lungs and leave the water.

There are a few examples, although rare, of viviparity (producing offsping that as embryos develop within the female) in urodelans. This is the case with the Lanza Salamander, which gives birth to live young, five or six perfectly formed individuals.

FEEDING AND CAPTURING PREY

Thanks to the fat reserves accumulated during the summer months, amphibians have an uncommon resistance to fasting and can go without food for several months. This is why when the weather is favourable they display such an insatiable appetite.

Most adult amphibians are carnivorous and feed mainly on insects, spiders, earthworms, various arthropods and molluscs. When there is nothing or too little to eat, however, they

will readily capture small vertebrates or even members of their own species. Cannibalism is in fact not an exceptional phenomenon and can manifest itself among larvae as well as in adults.

Each species has its own hunting technique. To detect prey, aquatic urodelans use their sense of smell and sensory cells in their flanks, which are sensitive to vibrations. Due to their slow and awkward movements, terrestrial urodelans are partial to fairly static prey such as snails, slugs and earthworms. They excel in waiting and mimicry strategies and are great masters in the art of blending with their surroundings to surprise their victims. At first, they very slowly creep up on the prey and then swiftly seize it between their jaws with their pointed teeth. These are not used for chewing but rather for holding on to the prey, which are often slippery and agile. It is taken in with jerky movements and swallowed whole.

Anurans chase by sight (they have very good vision in both air and water), and dine on insects, spiders, snails and slugs. Most can eat mice, birds and young snakes and even other anurans. Nothing stops their ravenous appetite. Capture being a reflex triggered by the movement of prey, they catch anything that moves (hence only live prey), sometimes also including undesirable elements by mistake, such as plant debris, which they quickly spit back out. They are not fussy eaters as long as they can swallow in one mouthful and so the size of the snack must be proportional to the mouth's opening capacity. Some species use their forelegs to help them push the food into their mouths. Anurans close their mouths to swallow. Their eyeballs push the food downwards and down the throat.

Frogs are more active predators than most toads and they like to supplement their meal with a few flying insects, which they catch using their sticky tongue. In fact all anurans have a long viscous tongue attached at the front of the mouth, which they can project at lightning speed. The prey sticks to the tongue and can then be swallowed.

Some have a much less varied menu. The African Bullfrog, for example, is condemned to an ant and termite diet. Its minuscule mouth does not allow it to catch other prey. From time to time, however, they treat themselves to a real feast from right inside the termite mound.

AMPHIBIANS IN PERIL

They marked the history of evolution for all time by leaving the first footprint on dry land. They resisted the great heat of the Tertiary period and the glaciations of the Quaternary period. They lived through the age of the dinosaur. But today they are disappearing. Silently. Discreetly. Massively. Amphibians are sinking further and further into the eternal night of vanished species. This is not a recent phenomenon. It goes back fifty or so years, but it has taken on such considerable proportions these last twenty years that specialists have gathered together to try to understand the causes of such a devastating decline. Climate change? Pollution? A pandemic? There are several answers.

INCREASINGLY DIFFICULT LIVING CONDITIONS

The modern world, and its uncontrolled industrialisation, have made life hard for amphibians. As in all cases of suspicious disappearance, loss of habitat is singled out – and

Litoria caerulea (Hylidae)
Distribution: Papua New Guinea, east and north Australia, Torres islands, introduced into New Zealand
Average length: 7 to 10cm (2¾ - 4in)

not without cause. Massive deforestation and destruction of wetlands all over the world are greatly responsible for the situation.

In addition, chemical waste discharged into the air and water poisons and asphyxiates them mercilessly. All of the harmful effects of modern life – the increase in ultraviolet radiation due to the thinning of the ozone layer, acid rain – impact amphibians directly, since it is their nature to soak up the surrounding environment like a sponge (which also explains why, to scientists, they are excellent bio-indicators of the quality of natural environments).

The consequences of all this pollution on the organism are understandably disastrous: reduced immune defence, physical deformities, and sterility. The worst is probably still to come as the global warming underway gives a sombre outlook for the future.

MAN: A FEARSOME PREDATOR

The abusive exploitation of some species for purely commercial reasons can lead to their serious decline. This is the case of the Giant Salamander, for example, which has undergone a considerable drop in numbers in Japan and China, where it is a highly sought-after delicacy. In eastern China, Hynobiids (primitive salamanders) are captured and turned into powder to treat stomach pain. They meet the same fate in Japan, where they are used as vermifuge.

In Peru frog cocktails are all the rage: mixed with corn, roots, honey, eggs or pollen, the juice is believed to have aphrodisiac qualities. Although the effects have not been proven, the smuggling involved in this lucrative market is wreaking havoc on the species concerned. France is the biggest consumer of frogs' legs in the world, with some 100 million pairs of legs imported every year.

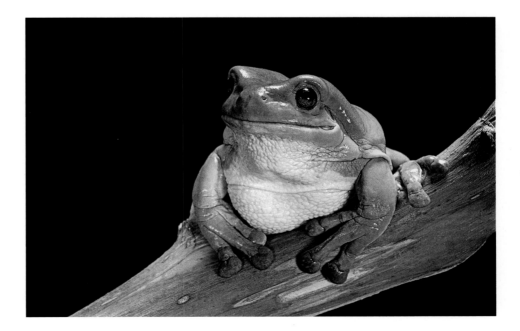

A KILLER NAMED *BATRACHOCHYTRIUM DENDROBATIDIS*

As misfortune never comes alone, amphibians have been confronted for the last ten or so years with a new hurdle: two highly contagious and fatal illnesses that are annihilating almost all species, a parasitic epidemic and a devastating infection, vectored by a fungus, *Batrachochytrium*. As the mortality rate of contaminated animals is close to 100%, this could well be the final blow, unless it serves to shock the mind into awareness…

A PREMONITORY WARNING?

The conclusions of specialists on the survival chances of amphibians are pessimistic. Today half the species are threatened with extinction. Humankind's responsibility in this disaster is unfortunately indisputable. Amphibians are paying a high price for the mistakes of humans: climate change, pollution, and rampant urbanisation. In just a few decades one of the oldest animal families on the planet will have been destroyed. The human race is more resistant, for now. Out of the depth of their suffering, amphibians are sending us a warning. Will it be heard?

AMPHIBIANS TO THE RESCUE OF PHARMACOLOGY

It has long been thought that the skin of amphibians has 'magic' powers. In ancient China, patients with heart trouble were given brews made from toads. Amazonian Indian tribes used the toxic secretions of a tree frog, the Giant Monkey Frog (*Phyllomedusa bicolor*) in ritual ceremonies to stimulate the senses of participants by plunging them into an altered state, close to a hallucinatory trance; the secretions of the 'Kampu' (Monkey Frog) were applied straight to a deliberately cut naked wound. After a violent transitional reaction, the participants reached a state of euphoria, during which all their senses were more heightened. Indians also knew of the devastating properties of the venom of another variety of frog, the dendrobates, and used it to poison their arrows.

The various uses for these venoms and their strange powers were related in the writings of travellers, and in the 1960s this sparked the interest of biochemists into the amazing skin properties of amphibians. They analysed the defensive secretions of certain toxic frogs and the results exceeded their expectations: the toxins contained concentrations of various cocktails of molecules, opening up immense perspectives for modern medicine. An extraordinary scientific adventure had begun.

AN UNEXPLOITED GOLD MINE

This research has led to some amazing discoveries today. For instance, a molecule isolated from the famous South American Giant Waxy Monkey Frog, known as dermorphine, has proven to be a thousand times more effective than morphine for blocking pain. Recently, an appetite stimulating neuropeptide for mammals has been identified and could some day lead to therapeutic applications. And that's not all: thanks to an Australian frog (*Rheobatrachus*

Leptopelis brevirostris (Hyperoliidae)
Distribution: Gabon, Cameroon and Nigeria
Average length: 5 to 6cm (2 - 2⅜in)

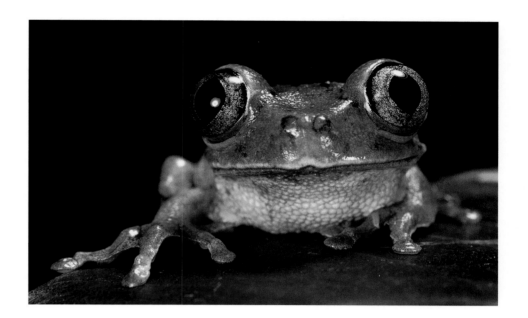

silus), which incubates it eggs inside its stomach and produces a substance to protect them from gastric juices, researchers have developed a medicine that could well become the ideal remedy for ulcers. This small Australian frog still has a lot to teach us: scientists suspect the eggs may produce an anti-vomiting substance, as the mother does not reject them.

An antihemorrhagic agent, a nervous system stimulant… a number of new medications and treatments today trace their origins to amphibians. These animals could hold in them the future of medicine. In order to one day benefit from these innovative treatments we must start by preserving this living resource that still has so much to teach us. If amphibians were to disappear, it would (most likely) mean a vital medicinal source would be lost to us forever. This is not a warning to be taken lightly: the small Australian frog that incubates its eggs inside its stomach has actually been presumed extinct since the 1980s. What if its secret is lost forever? Nature has already proven it has the remedy for most of the many ailments that afflict us. We have just skimmed the surface; our great journey of discovery has only just begun… the question is whether the threats that weigh on amphibians (and on all of the last untouched environments of the planet) leave us time to complete it?

PROTECTION OR AN ILLUSION

Efforts have multiplied these last years in terms of animal protection, yet, despite significant advances, the means deployed remain insufficient and are often unsuited.

In France, most threatened species are protected by a law of 1977 banning the transport, capture and trade of the animals as well as the destruction or degradation of their habitat. Sadly, its enforcement has come up against a lack of means and regulations have not adapted to the evolution of the many new threats. As a result, it is impossible to apply this law protecting their habitat, a precondition that is, nevertheless, vital to the conservation of species. Officially, the preservation of wetlands has become a national struggle for many

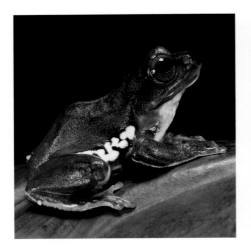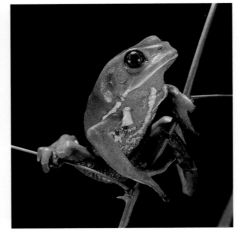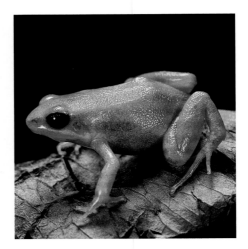

European countries. Yet at the same time, developers are actively destroying these very wetlands more than ever before.

Of the 265 amphibian species occurring in the US, fifty-three species are threatened and three – the Mountain Yellow-legged Frog, Dusky Gopher Frog and Ramsey Canyon Leopard Frog – are listed as 'Critically Endangered'. Population declines are particularly serious in California, the Rocky Mountains and the southwest, mostly due to habitat loss, introduced predators and competitors, disease and pollution.

Though all of the eight species of amphibians native to the British Isles – the Pool Frog, the European Common Frog, the Agile Frog (Jersey only), the Common Toad, the Natterjack Toad, the Great Crested Newt, the Palmate Newt and the Smooth Newt – are only categorized as a species of 'Least Concern' by the IUCN Red List, four of them (the Pool Frog, the Agile Frog, the Natterjack Toad, and the Great Crested Newt) have Species Action Plans in place for their conservation and all are in decline due to habitat loss.

Rampant urbanisation and sprawling road networks fragment habitats and increase the distance between water areas. Every spring, thousands of frogs and toads are killed on European roads as they try to cross to get to their breeding pond. This phenomenon has reached such considerable proportions that initiatives are being carried out here and there to try to stop the carnage: nets erected along the deadliest roads and narrow tunnels ('toad tunnels') dug under motorways to allow small amphibians to cross. Results have been quite encouraging.

On an international level, experts gathered in Washington for the World Conservation Union (IUCN) have thoroughly examined the problem facing amphibians to make a diagnosis. They estimate the global plan to save frogs and salamanders would cost 400 million dollars! A substantial part of this sum would be dedicated to research into the infamous *Batrachochytrium dendrobatidis*, the fungus that weakens the skin of amphibians, causing devastation in their populations. One lead to follow would be the study into the mechanisms that protect certain species from the lethal effects of the fungus (notably in African frogs from the genus *Xenopus*) and to develop this resistance in amphibians in captivity before releasing them into nature.

Polypedates dennysii (Rhacophoridae)
Distribution: Myanmar (form. Burma), Laos, China
Average length: 6 to 13cm (2⅜ - 5⅛in)

Phyllomedusa sauvagii (Hylidae)
Distribution: Bolivia, Paraguay, Brazil and Argentina
Average length: 10 to 12cm (4 - 4¾in)

Mantella aurantiaca (Mantellidae)
Distribution: central Madagascar
Average length: 2 to 3cm (¾ - 1¼in)

For the more pessimistic, breeding animals in captivity is the only way to prevent hundreds of species from disappearing in the short term. However, our current knowledge of the life history of some species is insufficient to recreate proper breeding conditions.

Whatever the case, more and more scientists are at work in tropical forests throughout the world to study their fragile inhabitants and try to learn how better to protect them. Time is running out as the countdown has already started, but it is not to late to save what is still left. As long as we do not consider a species as doomed to extinction, there is still hope.

BELIEFS, MYTH AND PARADOX

Disturbing, grotesque and fascinating, amphibians might have escaped from an illustrated bestiary of fantastical creatures, the heritage of a forgotten world. A world where the border between dream and reality, belief and superstition, science and literature is sometimes so fine that we no longer really know which side we are on.

Declaimed by poets, vilified by the church, depicted as heroes in fables, associated with the witches' Sabbath, victims of laboratory experiments and the chef's kitchen, amphibians have experienced hard times in every century, condemned for their 'unsightly' appearance.

Yet, while some managed to sneak into the court of kings and princes through back doors, in the form of poisons or evil potions, others were brought in through the main door and adopted as a symbol of royalty. François I adopted the salamander as an emblem and the motto "I feed from it and put it out", a reference to a legend whereby this animal was capable of living in flames without burning.

The frog is a symbol of life in Ancient Egypt, yet one of evil and sin in the Judaeo-Christian tradition. It suffered for its relation to the toad, which had indeed a bad reputation, a firmly entrenched reputation, leading it to be forever labelled as "a slobbering animal used for flavouring witches' brews"

Generally, the frog benefits from a much more favourable image in popular opinion. No question of a mere broth for the frog, Pline reserved it for a much more elaborate use: the treatment of quartan fever (after boiling it in oil, naturally). He also recommends it to cure a cough. The recipe is very simple: you need only to "cook it in its juices, like fish".

Viewed by many as symbols of immortality and power, amphibians participated in ritual ceremonies, and appeared on masks, pottery, fabrics, sculptures, carvings and totems. Our collective imagination often endowed them with magical powers. In the Jura or Berry regions of France, for instance, the salamander was said to kill with a mere look of its eyes, or maim from a distance. In Brittany, its name was never uttered for fear it might think it was being called and spread evil. More innocently, popular folklore gives the tree frogs of our prairies and gardens the power to predict the rain or sunny weather.

Their richness in forms, colours and history has been a permanent source of inspiration for writers of fables, storytellers and painters. The legends and beliefs they have generated are drawn from this duality, and relate back to our own fears: the dark side in every one of us. This duality, so familiar in all of us, is perhaps also what gives them their charm – in the magical sense of the word.

ANURANS

With more than 5,200 species from 29 families, anurans (frogs, toads and tree frogs), form the greatest, most diversified and best-known group of amphibians. While they are present almost all over the planet, their density is much higher in tropical regions, particularly in rainforests.

Their Greek name (*an* ='lacking in', and *ouros* = 'tail') means 'ones without tails'. This characteristic is specific to them as, unlike other amphibians, they lose their tails at the end of their metamorphosis. It is impossible to confuse an anuran with another animal. Its morphology is fully adapted to leaping (long muscular hind limbs, short back bone), making it immediately recognisable regardless of the environment — tropical forest, pond or sandy area — in which it is found.

The diversity of forms in anurans, sometimes even within the same family, comes from their adaptation to a specific way of life or environment. Tree frogs, for example have suction pads on their feet and hands for climbing, binocular vision towards the front and a wide field of vision towards the top and bottom. Aquatic anurans have webbed feet and their eyes are positioned on the top of the head, providing them with a wide horizontal field of vision as well as enabling them to remain underwater while keeping their eyes above the surface. Burrowing species have no suction pads or webbing but rather spade-like tubercles under the hind feet so that they can burrow into the sand within seconds.

Their incredible talent for adaptation is probably most developed in a frog originating from South East Asia: the *Rhacophorus reinwardtii* has the ability to glide from tree to tree with the help of the large webs between its toes.

From the miniature 10cm (4in) *Psyllophryne didactyla*, to the giant Goliath Frog, which can reach up to 30cm (12in), anurans must be admired for their ingenuity and inventiveness with which they have adapted to the most difficult conditions for millennia.

Ceratophrys ornata (Leptodactylidae)
Distribution: Argentina, Uruguay, Paraguay and Brazil
Average length: 10 to 15cm (4 - 6in)

BUFONIDAE

Present in most temperate and tropical regions, they frequent a great variety of habitats and are principally nocturnal and terrestrial, although a few rare species have adopted an arboreal or aquatic way of life.

This family is widely represented throughout the world with 35 genera and 400 species. It is however absent from a number of islands, including Madagascar and New Guinea.

Toads are characterised by a complete absence of teeth and generally have a plump and heavy build, relatively short limbs and dry and warty skin. Their hopping movements are often enough to identify them by. They are unable to escape predators by jumping or quickly fleeing but are often spared by their two prominent glands known as parotids, located behind the eyes, which secrete a powerful poison, rendering them quite unfit for consumption.

The genus *Bufo* is the most emblematic of the family and the most significant in number, with 250 species. Its members live a terrestrial life almost all year round. The mating period is the only very brief period when they venture in to an aquatic environment. Some species can lay up to 20,000 eggs at this time. Their clutch generally forms the shape of a gelatinous string wrapped around aquatic vegetation, and eggs are protected by a toxic outer layer.

The small African toad, *Nectophrynoides occidentalis*, has evolved such that it has no need for water at all. The development of its eggs and larvae takes place inside the female, which then gives birth to fully developed young frogs.

Bufonids are not normally very colourful. *Atelopus* are the exception with their very bright hues, they can definitely match Dendrobates when it comes to colour and toxicity.

BUFO BRAUNI [▶]

This tropical toad depends on primary mountain forests and shows very poor resistance to disturbance of its habitat. It is discreet and timid and will rarely venture out from the underbrush that protects it. In contrast, its two close cousins, with which it is often confused (*Bufo gutturalis* and *Bufo maculatus*), are content in all sorts of environments (such as forest, savanna and agricultural areas). It blends with the ground on which it lives, preferring to be close to ponds, rivers and even waterfalls when it comes to the breeding season.

Distribution: Tanzania,
Democratic Republic of Congo
Average length: 7 to 9cm (2¾ - 3½in)

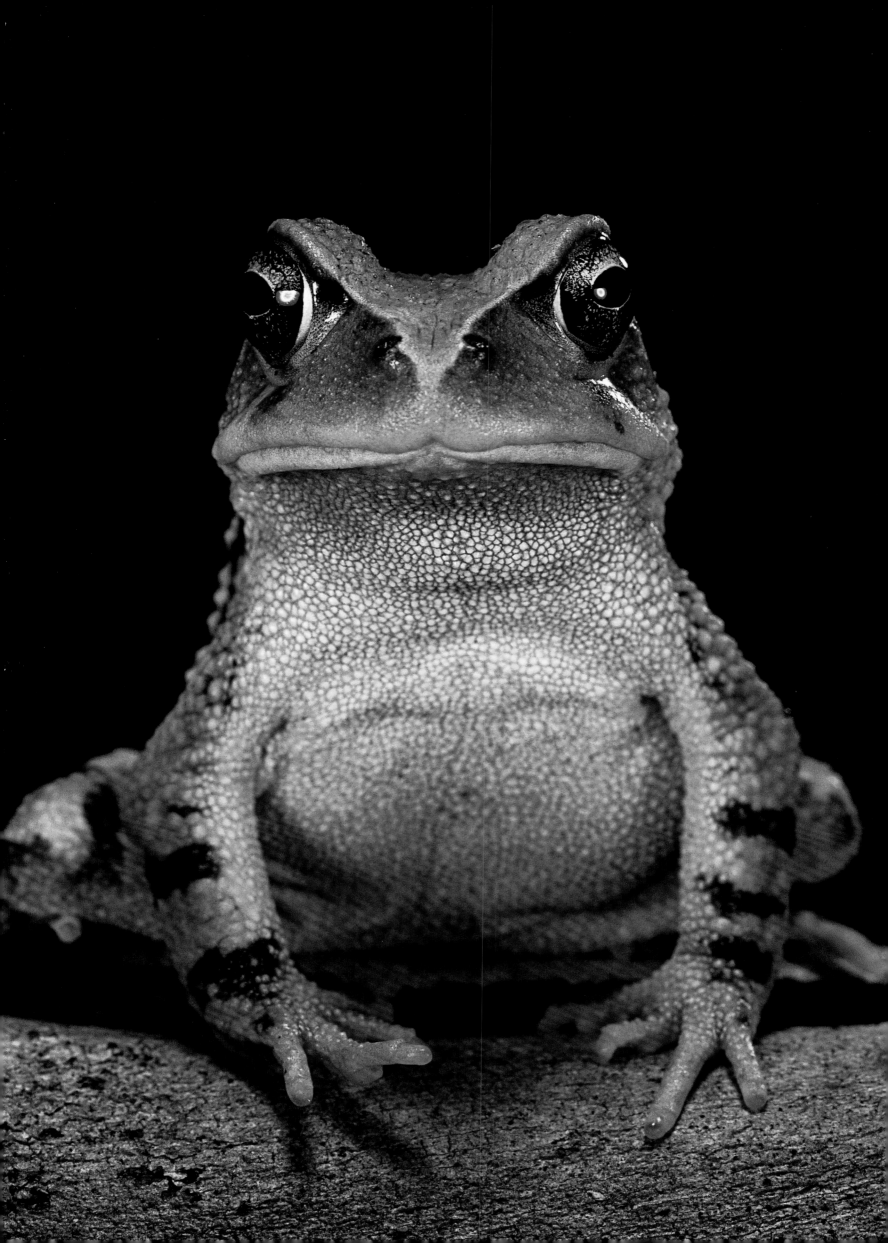

BUFO MELANOSTICTUS [▸]

It has the largest geographical distribution of
all Asian toads. It is highly opportunistic and
occupies a number of habitats – from forests
to residential areas, where it is easily observed.
It is a nocturnal animal and it is not
uncommon to see it feeding near street lamps
where insects that are attracted to the light
end up in its bottomless stomach.

Distribution: all South East Asia,
from the east of India to the Philippines
Average length: 7 to 11cm (2¾ - 4⅜in)

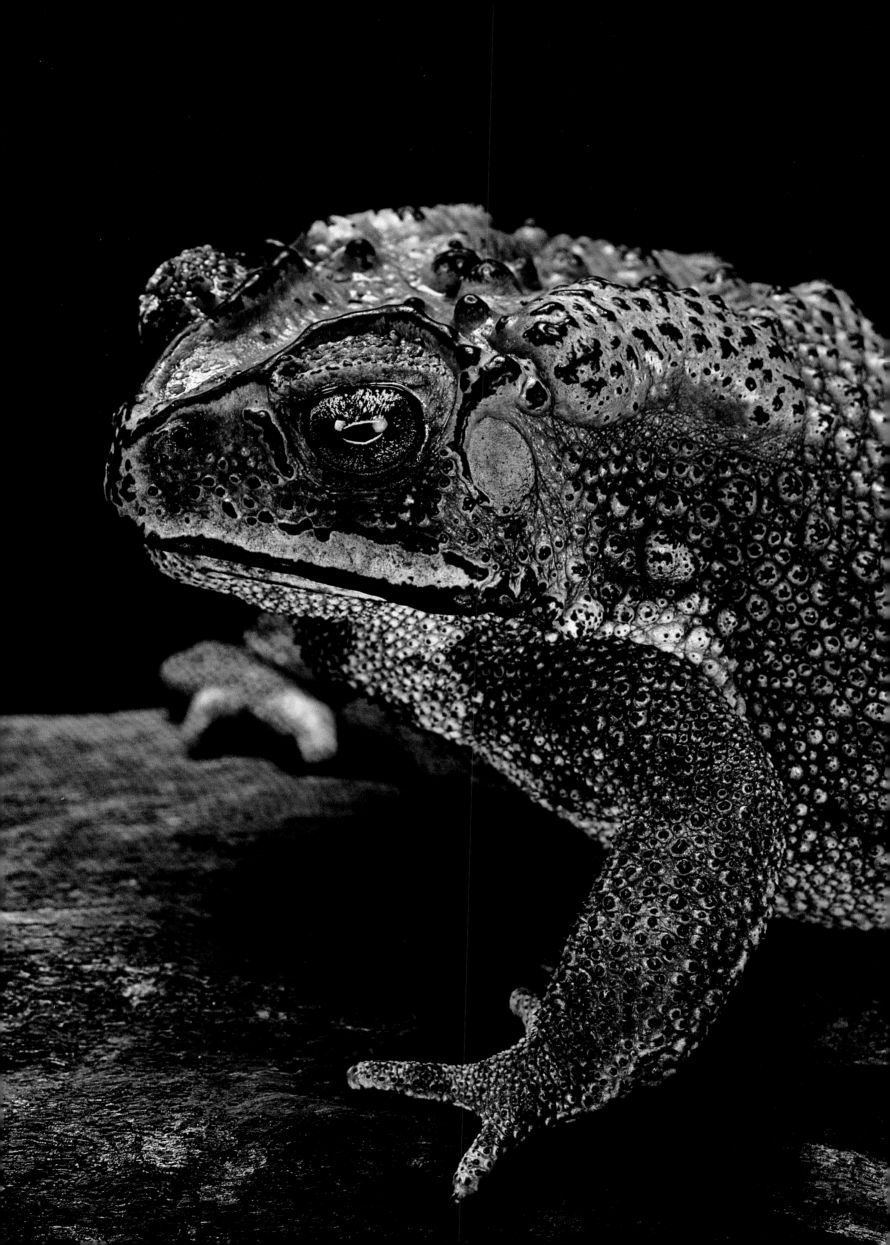

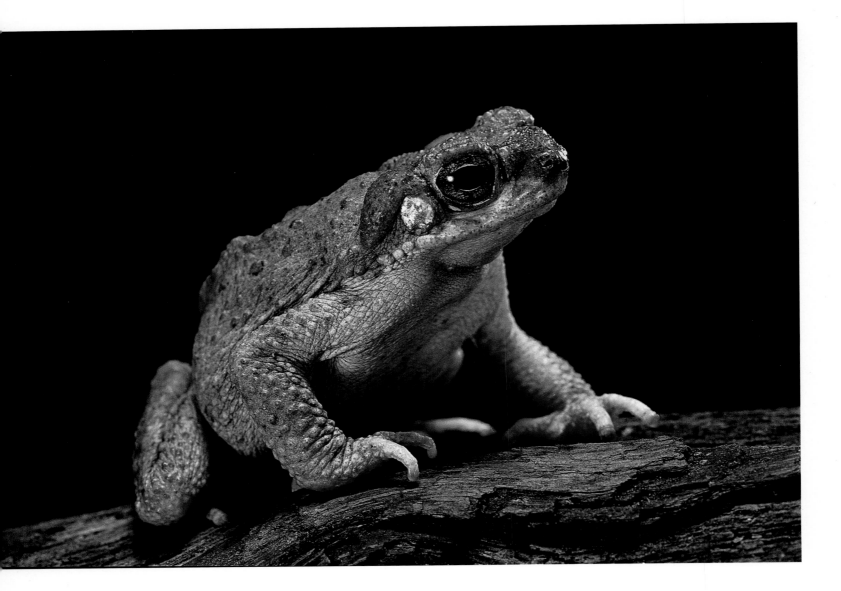

BUFO PUNCTATUS [▲]

(RED SPOTTED TOAD)

This terrestrial toad is generally found in rugged prairies, sheltered in rock fissures. It is a skilled climber and will not hesitate to climb over obstacles. It likes crowded water spots or relatively moist areas. It is nocturnal most of the time but it is not uncommon to come across it in broad daylight, looking to satisfy its insatiable appetite or to find a pleasant spot for its diurnal rest.

Distribution: from the south west of the United States to Mexico
Average length: 5 to 7cm (2 - 2¾in)

BUFO AMERICANUS [▶]

The American toad can adapt and colonise all kinds of habitats including artificial ones and can resist periods of drought. This ability has enabled it to have a widespread geographical distribution, making it one of the most common toads on the east coast of Canada and the United States. Its highly contrasted camouflaged appearance is remarkably well adapted to the rocky soils and lichen, which they are particularly fond of. The animal is principally nocturnal, but will readily prolong its insect hunting into the day. It is common in gardens and farmland and its gluttony may even lead it to enter houses and feast on insects attracted to the light.

Distribution: United States and Canada
Average length: 10cm (4in)

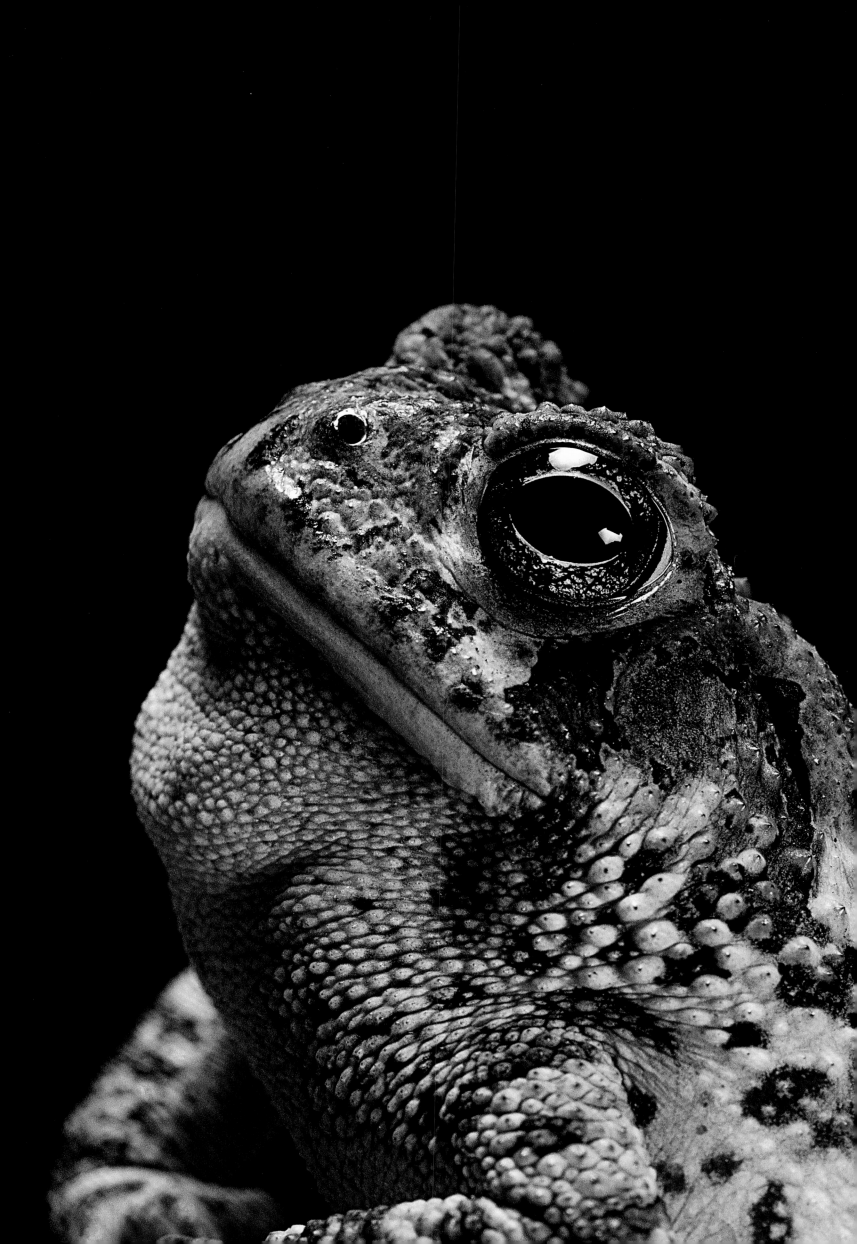

BUFO ASPER [▶ | ▶▶]

This large, warty toad has its very own technique to protect itself from danger: it falls backwards, sticks its four legs up in the air and plays dead. This ruse will give it a chance to escape death, as a predator may be reluctant to eat dead prey. It likes to keep a lookout on mounds of plant debris, tree trunks or stones by water spots where it can surprise its prey.

Distribution: Thailand, Myanmar (form. Burma), and Java
Average length: 12cm (4¾in)

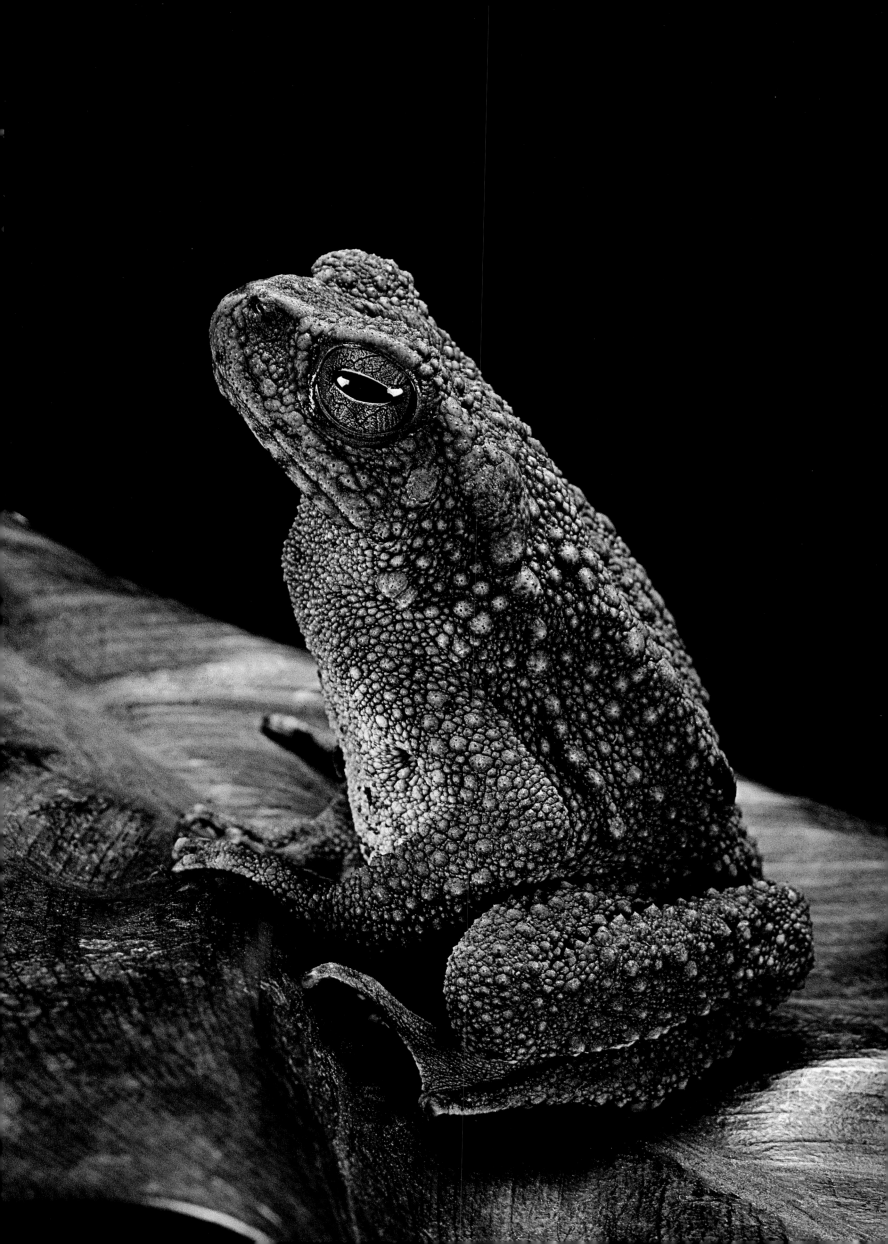

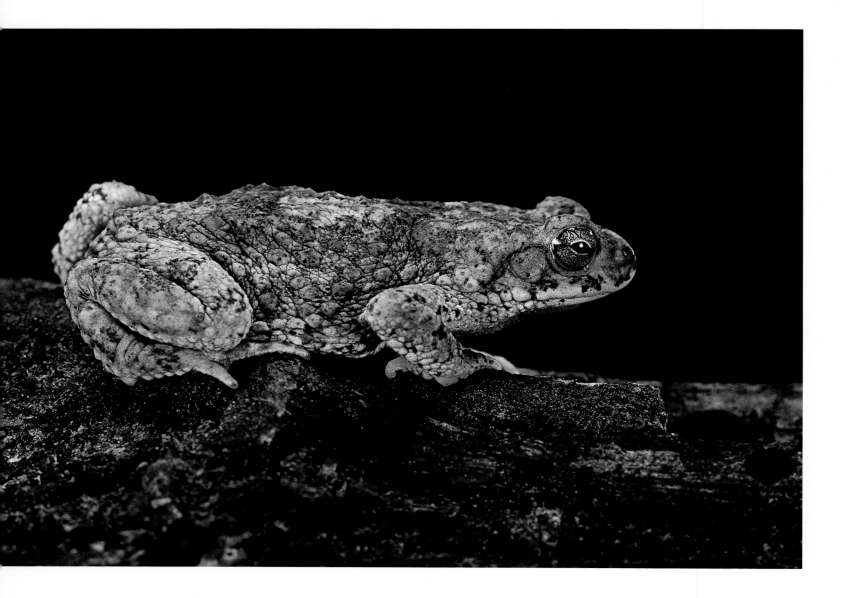

STEPHOPAEDES USAMBARAE [▲]

This species is endemic to the Usambara Mountains and lives on the forest floor, protected by the lush tropical vegetation of the mountains. It has a slightly flattened morphology, large and flat parotid glands and proceeds on all fours and is, therfore, not immediately recognisable as a toad.

Distribution: Tanzania
Average length: 4cm (1½in)

BUFO GARMANI [▶]

This very common toad has one of the greatest geographical distributions in Africa after *Bufo regularis*. It has adapted to many biotopes: arid savanna, wooded savanna, and agricultural areas. This very prolific breeder can lay up to 20,000 eggs. It is a champion of adaptation and will readily lay eggs in artificial sites such as dams, swimming pools or even abandoned kitchenware such as pots or bowls!

Distribution: from Ethiopia to South Africa
Average length: 9 to 11cm (3½ - 4⅜in)

BUFO REGULARIS [▶▶]

The most common of African toads. It is fond of a great variety of habitats and will readily frequent oases in Saharan areas, right up to humid tropical environments. It spends its days sheltered under a stone, tree trunk or in dense vegetation and only comes out at night to hunt. It has a voracious appetite and as such is not a fussy eater, preying on virtually anything and everything that passes its mouth.

Distribution: practically all of Africa, from Algeria to South Africa
Average length: 6 to 13cm (2⅜ - 5⅛in)

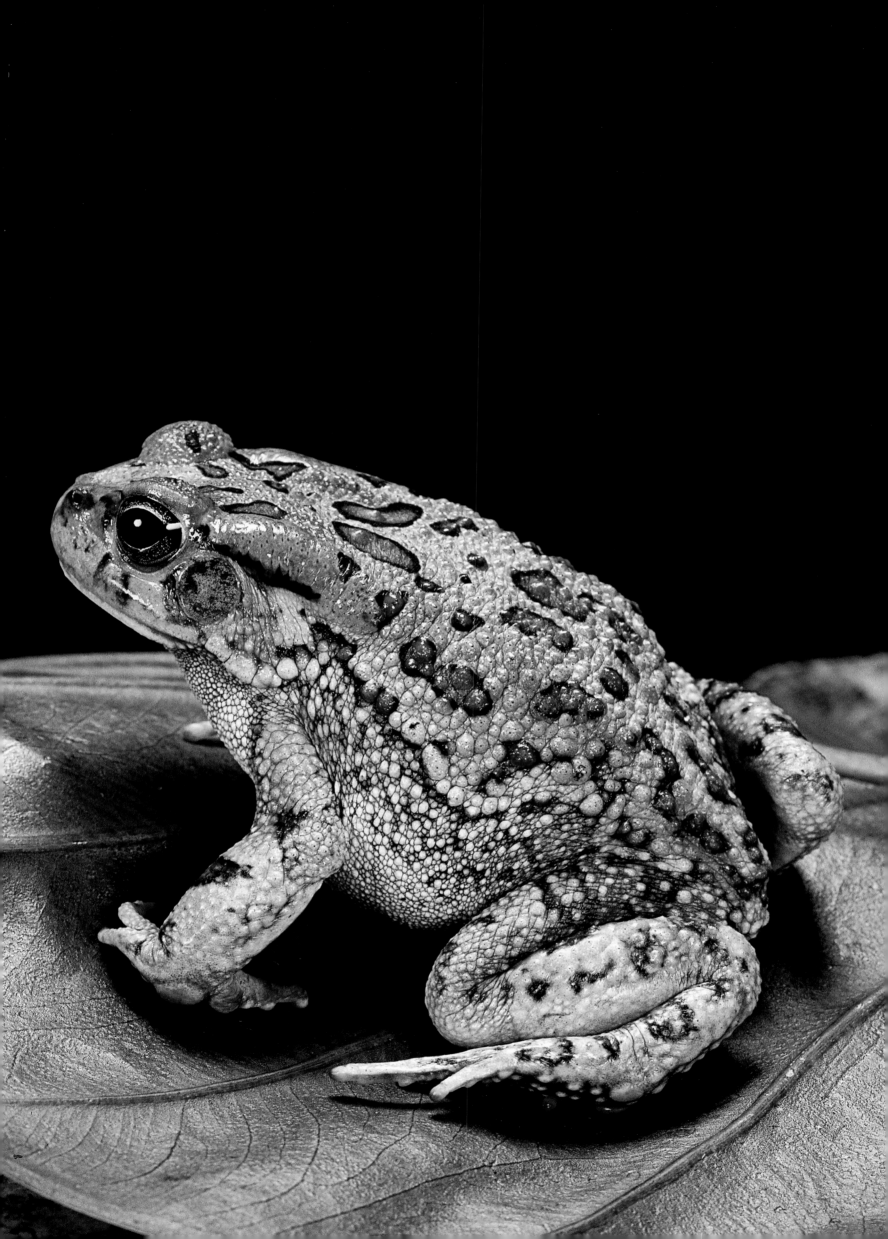

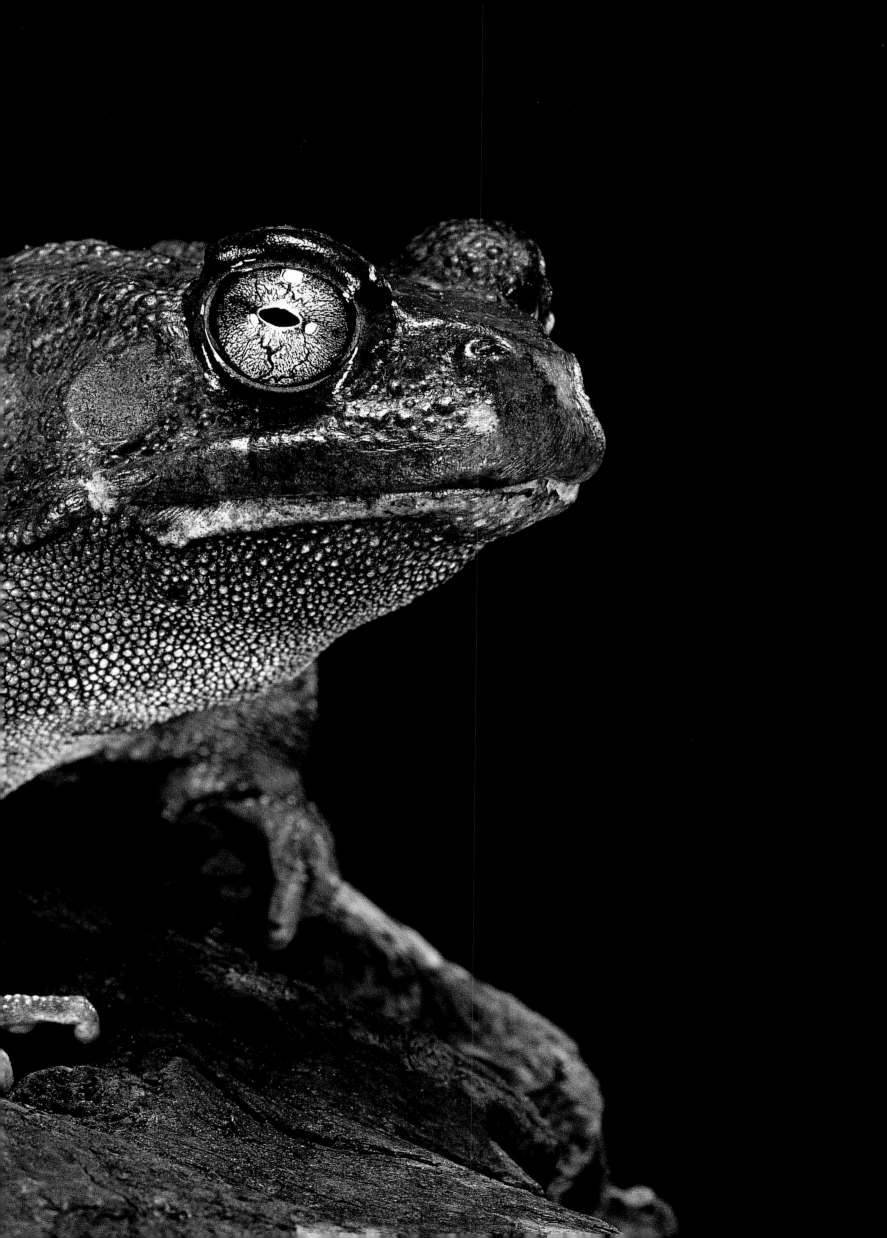

DENDROBATIDAE

Certainly one of the most spectacular anuran families, with fantastic atypical characteristics. Originating from the New World, these tiny frogs have colonised the heart of Central and South American rainforests, from Nicaragua to Brazil. They are diurnal and mostly terrestrial, although a few rare species have adopted an exclusively arboreal way of life. They spend their days travelling across their territory with jerky, skittish movements, in search of the tiny arthropods they relish. New species are described almost every year and no less than 240 have been identified so far, which are divided into 9 genera in a continuously evolving classification. While the skin of most amphibians contains traces of venom (varyingly toxic depending on the species), the dermal glands of Dendrobates secrete a formidable poison. As they have no inoculation system, they secrete venom continuously, all the while maintaining constant moisture levels in their skin. According to scientists, these secretions stem from a complex chain of biosynthesis: Dendrobates benefit from alkaloids present in some plants in their habitat by ingesting the insects that feed on them. The danger of these poisons vary from one species to another, and only a few secrete venom capable of killing a human being.

This toxic identity is generally expressed in an incredibly bold, almost extravagant colour palette, which warns of their venomous nature and drives away potential predators. Their social and territorial behaviour is sophisticated, such as the vigorous territorial combats that can take place between males or between females, as well as their commitment to parental care, a task often carried out by the male as distinct from other anuran families. They watch over their future offspring with almost obsessive care and patience: guarding and moistening the eggs until they hatch, and then transporting the tadpoles on their back to a water spot where they will complete their development.

DENDROBATES PUMILIO [▸]
BASTIMENTOS MORPH

This charming Dendrobate exhibits a wide spectrum of colours and patterns, as well as a sizeable geographical distribution with a variety of habitats. While it favours coastal tropical rainforests, it is also very fond of agricultural plantations (cocoa, coffee, coconut), which are rich in insects and potential breeding sites. In some agricultural areas, their population is so abundant that the ground and low-lying vegetation is littered with them, a rare example where human presence actually favours the amphibian demography. They are highly territorial and their vocal calls, with little buzzing noises, are somewhat similar to the song of the cricket. These are interrupted by vigorous brawls between males fighting for a territory or a mate.

Distribution: south of Nicaragua, Costa Rica and Panama
Average Size: 2 to 2.5cm (¾ - 1 in)

DENDROBATES GALACTONOTUS [▸▸]

Now very common in captivity, until recently it was not well known amongst breeders. Very little is actually known about this species in its natural environment despite successful captive breeding to supply the amphibian pet trade. It lives on low altitude forest floor and its lifestyle is very similar to that of its cousin, dendrobates tinctorius.

Distribution: known in limited areas south of the Amazon in Brazil
Average length: 3.5cm (1⅜in)

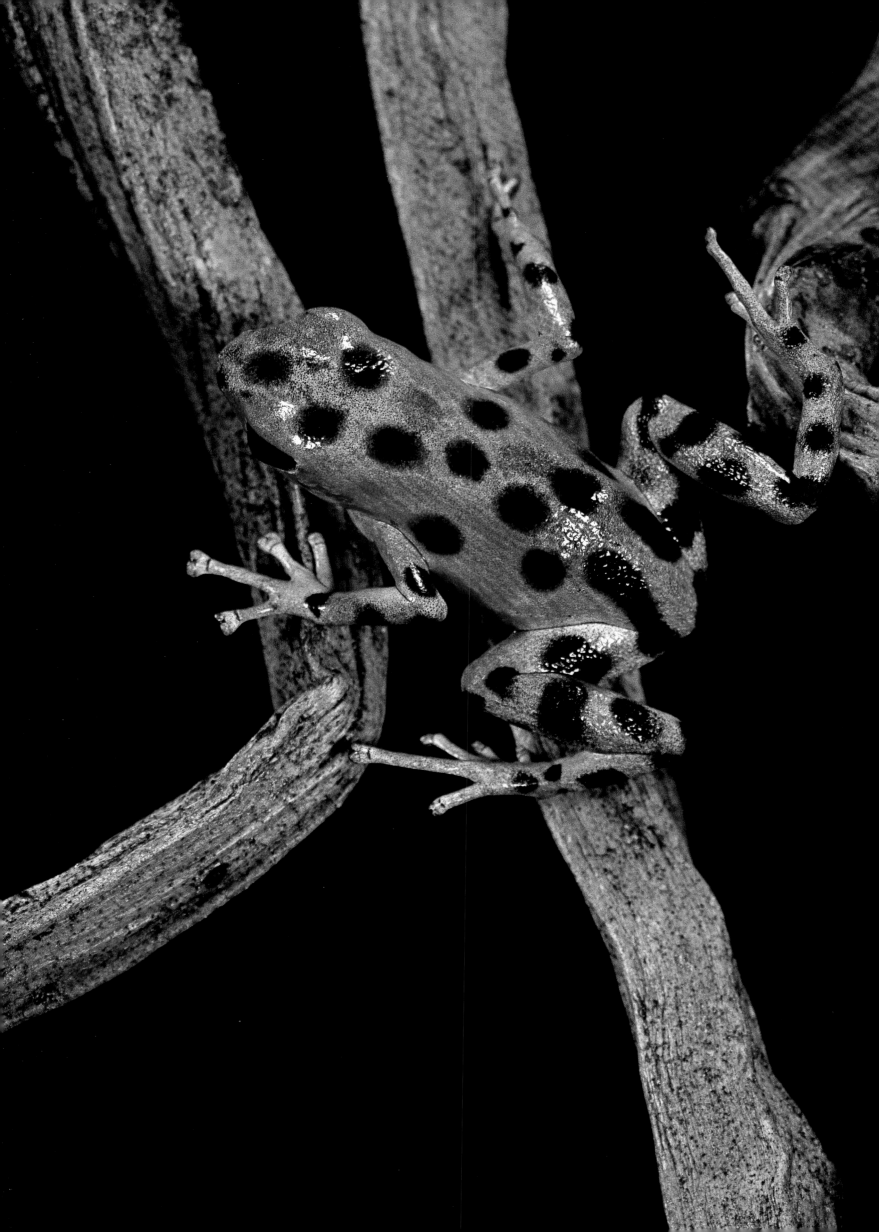

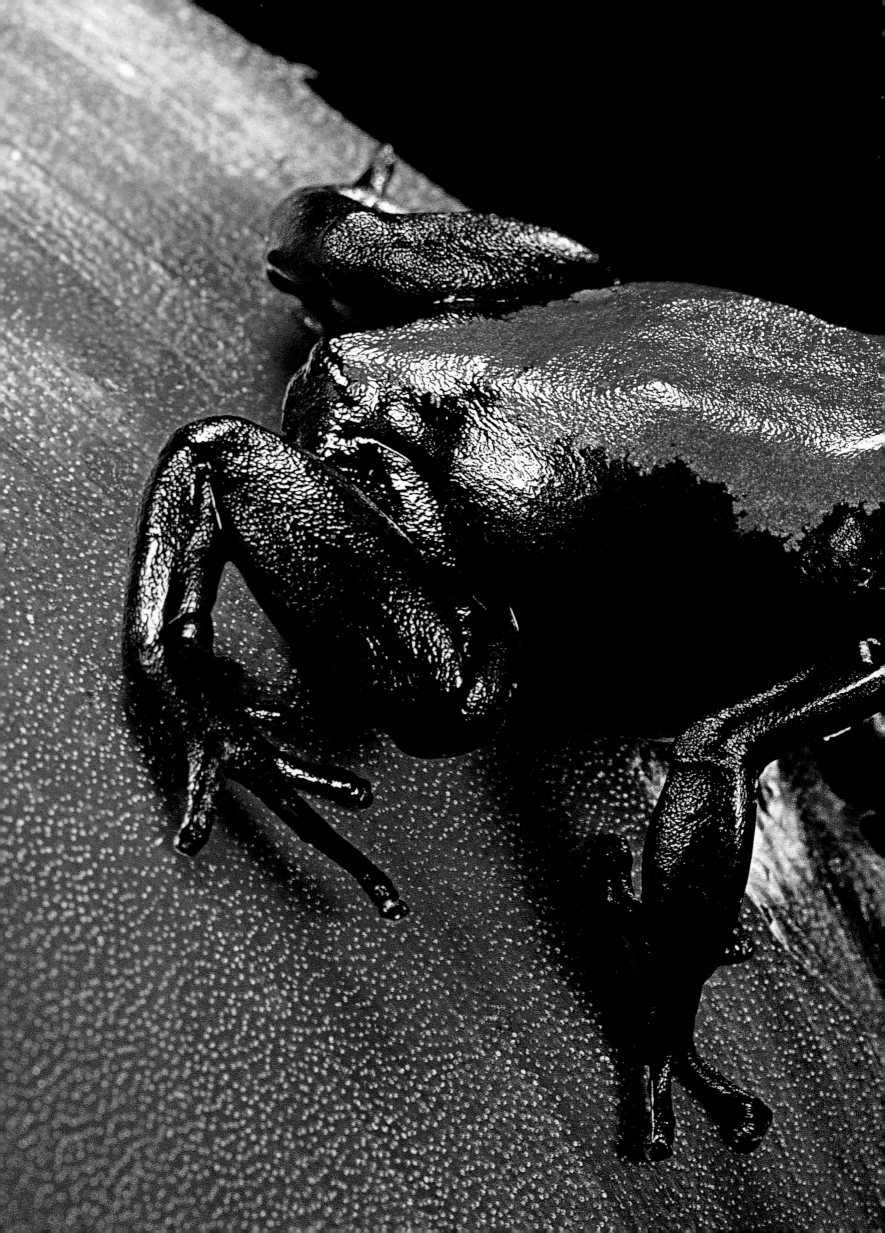

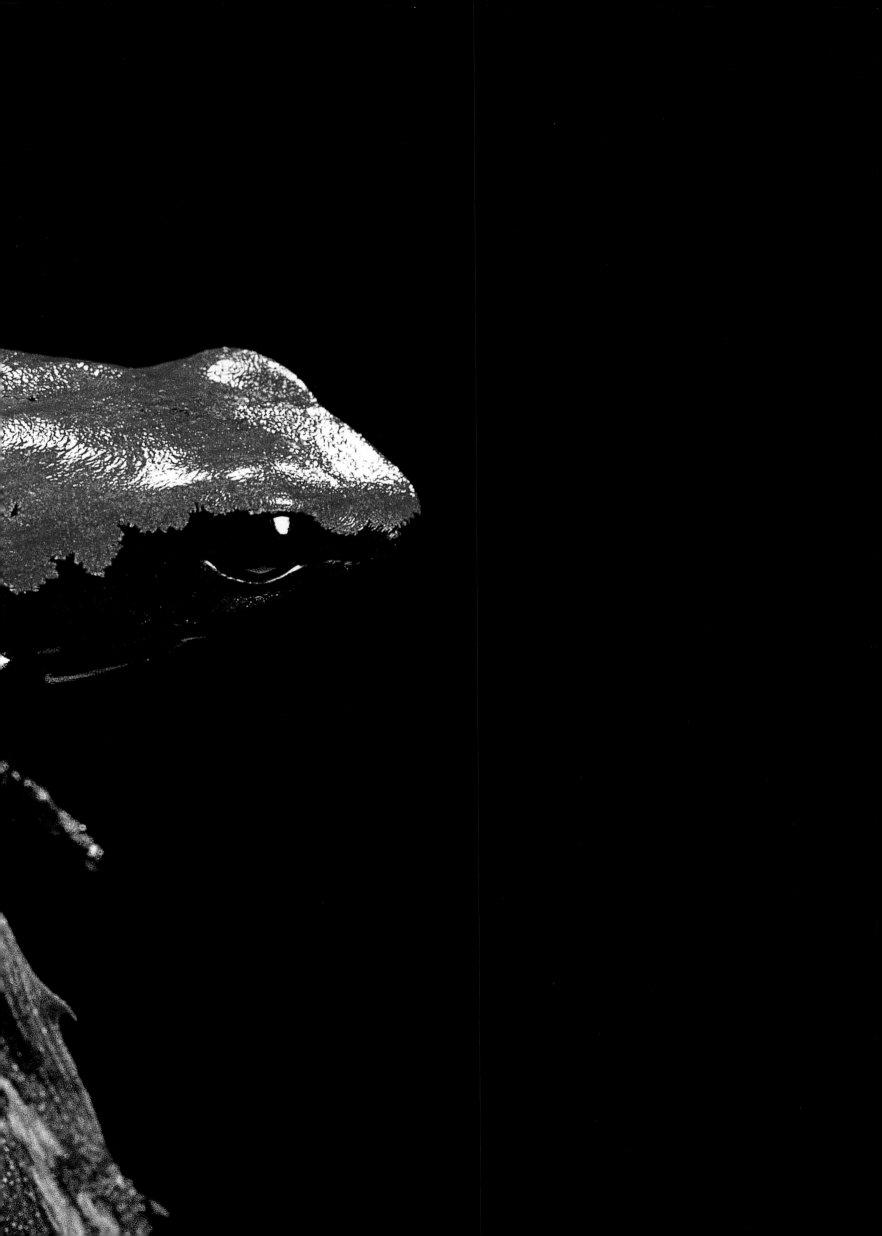

DENDROBATES TINCTORIUS [▶]

DYEING POISON FROG

Its name comes from the ancient Indian practice of dyeing textiles. It was rubbed against the feathers of a young Amazonian parrot, so that its venomous secretions could modify its colour. No longer practiced today, this procedure was used to brighten the multicoloured adornments of some American Indian tribes.

It is certainly one of the very first amphibians from Guyana to reach the King of France's Royal Garden collection at the end of the 18th century. The great naturalists of the time praised its beauty and Buffon himself spoke of it as the "prettiest frog in the world". There are a multitude of different colour variations within the species, depending on geographical location, adding additional wonder to this already famous amphibian.

Distribution: French Guyana
Average length: 4 to 5cm (1½ - 2in)

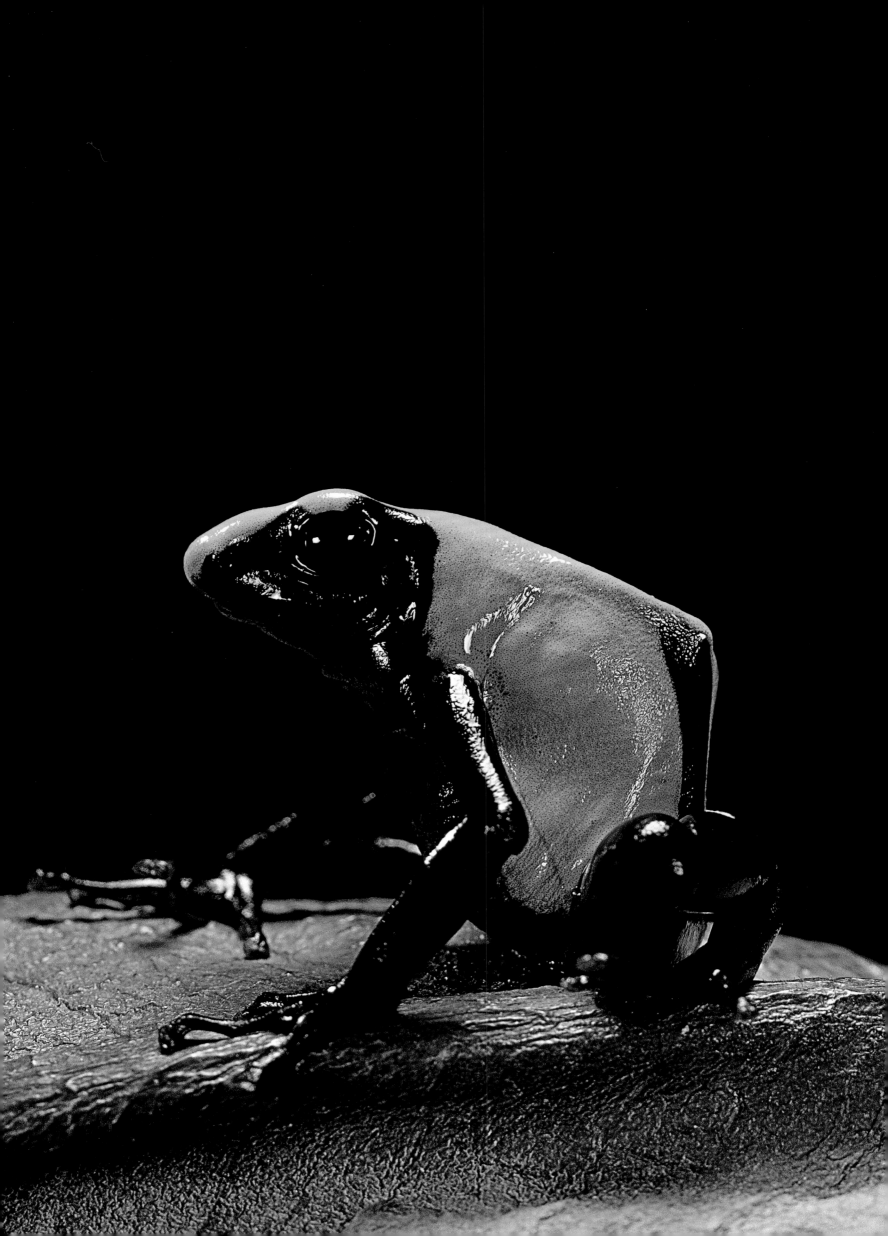

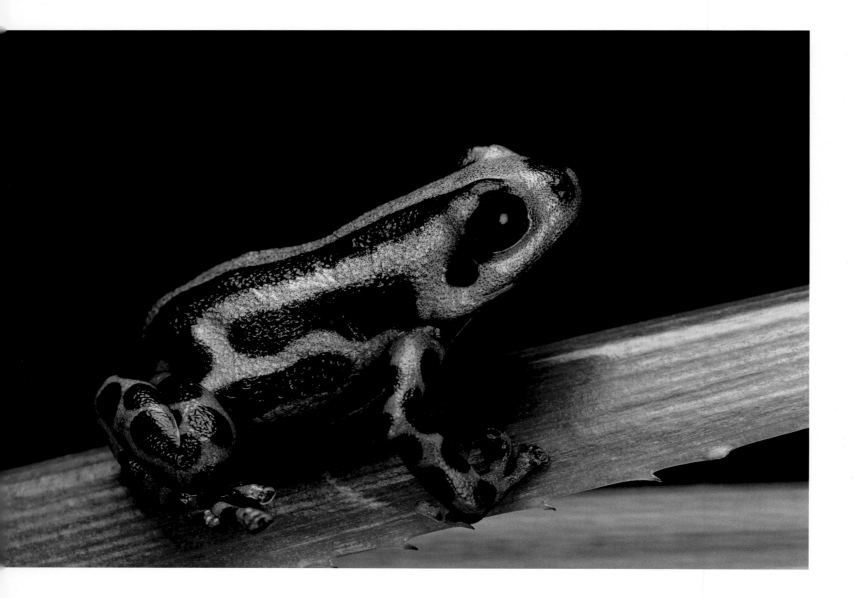

DENDROBATES LAMASI [▲]

First described in the early '90s, this small, tree-dwelling jewel is still not well known and its reproduction in captivity remains rare. Its spectacular colouring warns the forest of its untouchable nature. Only a few rare predators, who have developed resistance against its poison, dare to attack the sublime and toxic outcast. As is true of a great number of dendrobates, its dedication to parental care is beyond reproach.

Distribution: Peru
Average length: 1.5 to 2cm (½ - ¾in)

DENDROBATES VENTRIMACULATUS [▶]

This highly coloured Dendrobate lives in low lying vegetation, sheltered by leaves. The male will transport the tadpoles on its back to the protective chalice of a bromeliad filled with water.

Distribution: Peru, Ecuador, Colombia and a few patches of populations scattered throughout Brazil in the Amazon Basin, as well as the eastern part of French Guyana
Average length: 1.6 to 2.1cm (⅝ - ⅞in)

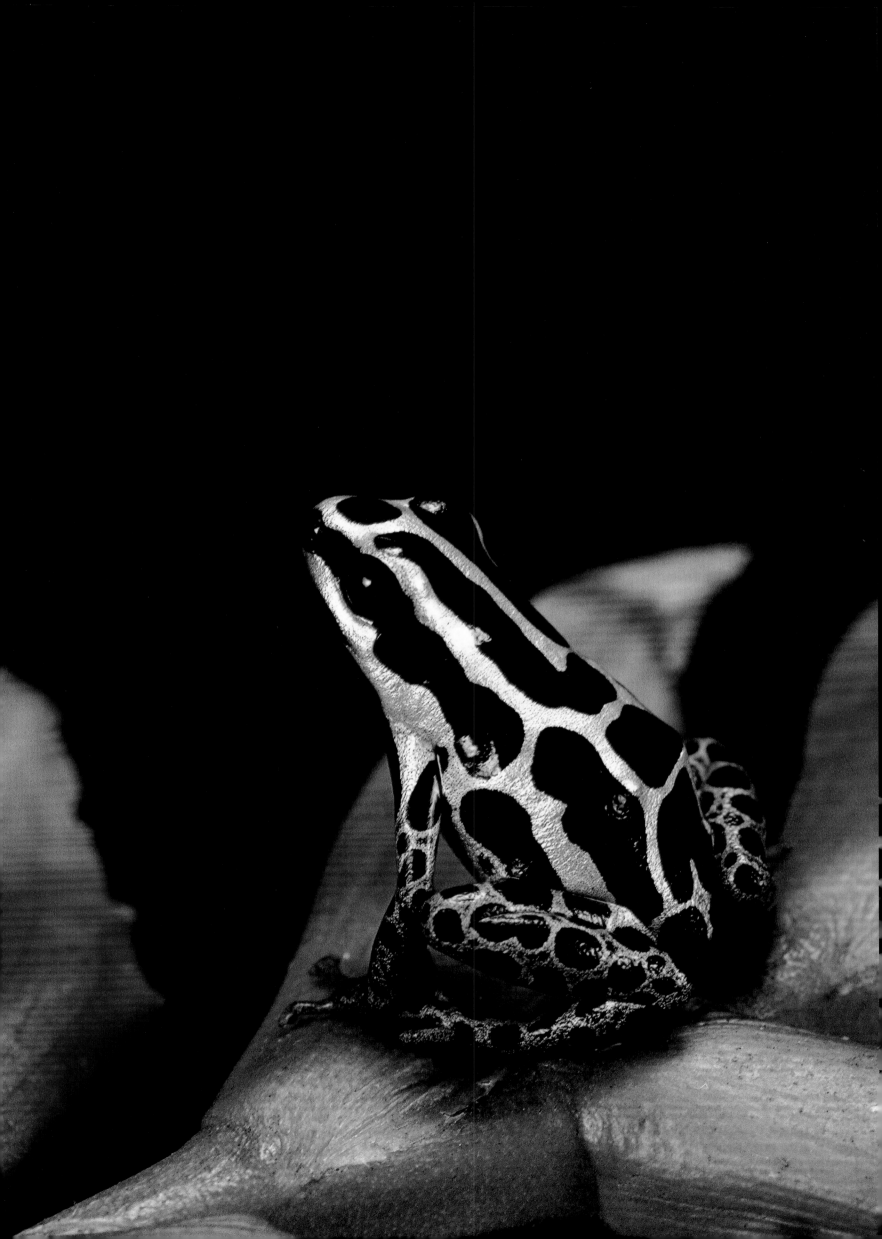

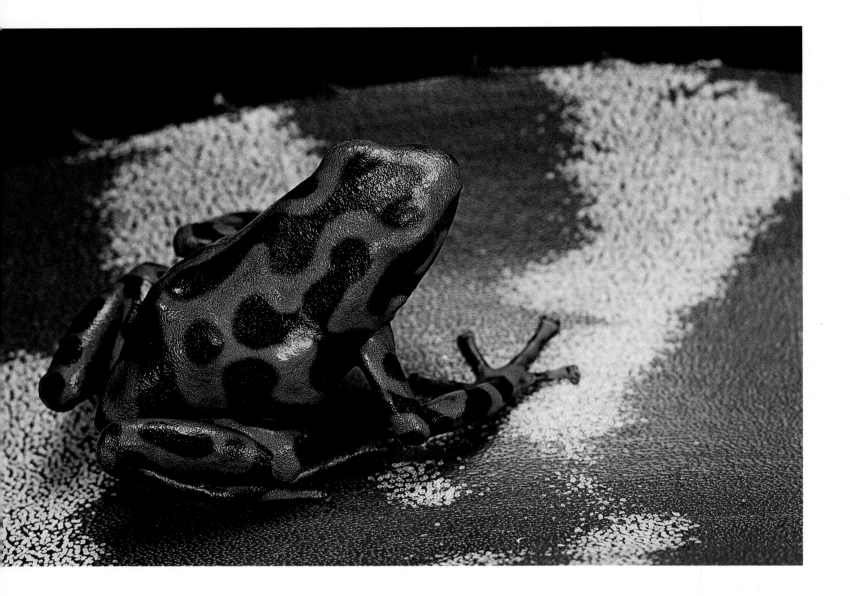

DENDROBATES AURATUS [▲]

This anuran's 'outfit' can present a great variety
of patterns and colours, often complicating
identification. This wealth of colours depends
greatly on its geographical origin: it is almost
black on some Panamean islands. Its
introduction to the Hawaiian archipelago in
the 1930s has given rise to a 'Hawaiian' form
with special colours and patterns.

Distribution: from the north east of Colombia
to the south of Nicaragua, imported in 1932
to the island of Oahu in Hawaii
Average length: 3 to 6 cm (1⅛ - 2⅜in); some
populations never exceed 2.5cm (1in)

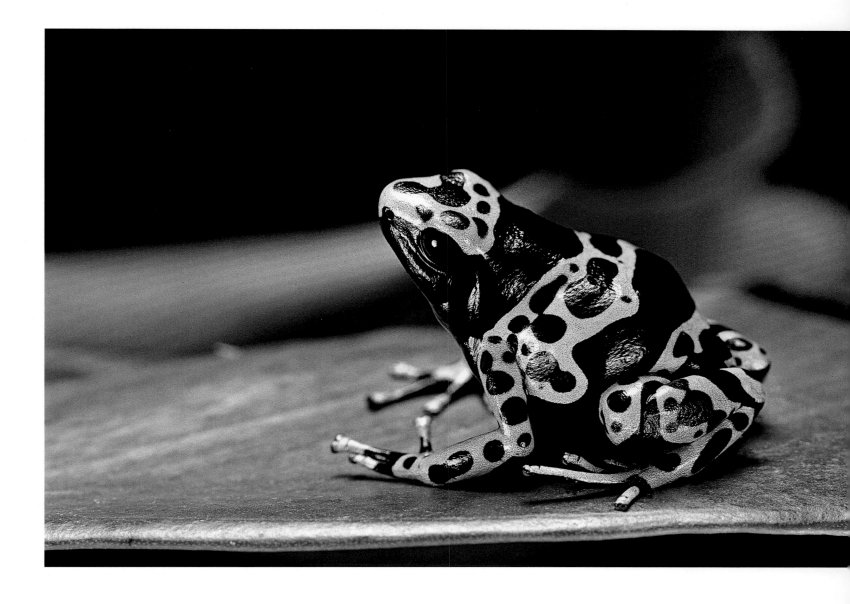

DENDROBATES LEUCOMELAS [▲]

These are the only ones to have a true
aestivation cycle during the cold period.
Living in regions that are subject to significant
variations in temperature, they are quite
tolerant of very dry seasons. They are also
known for being very territorial and males
will show aggression towards intruders and
express their sense of ownership, if necessary
by force. Their beauty, size and robustness
make them one of the most common
Dendrobates for breeders and collectors.

Distribution: Venezuela, Guyana, as well as the
border zones of Colombia and Brazil
Average length: 3.5cm (1⅜in)

DENDROBATES AZUREUS [▶▶]

This is an inhabitant of the small patches of
tropical forests surrounded by savanna.
Between the streams and plants of the
underbrush, it travels across its territory in its
electric blue 'pyjamas', an odd sight in this
natural environment. Its simple colouring
makes it very popular and highly sought after
by breeders and amphibian lovers. Now that it
is bred and raised in captivity it is much less
likely to be taken from its natural habitat. This
has certainly contributed to saving the species,
which is particularly vulnerable through its
small geographical range.

Distribution: Surinam
Average length: 4cm (1½in)

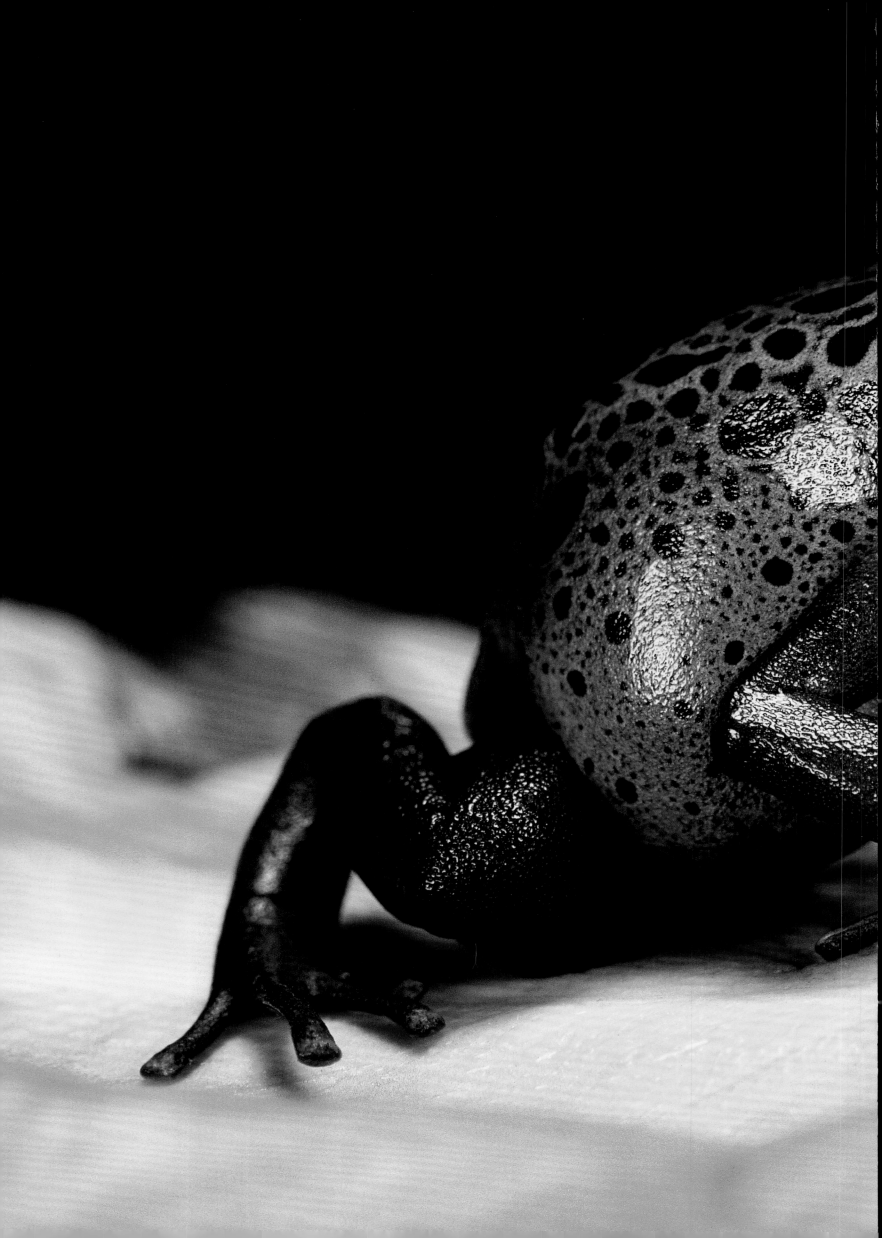

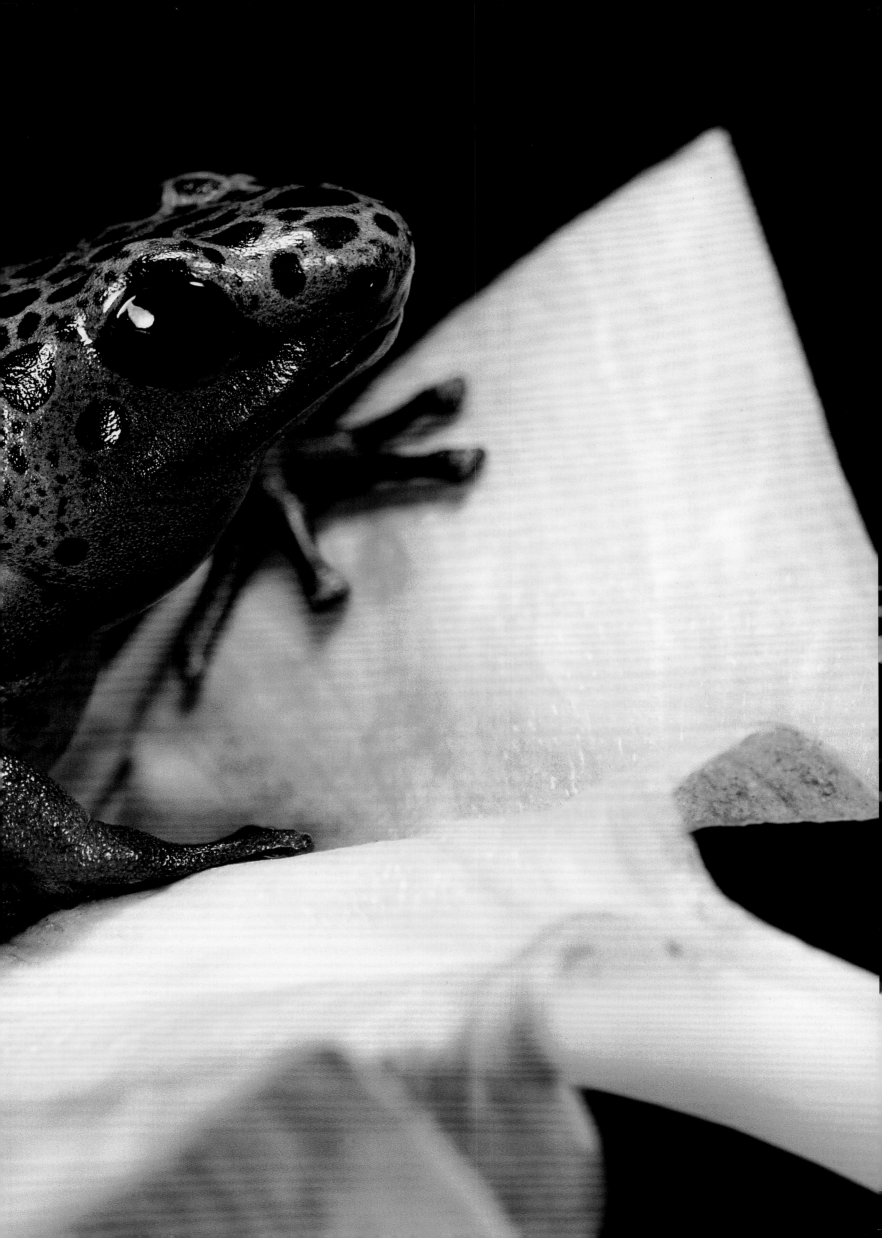

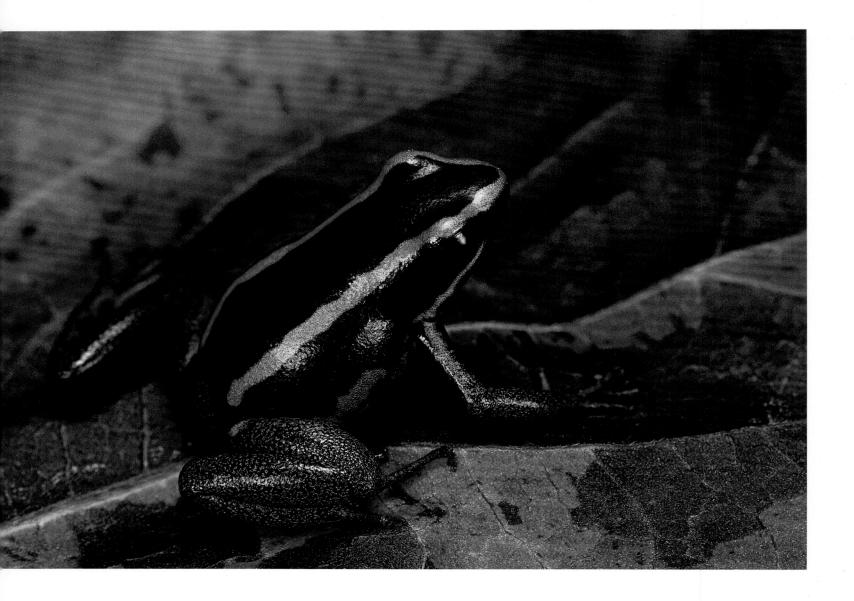

PHYLLOBATES VITTATUS [▲]

Its easy maintenance and beauty have made it
very popular in captivity, where it is very
commonly bred in significant numbers. It is
terrestrial and diurnal, living in the forests of
plains, where the climate is relatively dry for
most of the year. It journeys about the
underbrush in search of food and it is not
uncommon to see a male with its back almost
entirely covered with the young. It transports
them to a small collection of water, in the
hollow of a tree trunk or plant. Unlike other
Dendrobate tadpoles that clearly eat their
own, this frog's larvae cohabit relatively well,
with little or no predation among them.

Distribution: Costa Rica
Average length: 3 to 4cm (1⅛ - 1½in)

PHYLLOBATES BICOLOR [▶]

Bearing a great resemblance to its deadly
cousin, *Phyllobates terribilis*, it is also highly
dangerous and is one of the 3 most
venomous dendrobates in the world. An
attentive and devoted parent, it will care
almost obsessively for its many young
(between 10 and 25 eggs). This task is most
often accomplished by the males, who go as
far as regularly moistening and cleaning the
surface of their eggs to prevent the
development of fungi. Once hatched, tadpoles
are transported on their back to a site suited
to their proper development, such as the
hollow of a bromeliad leaf filled with water.

Distribution: the south east of Colombia
Average length: 3.5 to 4cm (1⅛ - 1½in)

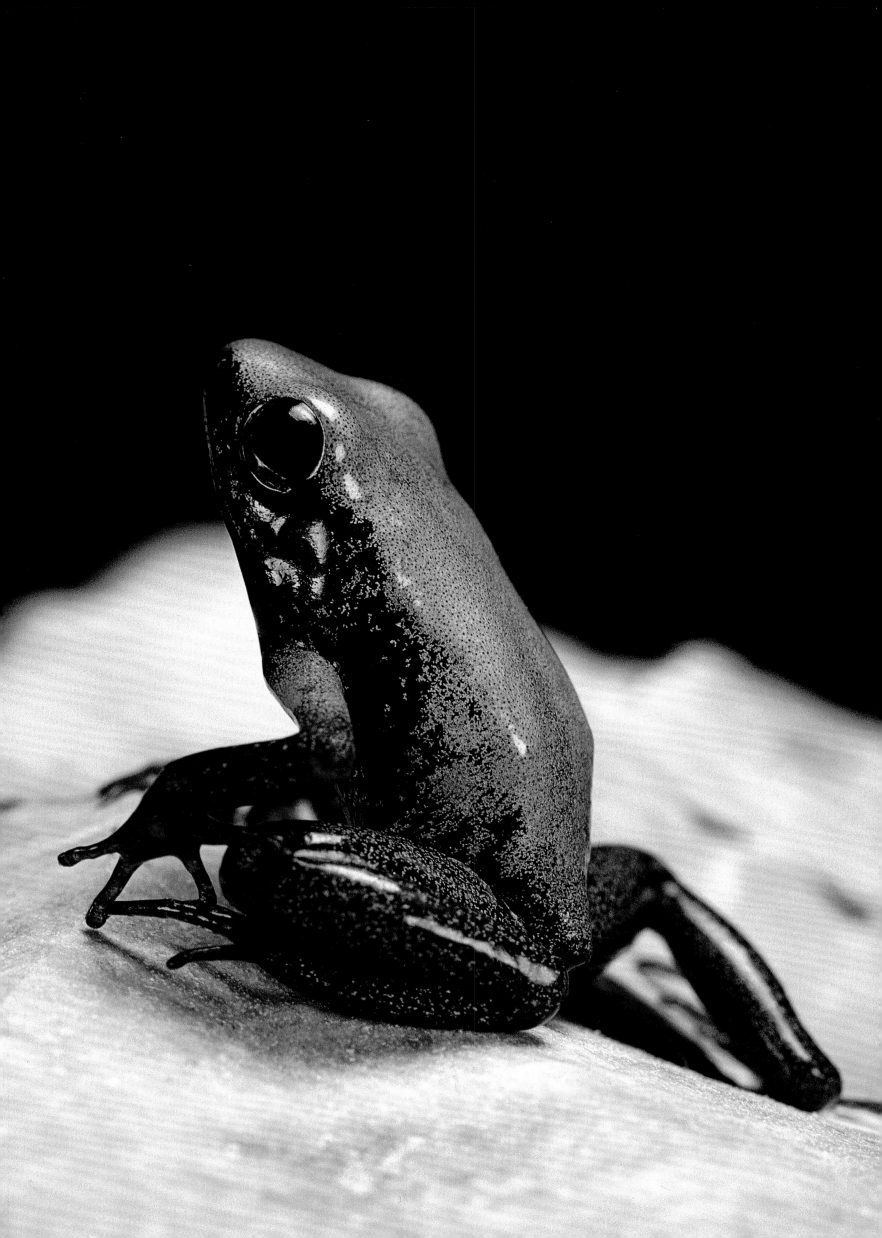

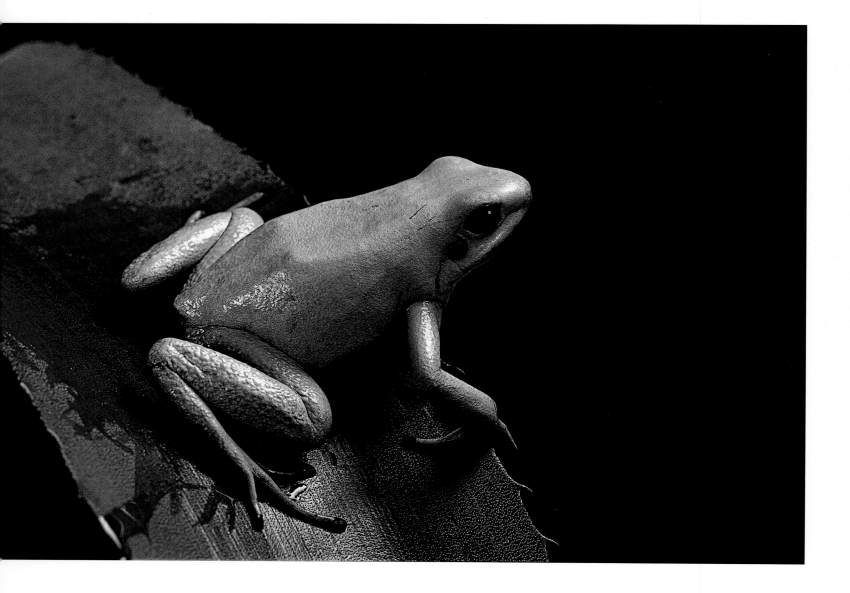

PHYLLOBATES TERRIBILIS [▲]
MINT FORM

Distribution: restricted location in south east
Colombia near the Patia river
Average length: 4 to 5cm (1½ - 2in)

PHYLLOBATES TERRIBILIS [▶]

This is the most venomous amphibian in the
world and one of the most toxic vertebrates
on the planet! Simply touching it with chafed
skin can be fatal. In its country of origin, the
Choco Indians used its toxins for generations
(by making it sweat above a fire or by
piercing it with a needle) to poison their
arrows; they could preserve their fatal
properties for 2 years.

Distribution: restricted location in south east
Colombia near the Patia river
Average length: 4 to 5cm (1½ - 2in)

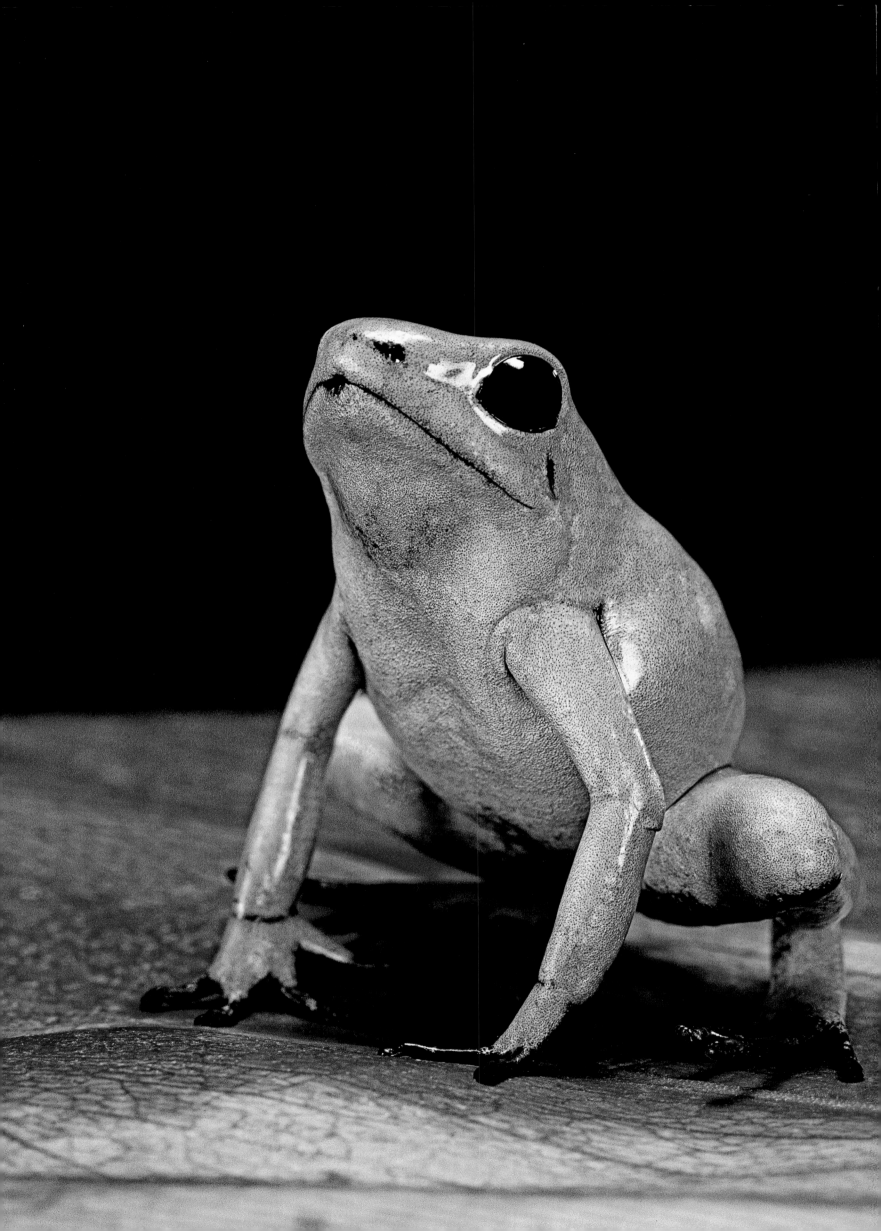

HYLIDAE

This graceful and elegant family is the most popular group of anurans. They are well represented, and show great diversity, on the majority of the continents, though they are absent from sub-Saharan Africa, South and South East Asia and many islands, including Madagascar. They are generally arboreal and colonise various types of biotopes, where they display considerable morphological variations. They are divided into four subfamilies made up of 48 genera embracing almost 800 species. Their anatomy is characterised by a distinctly flatter body than other anurans, and by long thin legs with adhesive discs at the ends of their fingers and toes. They are true acrobats, some of them have opposable fingers enabling them to master the vegetation as a monkey would. Although they are principally arboreal, there are a few burrowing species. The latter have the characteristic feature of aestivating below ground, covered in a fine protective veil of solidified mucous secretions.

During the breeding period, members of this large family get together on the edges of a stretch of water, such as a pond, pool or puddle, and start a concert of mating calls. Whether the eggs are laid directly in water, on leaves or in cone-shaped plant structures prepared for the purpose, the tadpoles will almost always complete their last stage of development in water.

LITORIA INFRAFRENATA [▸]

This giant is one of the largest tree frogs in the world: females can measure up to 14cm (5½ inches). It is most often perched on plants, moving about with agility and only at night. Breeding is the only time when they can be seen in numbers in woody areas, rested on their perch around a water spot. The song of the males is halfway between a bellow and a lament. These tree frogs lay low during the day, huddled up, exercising their skill in mimicry to perfection. Their beautiful light-green colour can abruptly turn to dark green according to temperature, humidity or light.

Distribution: Papua New Guinea and the extreme northeast of Australia
Average length: 10 to 14cm (4 - 5½in)

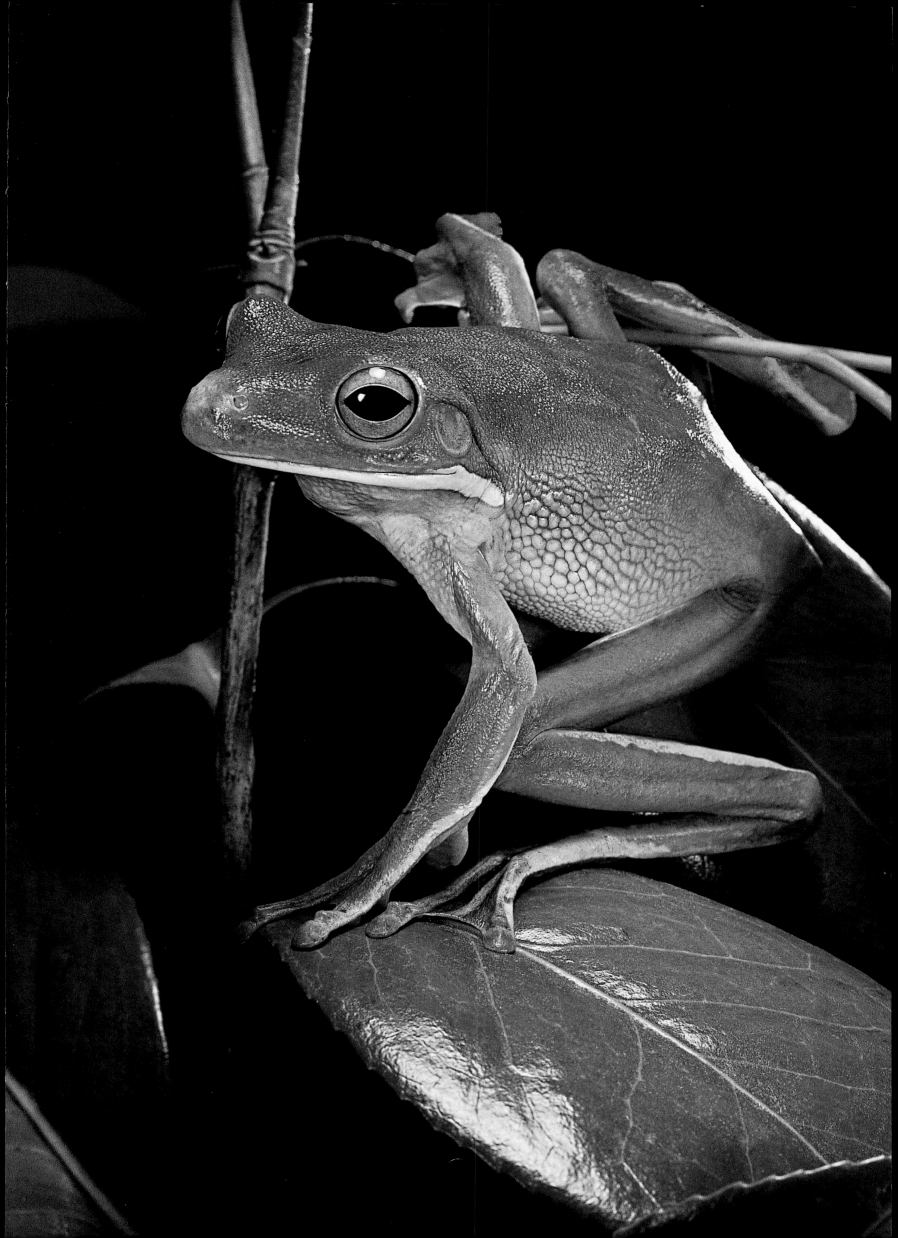

LITORIA CAERULEA [▸ | ▸▸]

The natural obesity of this fat tree frog
doesn't prevent it from being an agile climber
with the ability to perform remarkable leaps. It
is very common and will willingly enter
residences and may even take over the toilet
seat! Its insatiable appetite contributes to
regulating the proliferation of domestic pests
and is, therefore, fairly well tolerated by its
hosts. This imposing tree frog has an
interesting colour palette: from beige to
turquoise blue and pale green, depending on
its mood and geographical origin.

Distribution: Papua New Guinea, east and
north Australia, Torres Islands, introduced into
New Zealand
Average length: 7 to 10cm (2¾ - 4in)

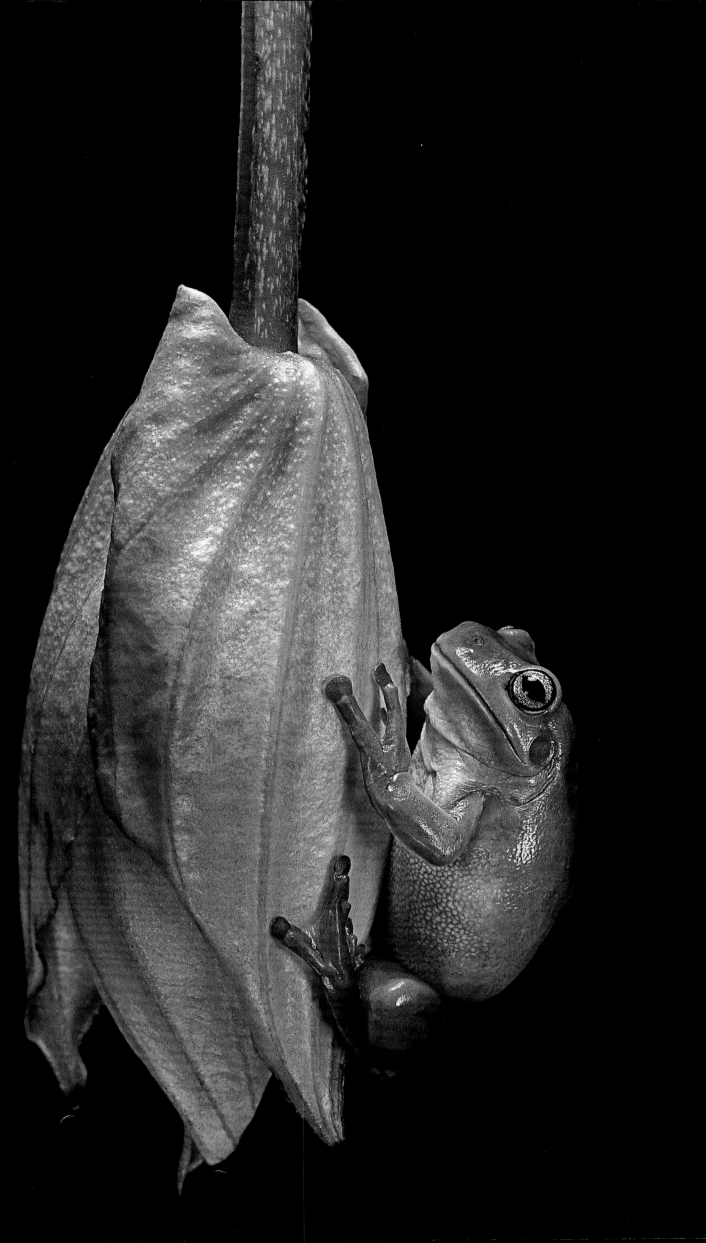

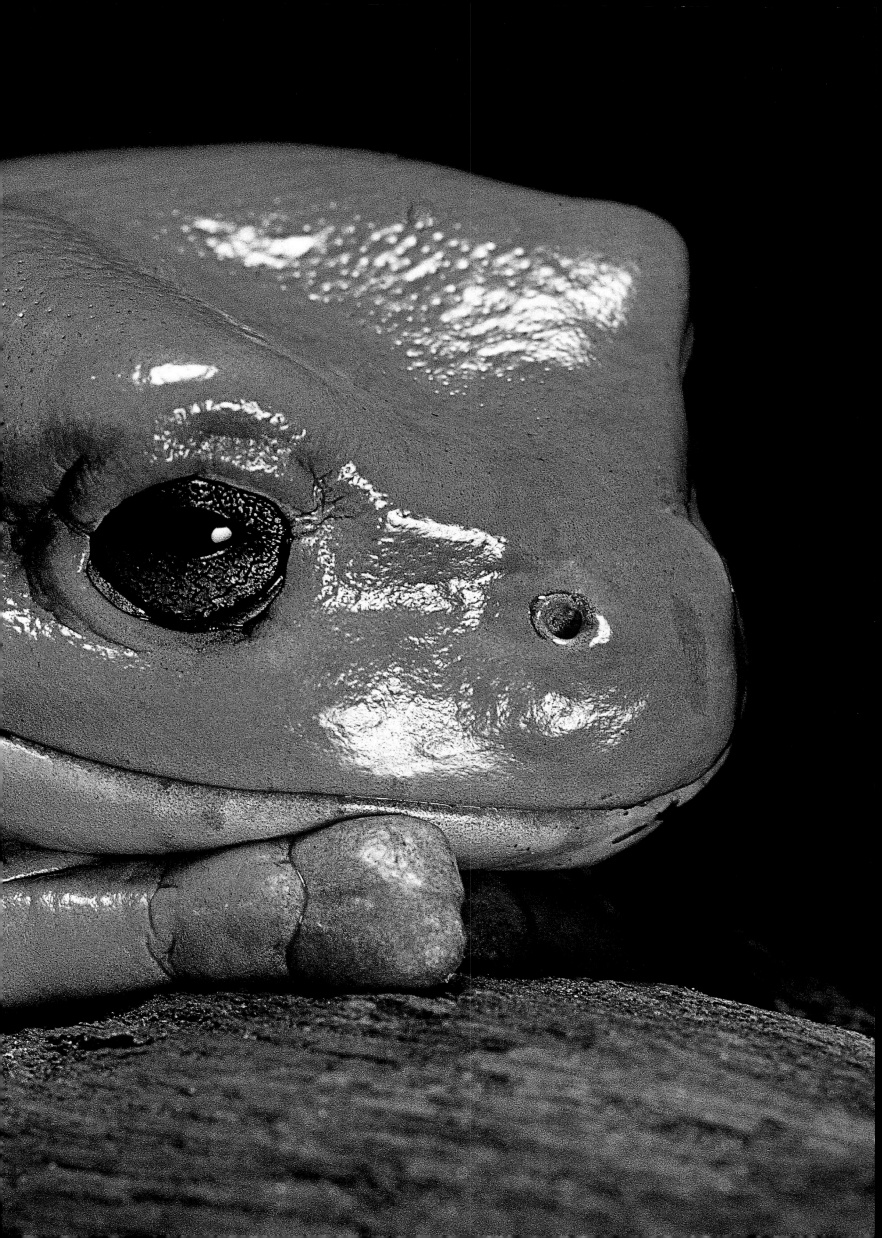

PHRYNOHYAS RÉSINIFICTRIX [▸ | ▸▸]

This beautiful frog spends most of its time in the high canopy of primary tropical forests, where its magnificent multi-coloured attire guarantees its absolute invisibility. The call of the males is a very characteristic sound that carries well, making it easier for females to locate them. The females then lay their eggs in a hollow trunk filled with water and once hatched, the tadpoles will continue their development to become marvellous little tree frogs. Although rarely mentioned, the colours of the young amphibians are a spectacle of rare beauty in some species, like this charming specimen here, whose pupils seem almost to display a Maltese cross.

Distribution: all of the Brazilian and Peruvian Amazonia, as well as Surinam and French Guyana
Average length: 7 to 10cm (2¾ - 4in)

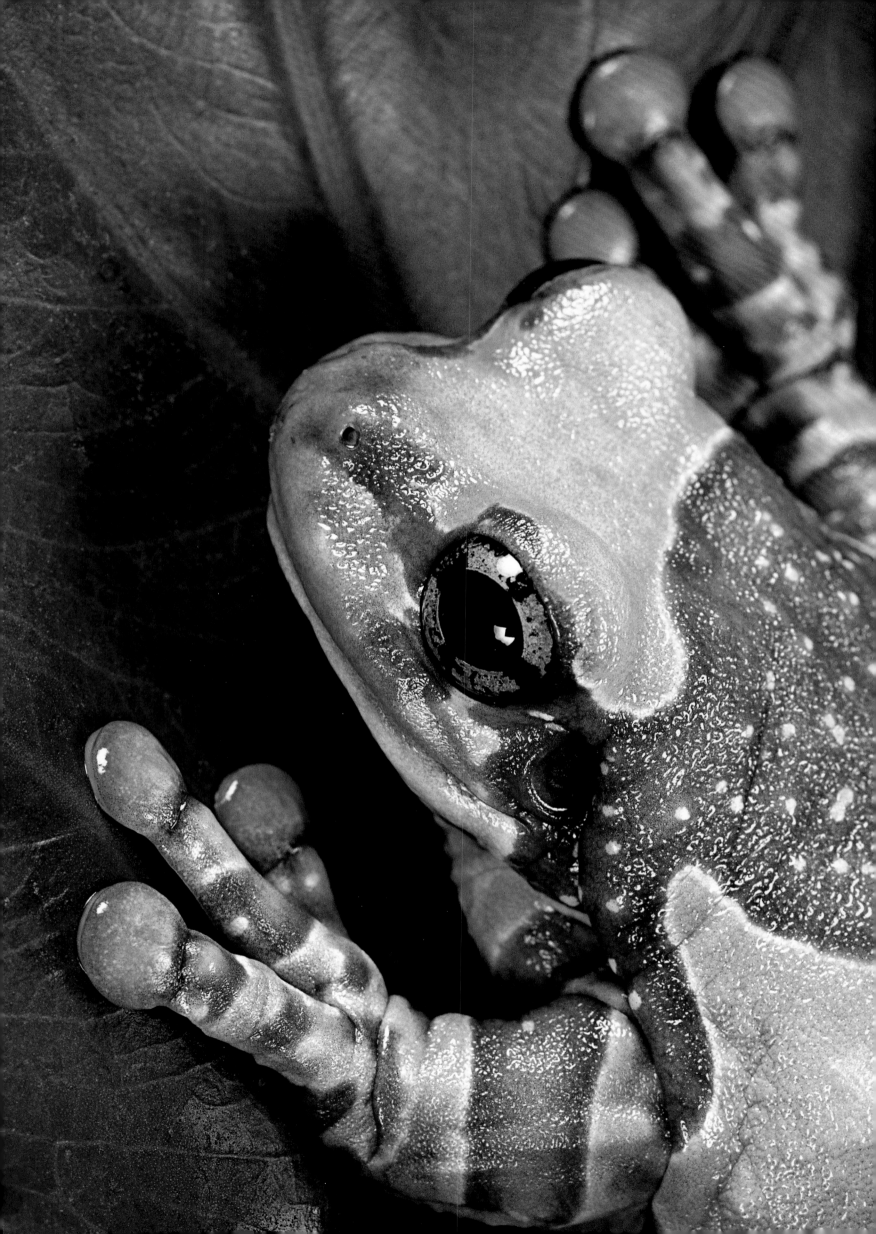

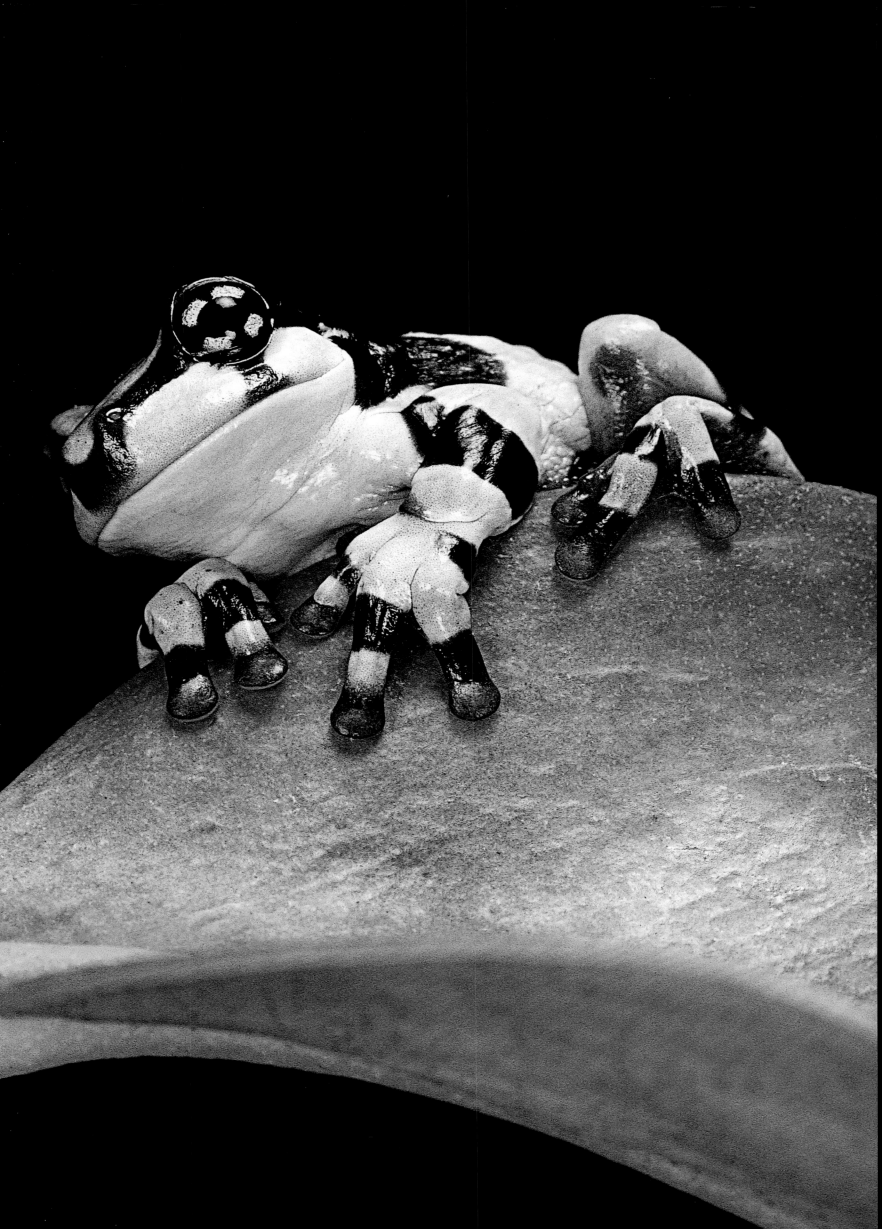

PACHYMEDUSA DACNICOLOR [▸ | ⇉]

A slight difference in morphology between males and females meant it was long believed that they were two distinct species. This frog is tree-dwelling and nocturnal, living in a habitat overlapping a desert environment dotted with impressive cacti and a luxuriant subtropical vegetation, that comes to life only after the summer rains. To survive in this environment, the pretty tree frog combines energy saving by limiting movement with a biological and anatomical adaptation: when the slightly warty skin of its abdomen is pleated it absorbs the little humidity present in the air.

Distribution: Mexico, along the Pacific coast, in southern Sonora
Average length: males - 8cm (3⅛in),
females - 10cm (4in)

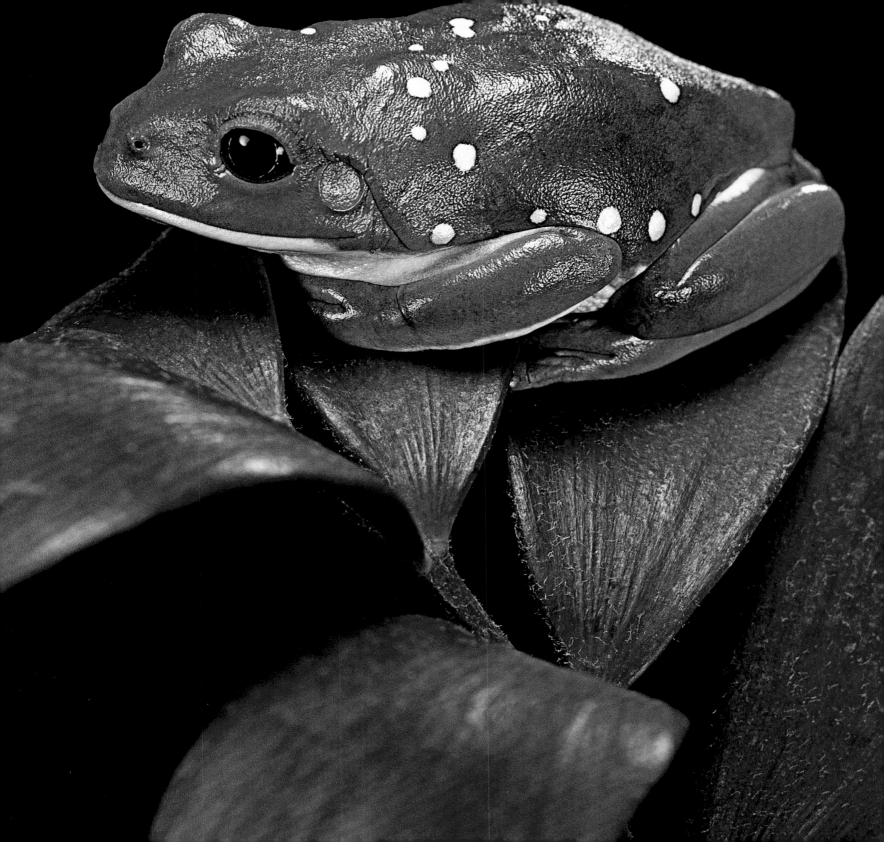

PHYLLOMEDUSA SAUVAGII [▸]

Against all expectations, this nocturnal tree
frog has actually made its home in a warm
and dry habitat and is very exposed to the
sun's rays. Over time, this ingenious frog
evolved to develop a waxy secretion that
has the same properties as sunscreen. It
layers it on throughout the day, in an unusual
spectacle, to hydrate and protect its fragile
skin.

Distribution: Bolivia, Paraguay, Brazil and
Argentina
Average length: 10 to 12cm (4 - 4¾in)

TRIPRION SPATULATUS [▸▸]

Recognisable, among other things, by its
helmet and duck-like beak, this frog is the
very example of the oddities nature can
concoct. Many theories have been put
forward to explain its strange appearance.
The scientific explanation is that in the dry
season, this tropical American frog minimises
water loss by taking refuge in narrow cavities
(holes in trees and branches or rocky
crevices) and then blocks the opening with
its head. Covered in a bony outer layer, it
loses only a minimal amount of humidity
while the rest of its body, isolated in a
confined space, benefits from a much higher
hygrometry than the outside environment.

Distribution: Mexico, along the Pacific Coast
from Sinaloa to Oaxaca
Average length: 7 to 12cm (2¾ - 4¾in)

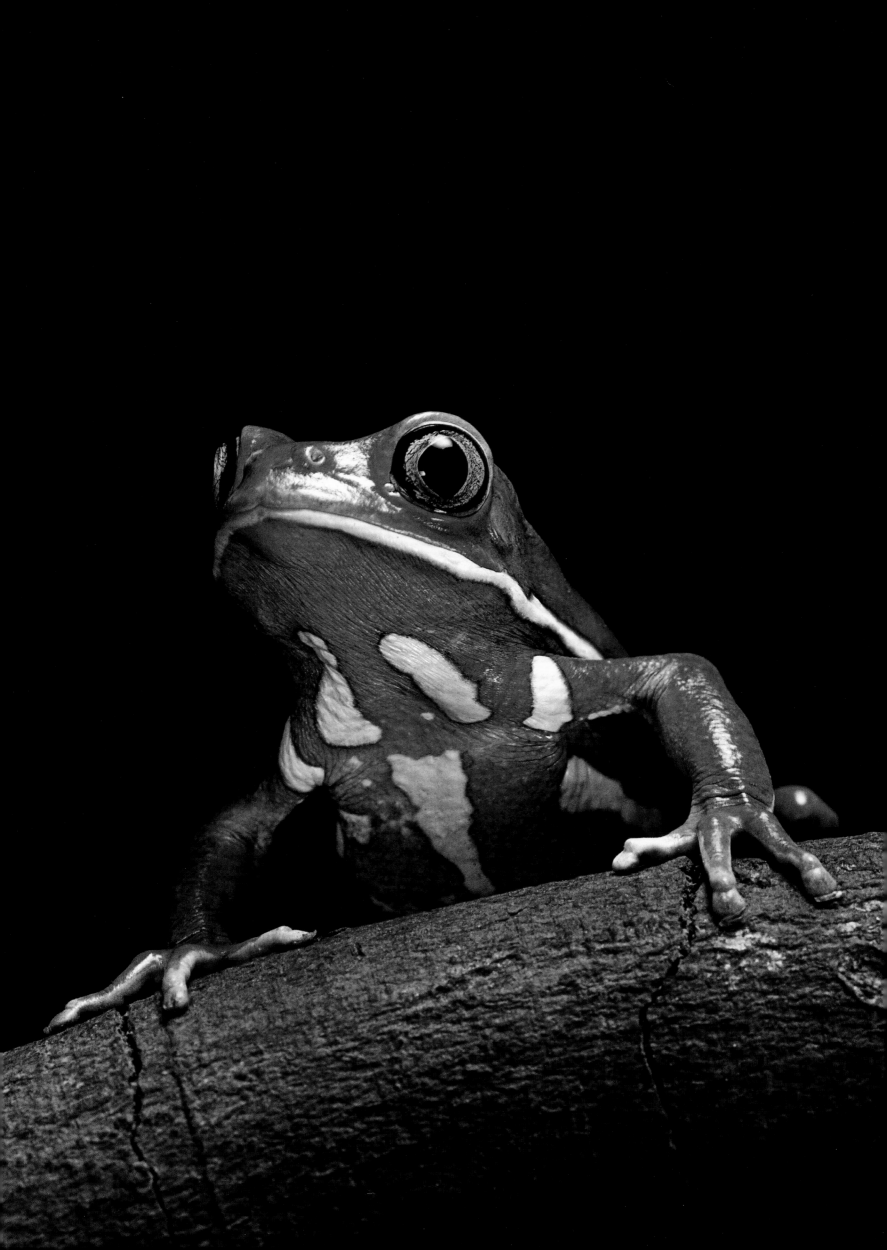

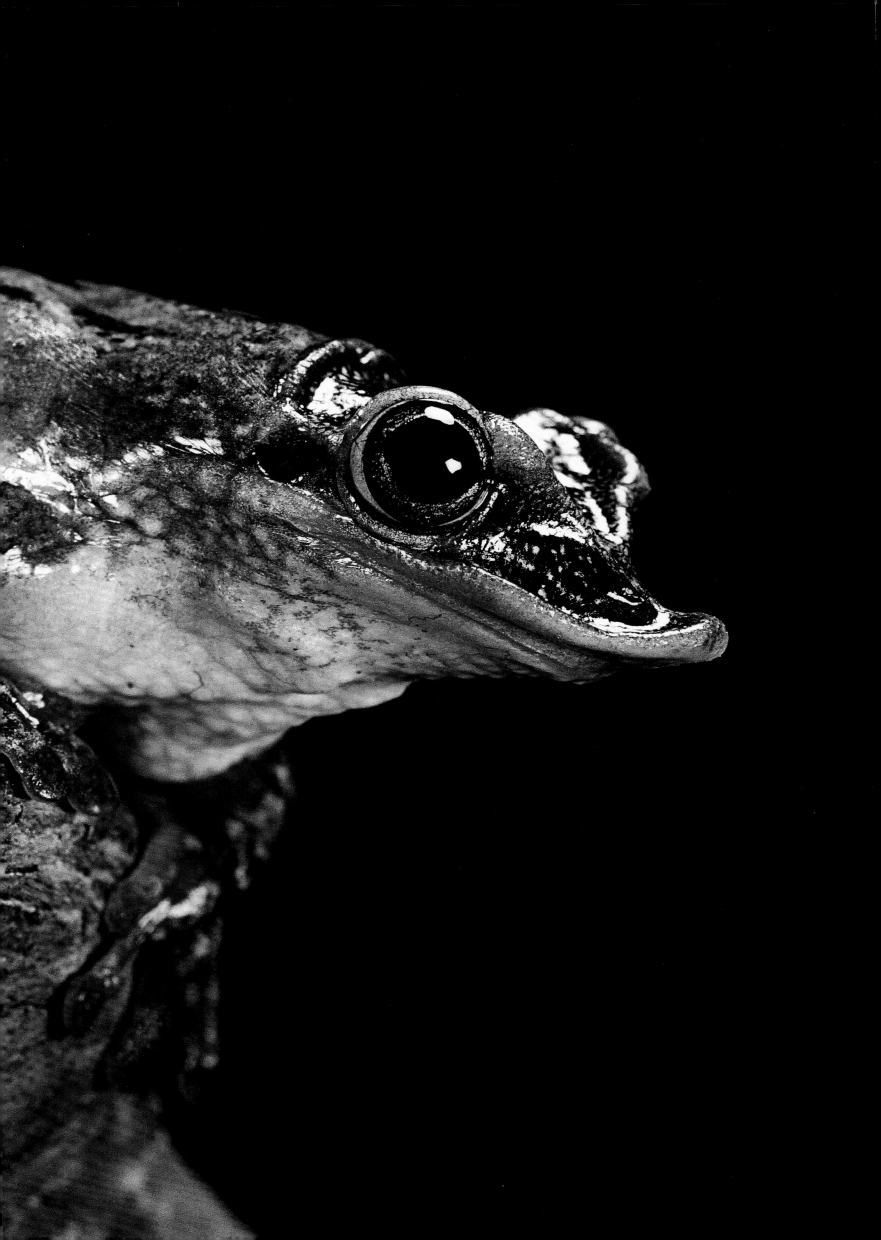

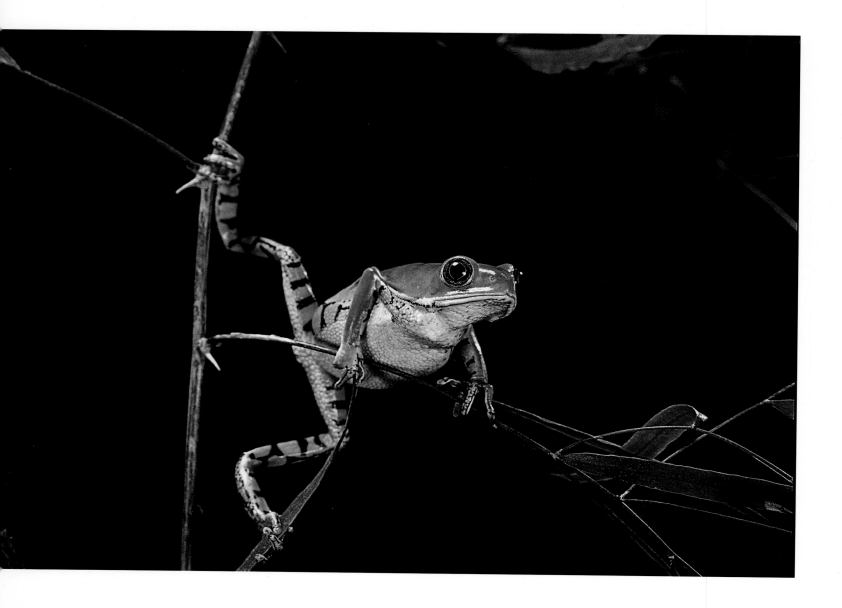

PHYLLOMEDUSA HYPOCHONDRIALIS AZUREA [▲]

Scattered tropical forests intermingled with flood savannah make up its hunting ground. From the onset of dusk, this captivating, semi-arboreal frog reveals its astonishing multicoloured garb. Commonly known as the 'monkey frog', it moves around with agility thanks to its opposable fingers equipped with adhesive discs. Its nocturnal travels over, it becomes a phantom again in the early hours of the morning, huddled under a leaf in its plant-like attire. For several months a year its normally dry habitat becomes completely flooded; these great stretches of water then become the theatre of vocal and acrobatic feats. Mating pairs build a cone-shaped nest above a water spot with the help of a curled leaf. Tadpoles will release themselves several days later to begin a new metamorphosis.

Distribution: Argentina, Paraguay and Bolivia
Average length: 4 to 5cm (1½ - 2in)

HYLA CHINENSIS [▶]

A forgotten member of the hylids. Hunched up in a resting position, this beautiful tree frog bears an astonishing resemblance to its European cousins. In movement, however, it is clearly distinguishable: its sides and inner surface of the legs reveal an unexpected display, captivating orange-yellow colours speckled in black. It is an outstanding climber, adopting the most incredible positions in the vegetation during its nocturnal hunting sessions.

Distribution: Vietnam, Taiwan and China
Average length: 3 to 5cm (1⅛ - 2in)

HYLA MÉRIDIONALIS [▶▶]

According to folklore this frog has the power to predict fine weather. This belief mostly stems from its tree-dwelling way of life and its ability to change colour according to the temperature of the surroundings and its mood. It frequents environments that are rich in vegetation, such as marshy prairies and vegetation belts around marshlands. It feeds on various insects and will often use its legs to catch them. It is, unfortunately, becoming more and more difficult to observe: the pollution of its habitat and rampant urbanisation has led to the destruction of its last biotopes.

Distribution: southern France, Spain, Portugal and North Africa
Average length: 5 to 6cm (2 - 2⅜in)

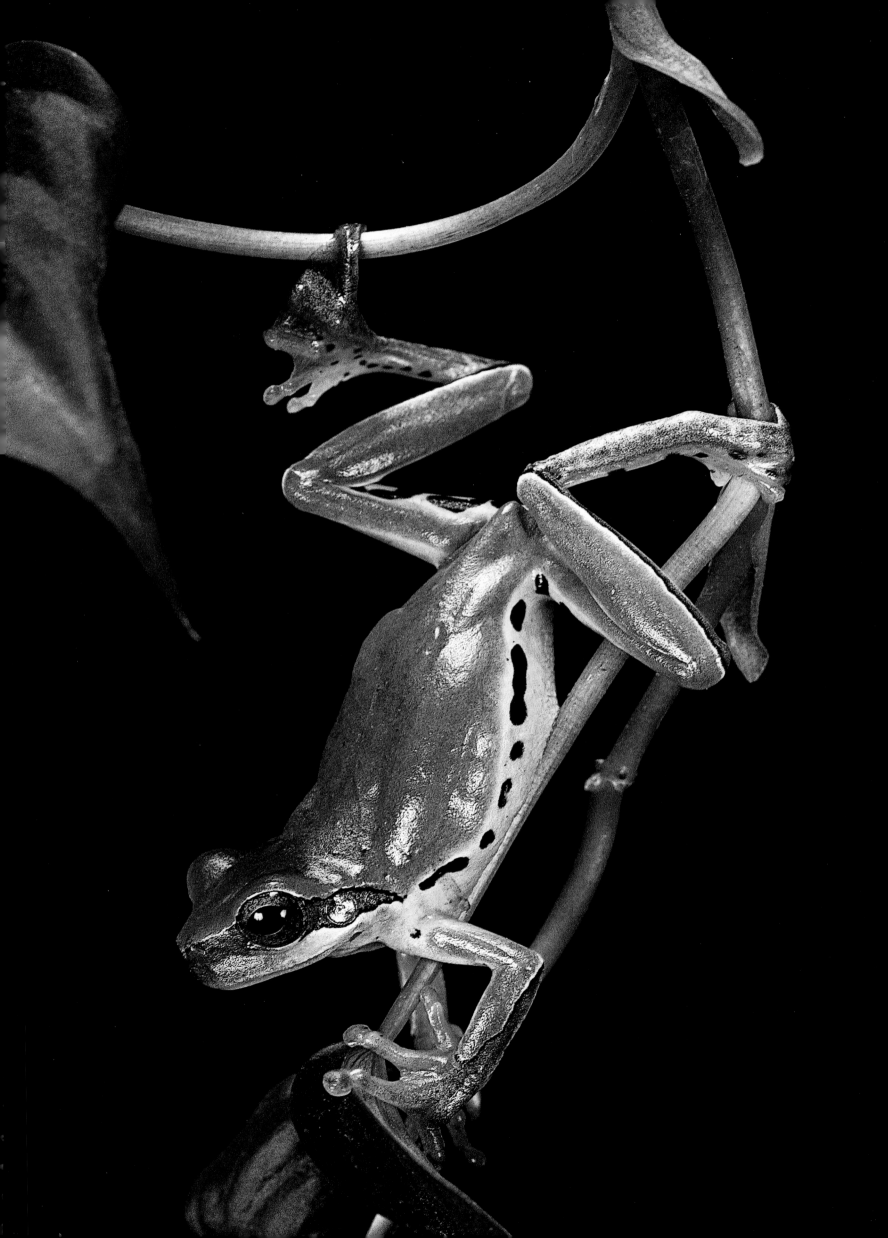

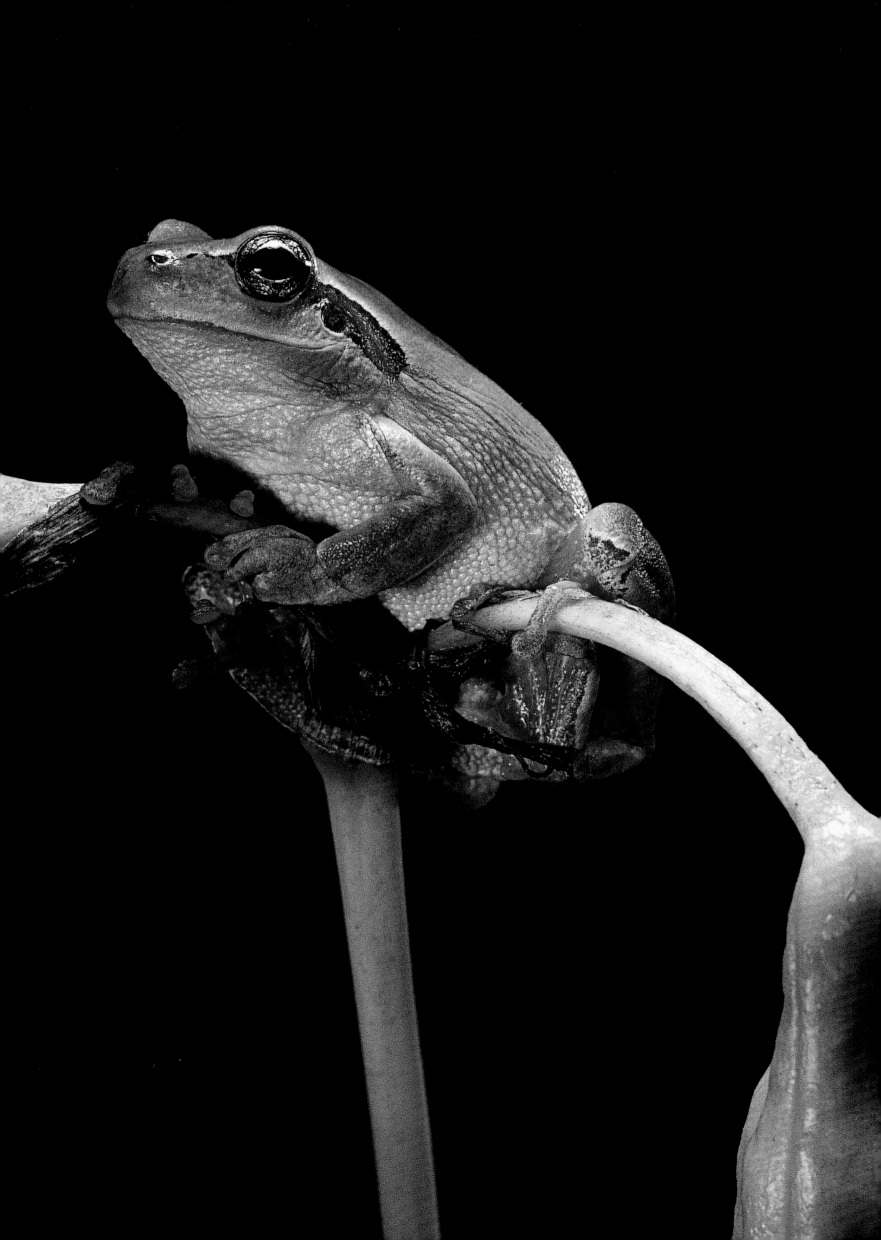

AGALYCHNIS CALLIDRYAS [▸]

With glowing red eyes, this tree frog is
extravagantly coloured. It is exclusively
nocturnal by nature and secretive during the
day, curled up beneath a leaf shelter, it
becomes totally invisible. When night falls,
however, it turns into a merciless insect hunter,
in the low foliage of the tropical forests it
inhabits.

Distribution: Panama, Costa Rica, Nicaragua
and Honduras
Average length: males - 5 to 6cm (2 - 2¾in),
females - 8cm (3⅛in)

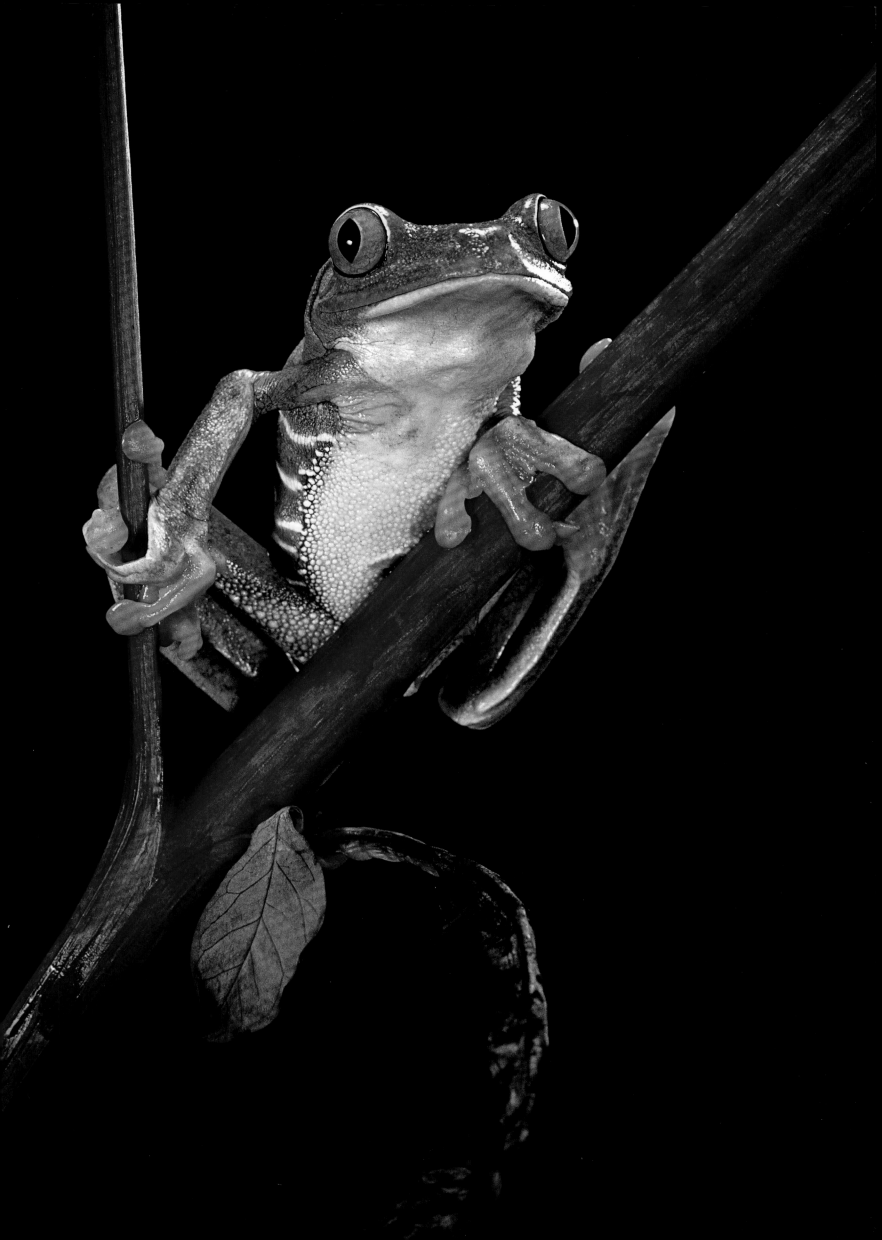

HYPSIBOAS HEILPRINI [▸]

This large and uncommon nocturnal tree frog
with piercing eyes frequents wooded areas. It
is very much at home on branches and
brushwood, moving about slowly but surely
after dusk. It painstakingly inspects its territory,
accelerating the pace as soon as it locates an
insect. With unrelenting precision, it flicks out
its sticky tongue to catch it, sometimes using
its legs to help put a stubborn prey into its
large mouth.

Distribution: Dominican Republic
Average length: 6 to 8cm (2⅜ - 3⅛in)

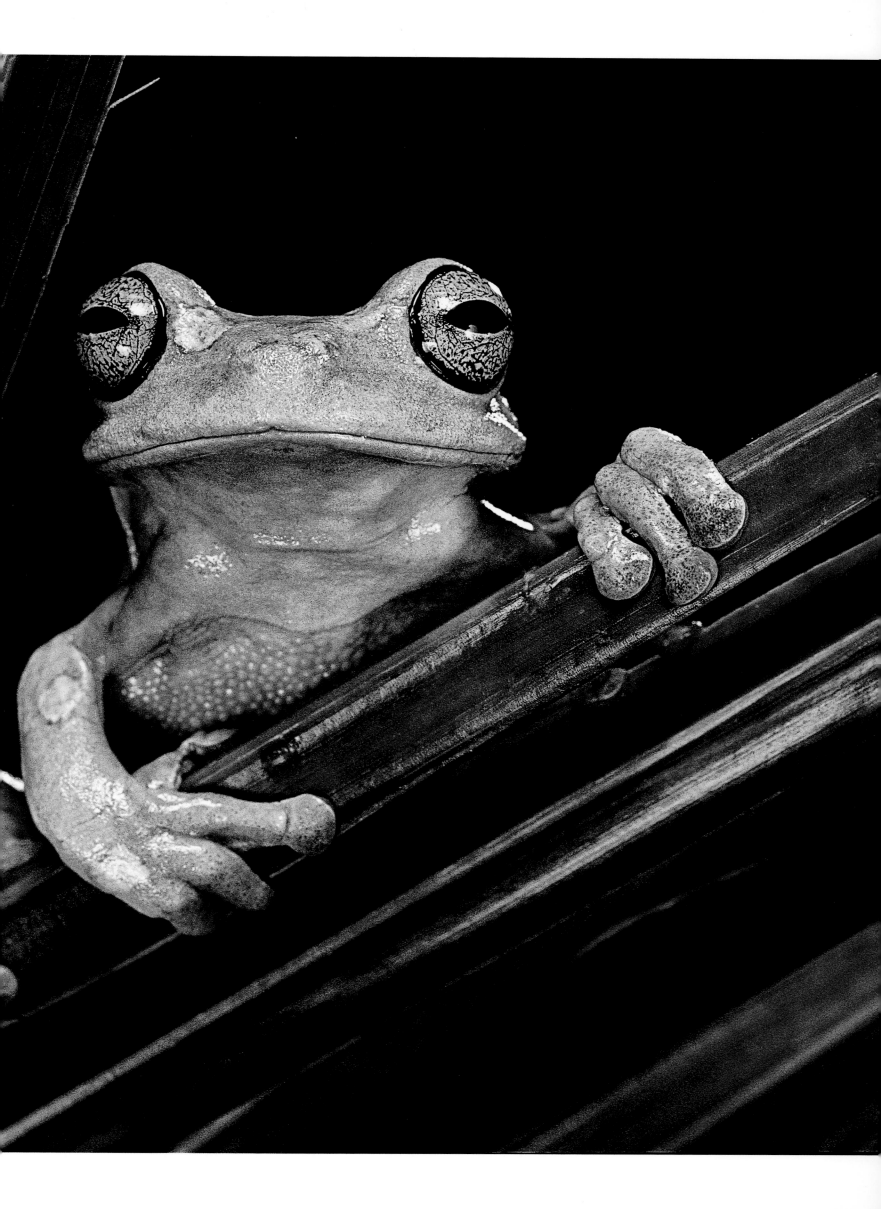

HYPEROLIIDAE

This family has 19 genera with around 260 species including many that are arboreal such as *Hyperolius*, *Afrixalus* and *Leptopelis*, but also some terrestrial forms such as *Kassina*. They are mostly found in Africa, though Madagascar and the Seychelles are also home to a few endemic species. One of their characteristic features is their bright, contrasted colouration, decorated in extravagant patterns. They are mainly insectivores, with one exception: *Afrixalus fornasinii*, which eats amphibian eggs and larvae. During the mating period the frogs keep up a nocturnal racket that lasts right throughout the cycle. Egg clutches are often suspended from the leaves of vegetation along the edges of ponds, except for Leptopelis, which lay their eggs on the ground, near a water spot. Once hatched, tadpoles are led by the rain to the nearby water spot.

LEPTOPELIS SP. [▸]

Distribution: Tanzania
Average length: 5 to 6cm (2 - 2⅜in)

LEPTOPELIS BREVIROSTRIS [▸▸]
Behind its large, expressive eyes hides a
ruthless predator, a specialist in snail hunting.
This beautiful frog is tree dwelling and depends
on a forest habitat. It captures its favourite dish
at night, generally in the leaves, but will
occasionally venture to the soil for its catch.

Distribution: Gabon, Cameroon and Nigeria
Average length: 5 to 6cm (2 - 2⅜in)

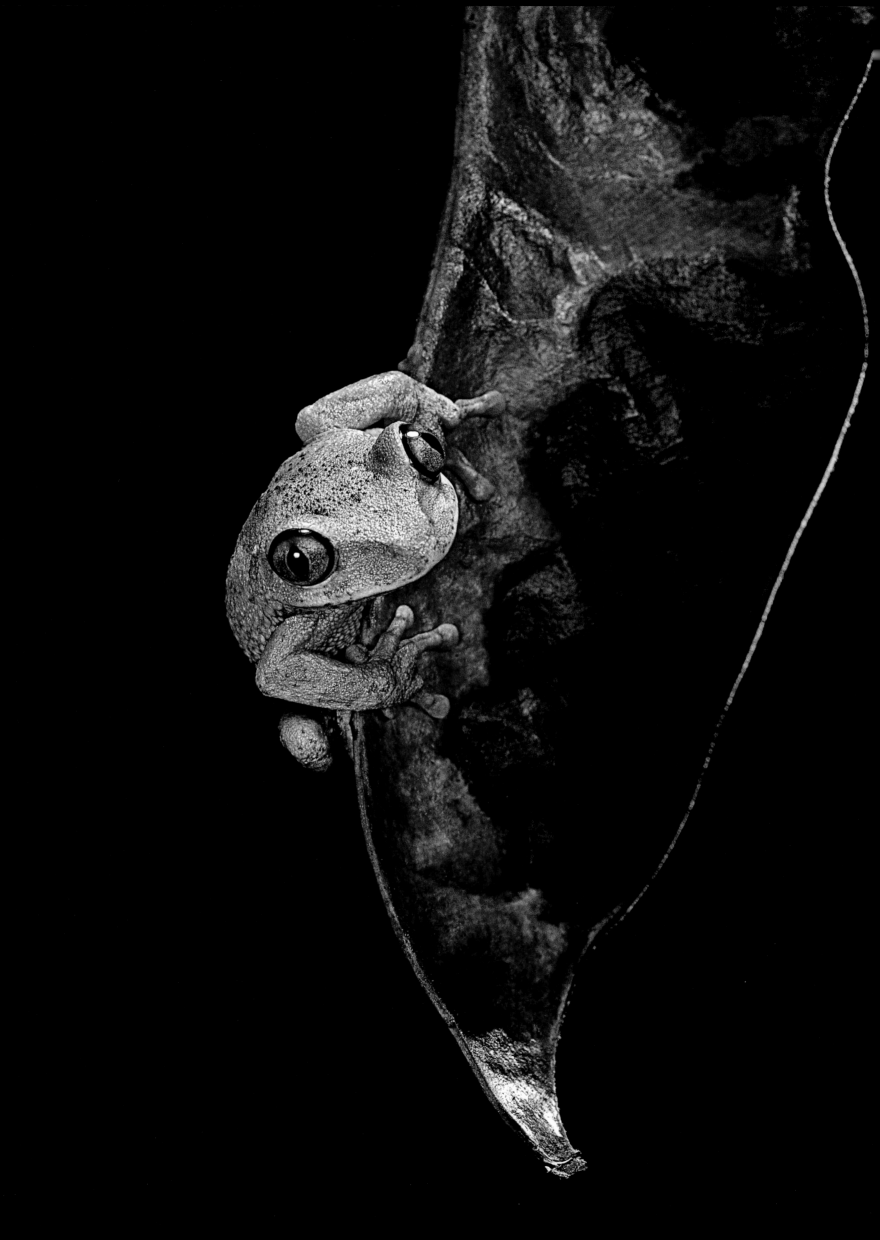

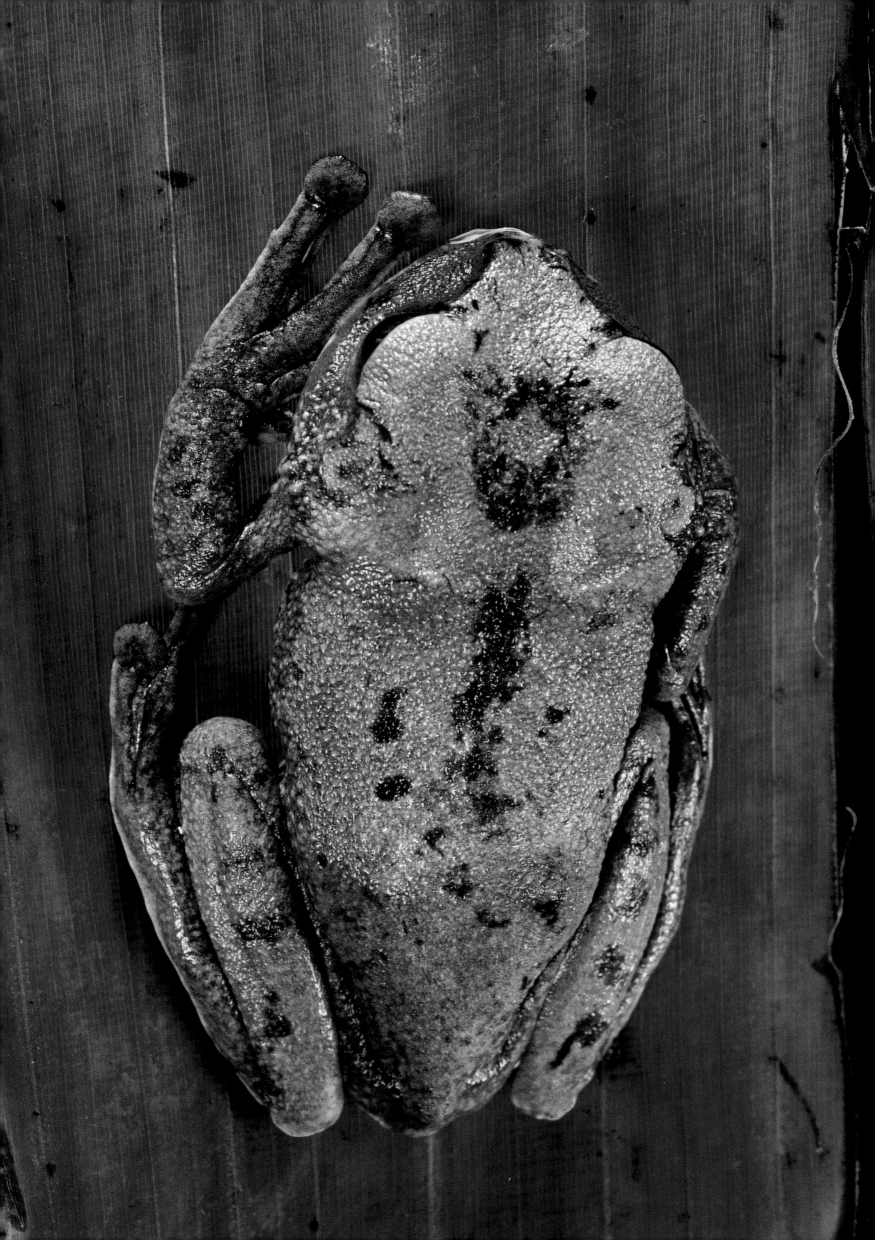

LEPTOPELIS VERMICULARIS [▸]

The flashy colours of its black reticulated juvenile attire fade over time. On maturity, females will develop a less contrasted beige-brown coloured skin. Only a few males can hope to retain their green colouring. Their big eyes are turned towards the front with a vertical pupil slit for highly efficient vision during night hunts, when they attack all sorts of insects.

Distribution: Tanzania
Average length: 6.5cm (2½in)

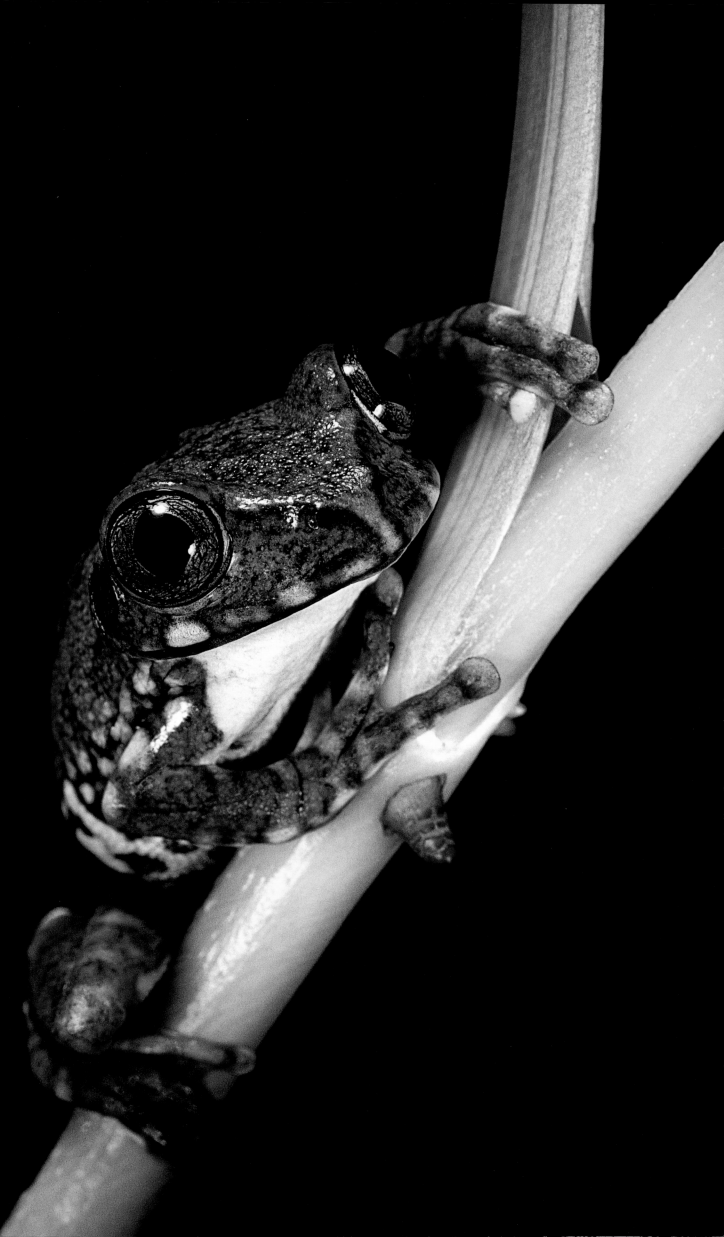

LEPTOPELIS BARBOURI [▸]

Only its big red eyes betray its presence in the
dense vegetation of the tropical forests of the
Usambara Mountains where it is still
widespread. Its translucent green colour is
sometimes speckled with little white spots,
giving it remarkable camouflage in the various
foliage in which it lives. The eggs are often laid
on a slope; on hatching, tadpoles embark on a
difficult journey of ten or so metres to a
close-by pond or stream, sometimes helped
by the heavy rains of the season.

Distribution: Tanzania
Average length: 3.5 to 4cm (1⅜ - 1½in)

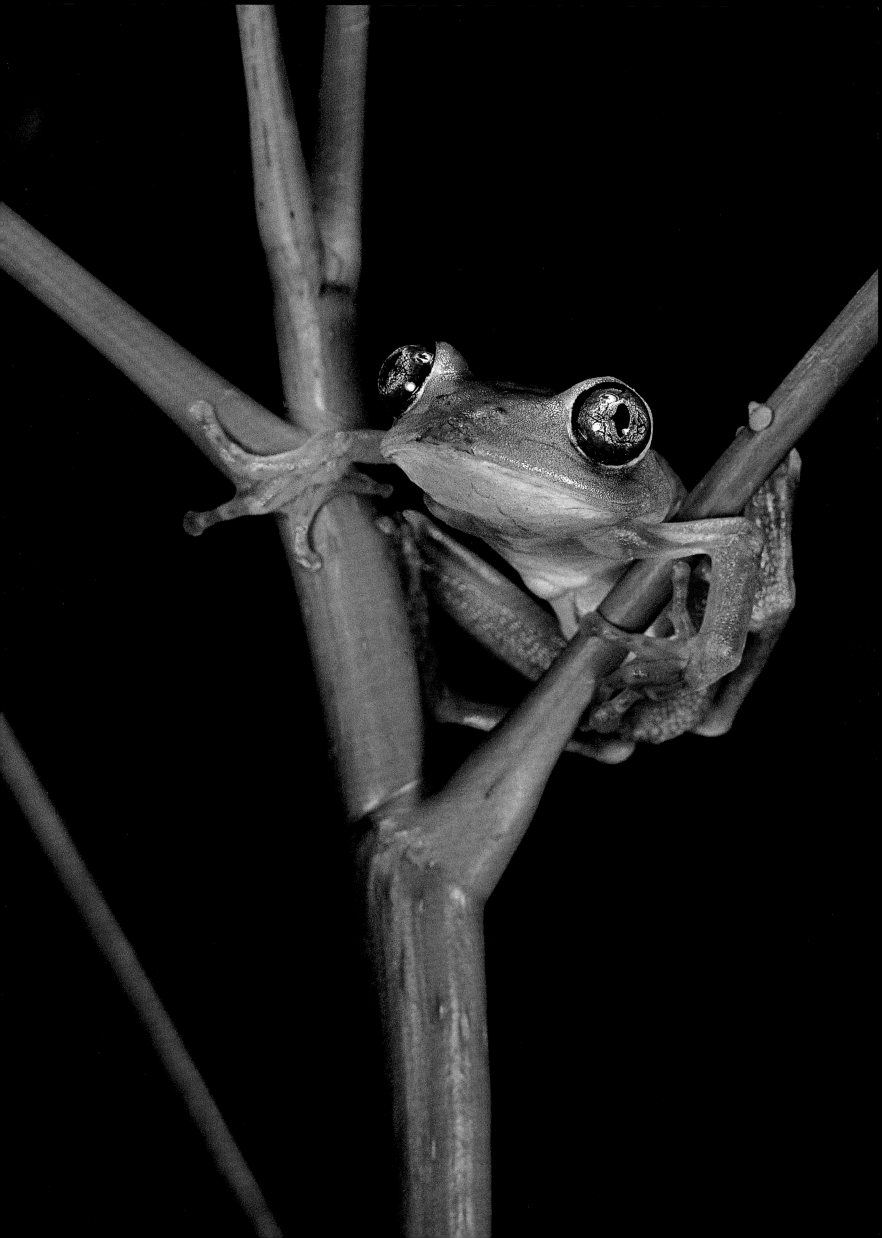

LEPTOPELIS ULUGURUENSIS [▴ | ▸]

Found only in the Usambara and Uluguru
Mountains, this spectacular species with
unquestionable charm, displays a colour
pattern linked to a very specific habitat. In fact,
in these humidity-saturated tropical mountain
forests, much matter is rotting, creating a
paradise for fungi, mosses and other moulds.
The frog's typical blue-green colour is the
result of its adaptation to this environment. Its
exterior is even adorned with speckled
markings that are a perfect imitation of leaves
attacked by mould. Only its big, dark red eyes
can distinguish it in this biotope.

Distribution: Tanzania
Average length: 3 to 5cm (1⅛ - 2in)

HYPEROLIUS

From small to very small in size, these animals
are known for their bright colours and
amazing markings. The multitude of colours
and designs can vary greatly within a single
species, to such a degree that biologists
increasingly rely on the analysis of their calls to
identify them. Tropical forests of plains and
mountains, savanna and even agricultural areas
are their preferred habitat. They are
commonly known as 'reed frogs' because they
are abundant in low vegetation surrounding
marshy areas and temporary pools, where
they live an exclusively arboreal and nocturnal
life. During the breeding season impressive
swarms of frogs gather; taking any perch they
can find, the males engage in a vocal wrestling
match, pumping up their voices to the
maximum to seduce a mate. Egg clutches are
protected by a gelatinous mass and suspended
in vegetation above the water. When the
mating season is over, males and females leave
the pond edges and blend back into the thick,
protective vegetation of wooded areas.

HYPEROLIUS TUBERILINGUIS [▸]

Distribution: Kenya to South Africa
Average length: 3cm (1⅙in)

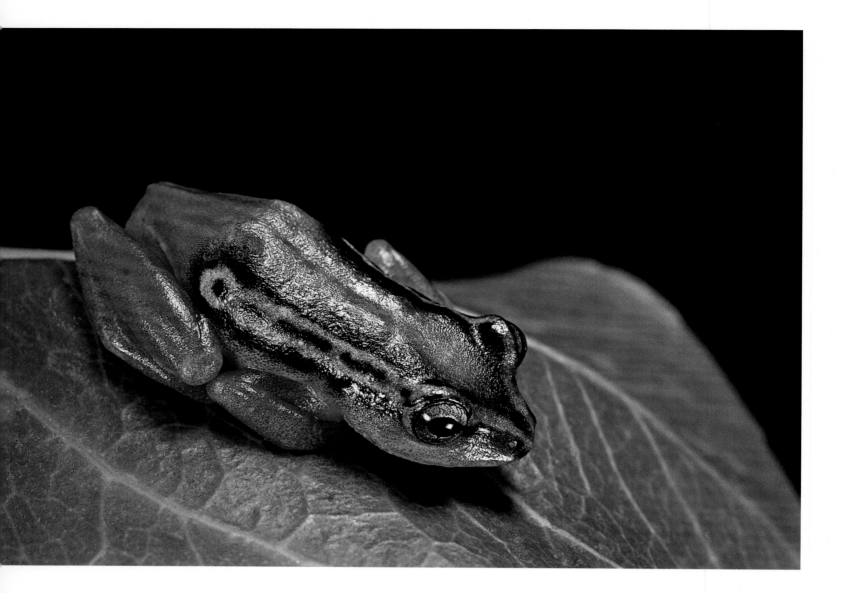

HYPEROLIUS PUNCTICULATUS [▲ | ▶]

Distribution: Kenya, Tanzania, Malawi
Average length: 3cm (1⅛in)

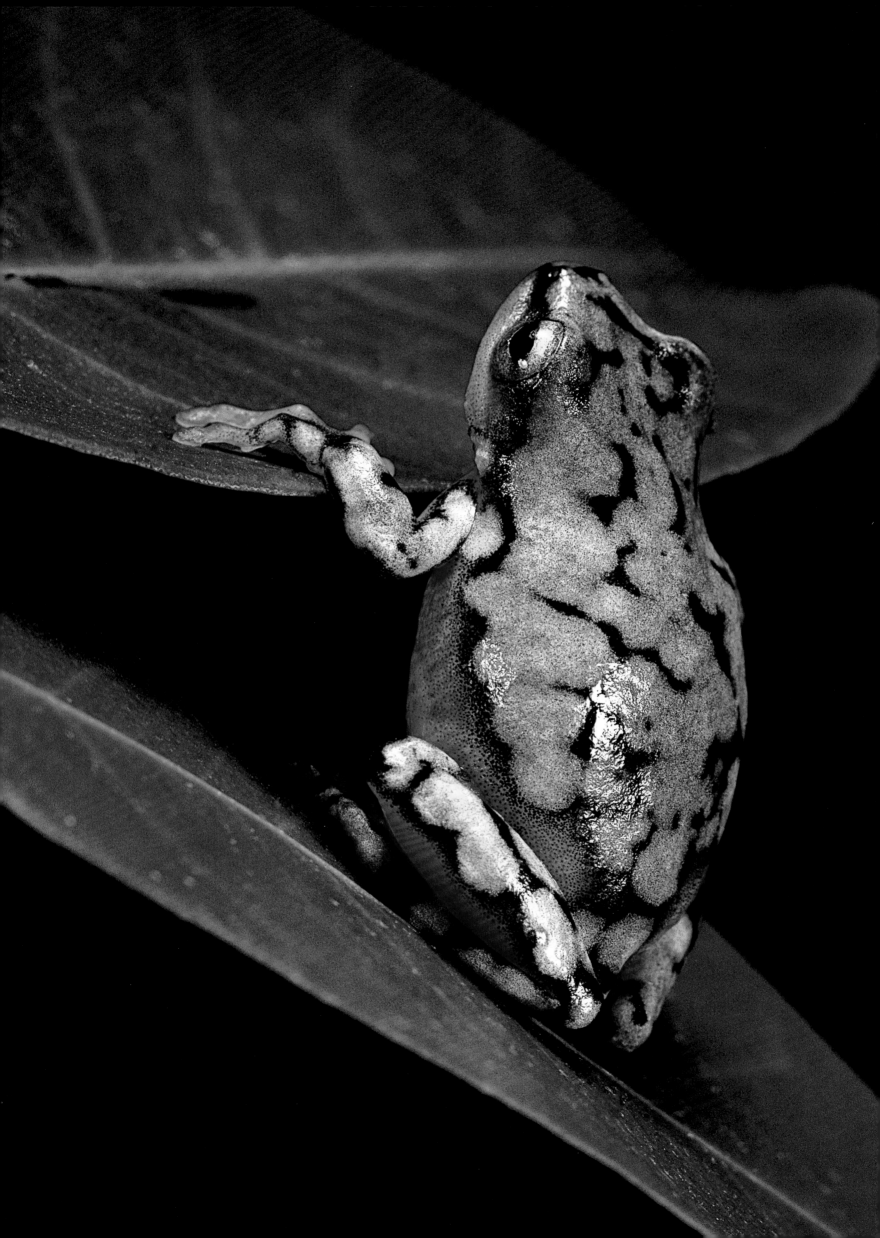

HYPEROLIUS PUNCTICULATUS AMANI [▸]

Distribution: Tanzania
Average length: 3cm (1⅛in)

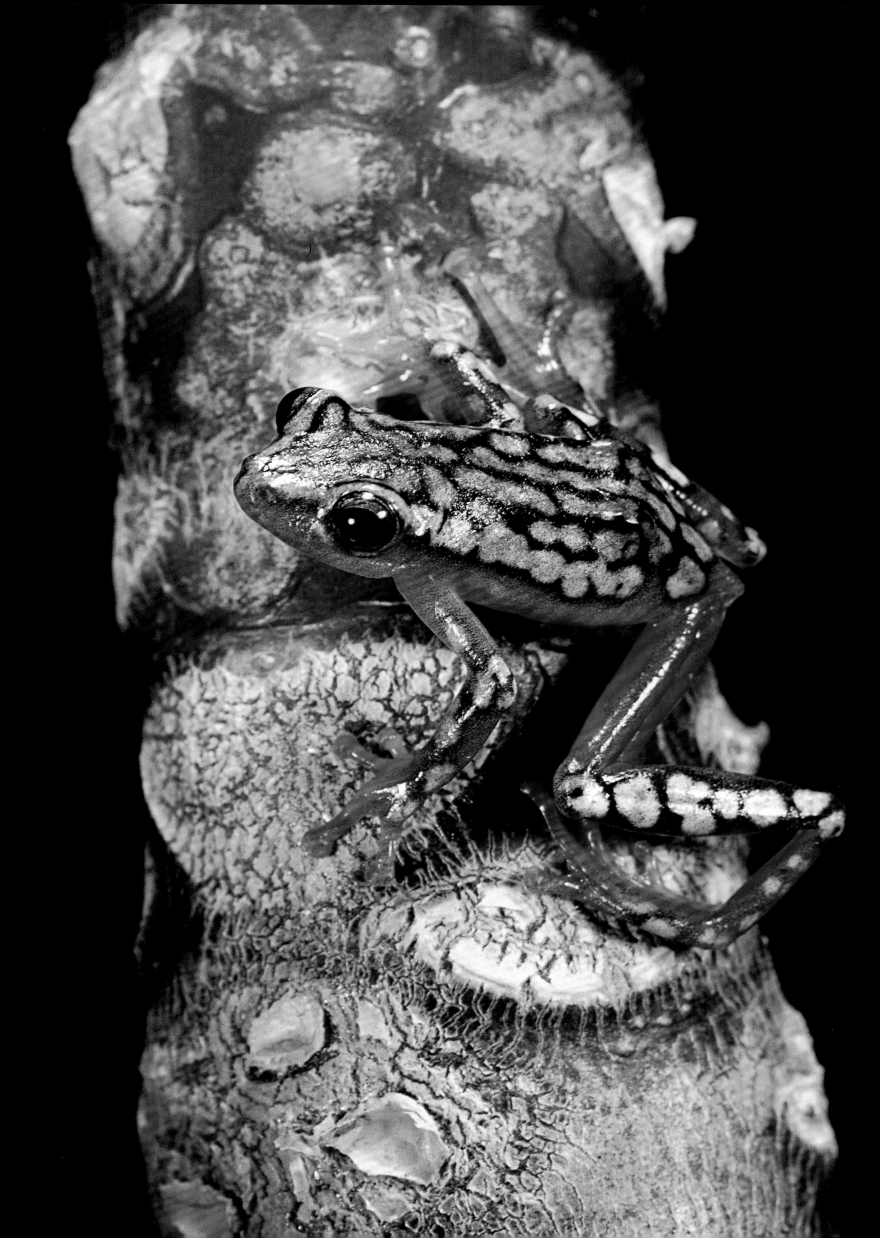

HYPEROLIUS ARGUS [▸]

Distribution: South Africa to Somalia
Average length: 2 to 3.4cm (¾ - 1⁵⁄₁₆in)

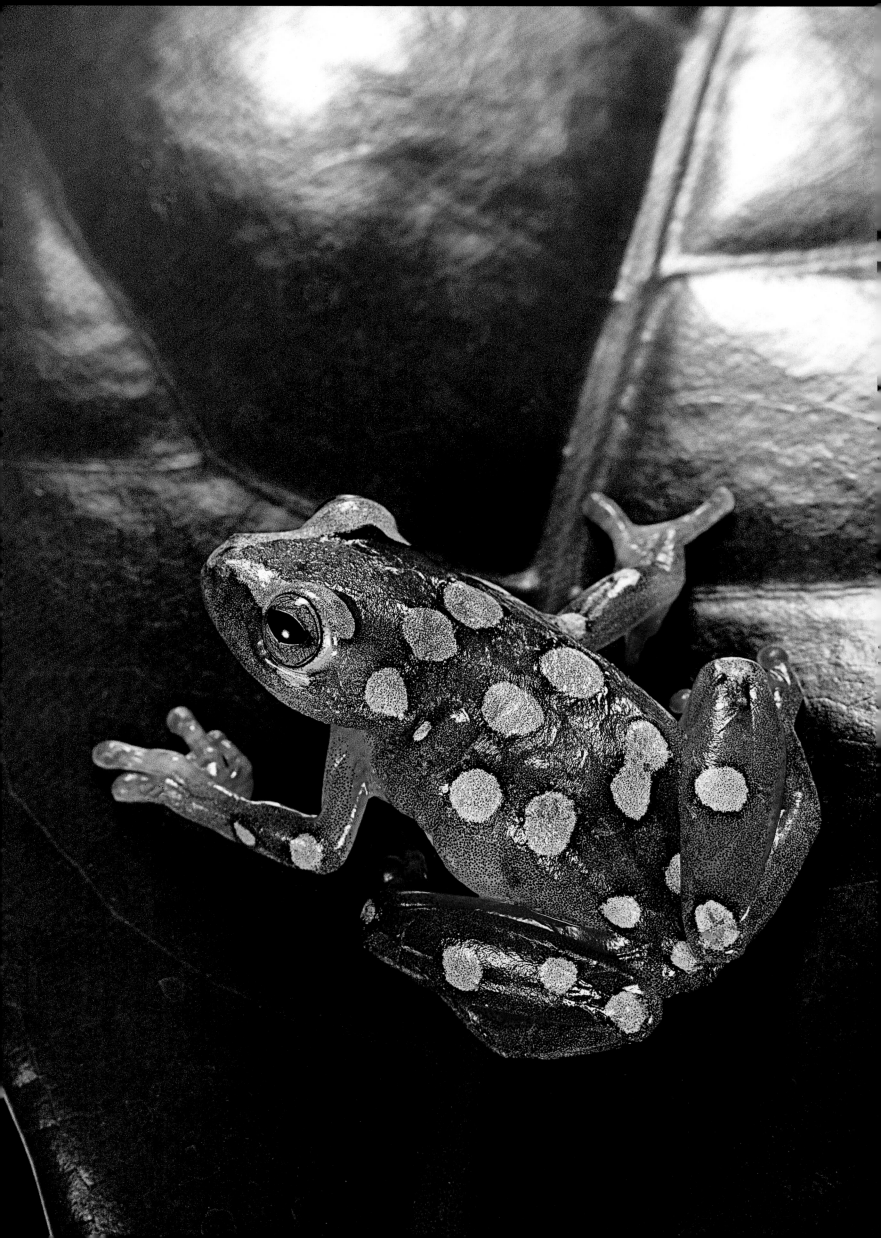

HYPEROLIUS VARIABILIS [▶]

Distribution: from Uganda to
the northeast of Tanzania
Average length: 3cm (1⅛in)

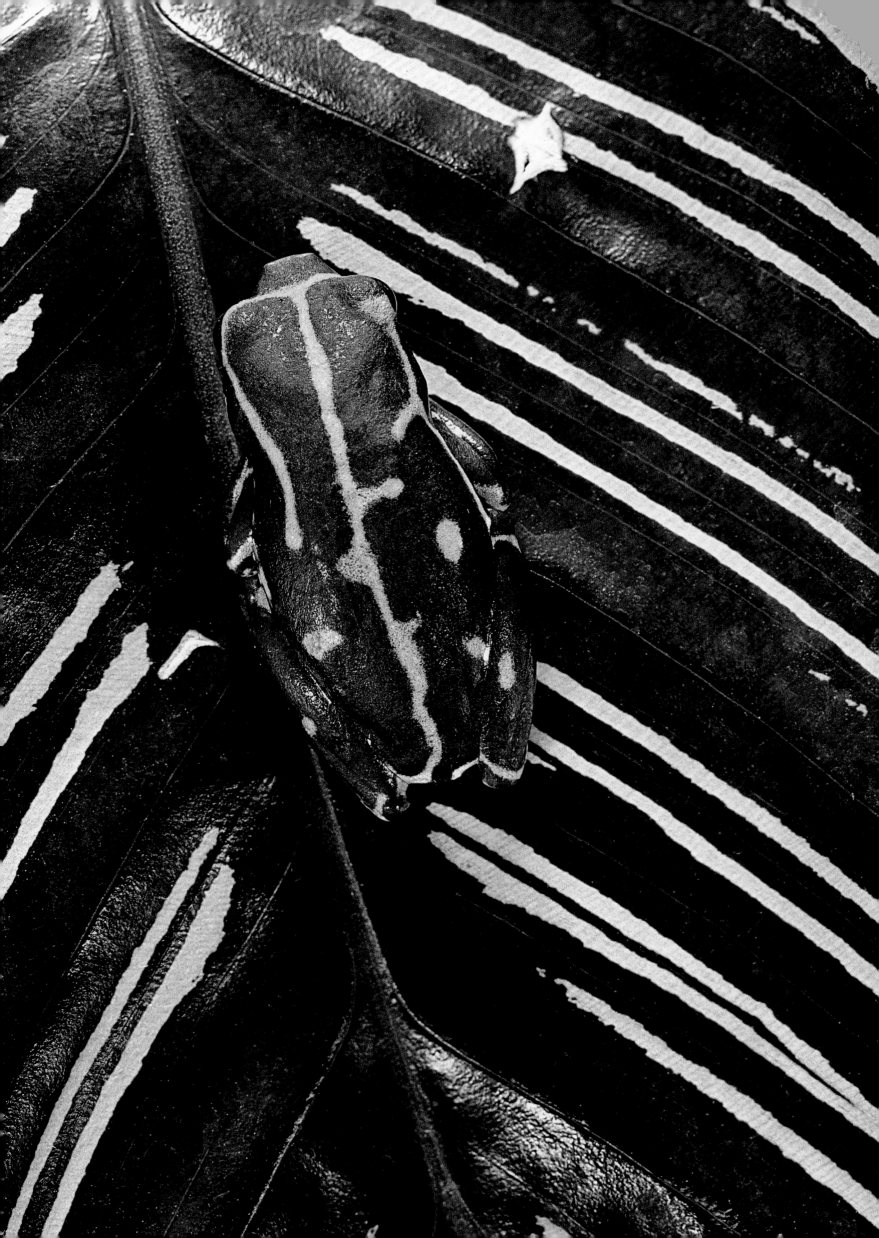

LEPTODACTYLIDAE

This family encompasses a great variety of species with very different anatomical characteristics and habits. With 1260 species and 50 genera, it is also one of the largest among anurans. With a range across all Central and South America as well as some Caribbean islands, *Leptodactylidae* populate areas that are as varied as they are astonishing: high altitude lakes in the Cordillera (like the amazing *Telmatobius culeus*, which lives in Lake Titicaca), or arid pampas in the northern regions of South America (such as the *Leptodactylus laticeps*, which stays burrowed in the ground for a good part of the year to protect itself from the harsh climate of the Paraguayan Chaco). The diversity of their habitats is reflected in the variation in their morphology: the genus *Eleutherodactylus*, for example, is made up of small frogs adapted to living in foliage, while *Leptodactylus pentadactylus* is an exclusively terrestrial species that reaches an impressive size: 20cm (8 inches) long and weighing up to 1kg (2lbs 3oz)!. Its leaps are so powerful and fast that it has a reputation of being impossible to catch.

The reproductive patterns also vary greatly from one species to another: oviparous (producing eggs that hatch outside the female), viviparous (embryos develop inside the female), terrestrial egg laying or aquatic egg laying. Some construct nests of foam in the water, others build a crater in the muddy ground in which to place their eggs. In the *Gastrotheca* genus, the female incubates her eggs in a pocket on her back until the young reach full maturity.

LEPTODACTYLUS LATICEPS [▸]

This secretive frog originates from a region with a harsh climate and wide temperature range. It stays underground for nine months of the year and only comes out in the rainy season– from November to January. It is very opportunistic (it only has three months to fill its reserves), and feeds mainly on amphibians and various small vertebrates. During the breeding period it builds a nest of toxic floating foam that exudes from its skin to protect its eggs and ensure the proper development of its tadpoles.

Distribution: Chaco region in Paraguay
Average length: 10 to 13cm (4 - 5⅛in)

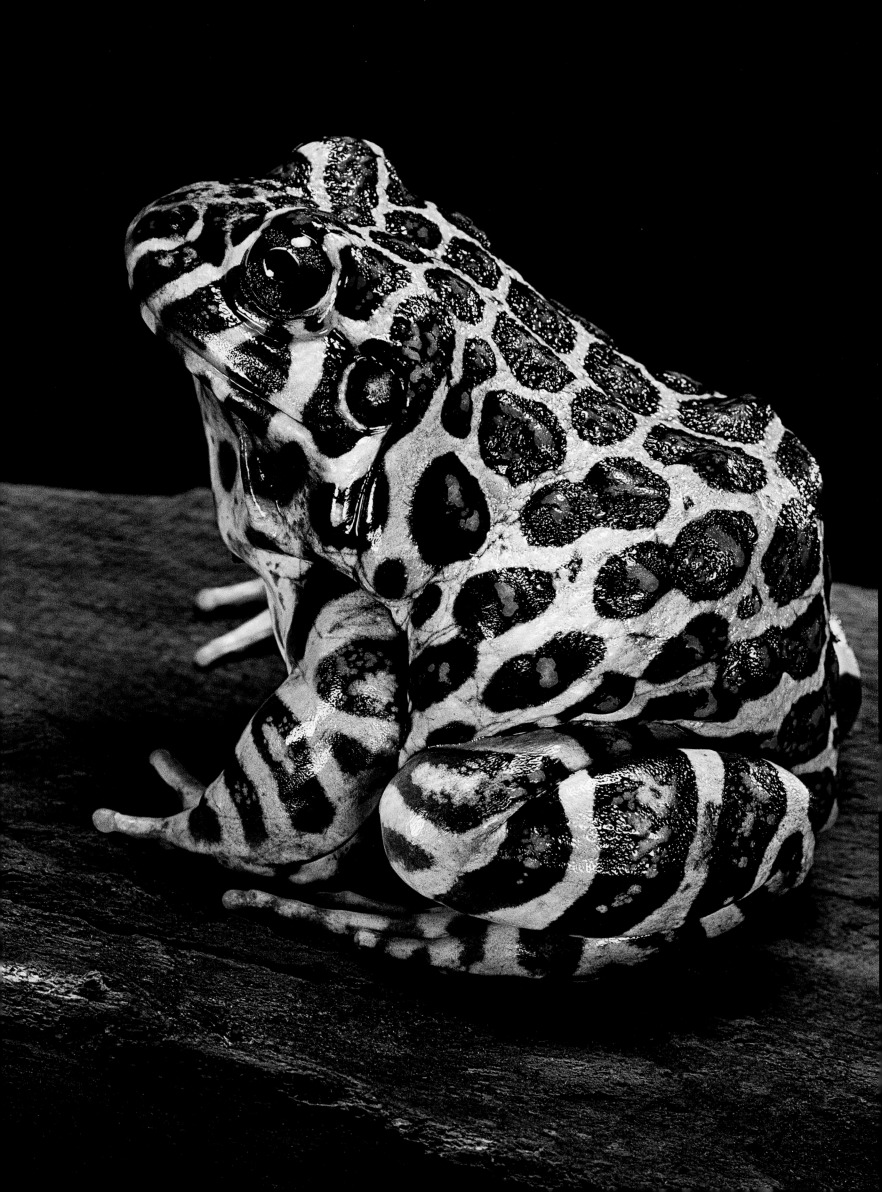

CERATOPHRYS

(HORNED FROG or PACMAN FROG)

Certainly one of the most astonishing anatomies among amphibians. Dressed in its amazingly rich and colourful attire, it is a ruthless, aggressive and voracious predator. It swallows all its prey indiscriminately to fill up its enormous mouth. It hates being disturbed and can show its discontent with a piercing and very frightening scream and may even bite the intruder. It is always burrowed in humus or plant litter, showing only its eyes and the 'horns' above its eyes, hence its name. Its static attitude and perfect homochromy are its two efficient weapons faced with an attacker or a prey.

Distribution: all of the Amazonian basin to Uruguay and in Argentina
Average length: 15cm (6in)

CERATOPHRYS CRANWELLI [▶]

Distribution: Argentina, Paraguay, Bolivia and Brazil
Average length: 10 to 15cm (4 - 6in)

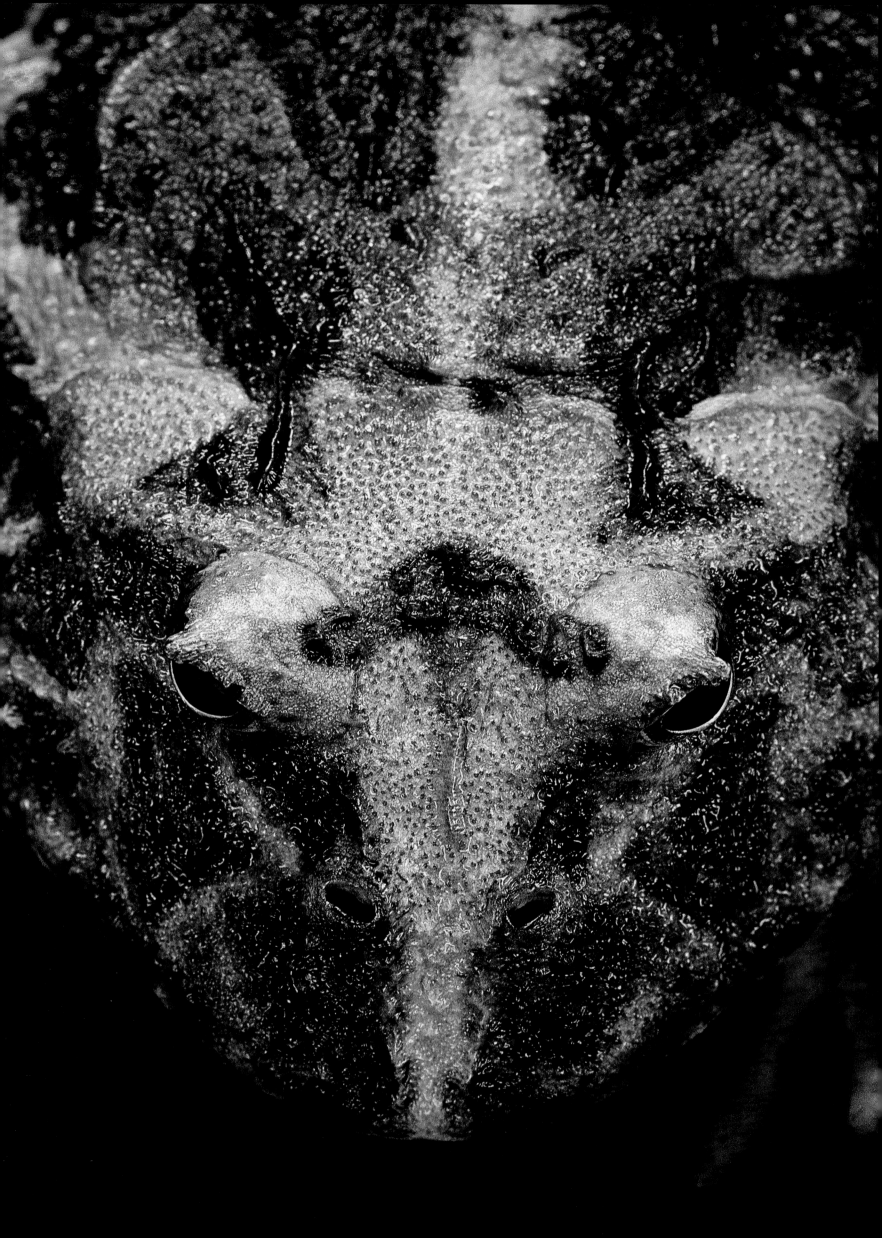

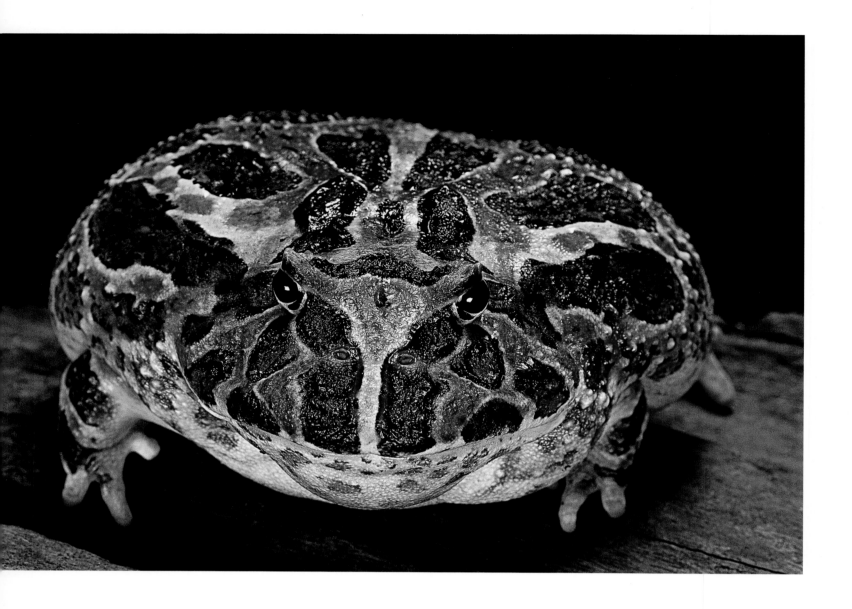

CERATOPHRYS ORNATA [▲]

Distribution: Argentina, Uruguay, Paraguay
and Brazil
Average length: 10 to 15cm (4 - 6in)

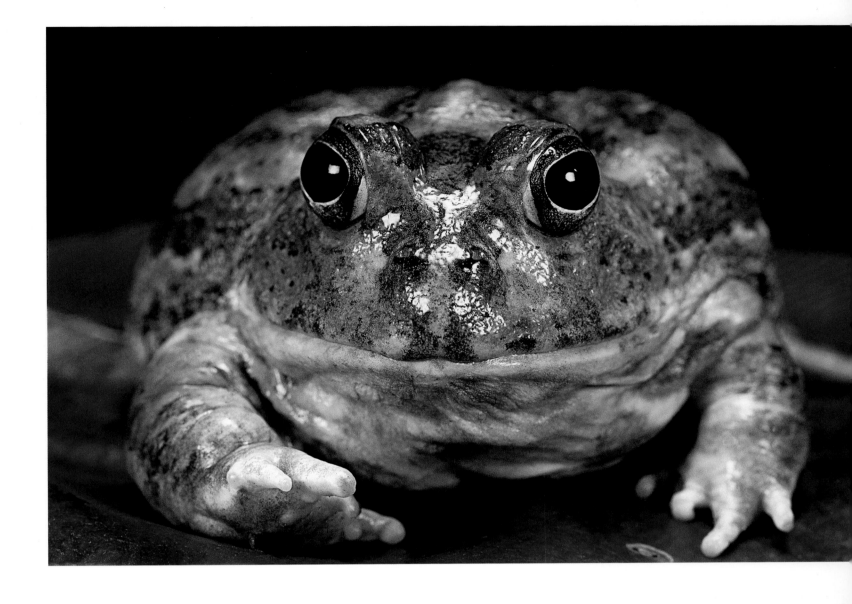

CHACOPHRYS PIERROTI [⌃]

It is difficult to encounter these stocky anurans in the gallery forests of the dry savanna of the Chaco. There is only one brief moment in the year, during the mating period, when it is possible to catch sight of them, and in great numbers. They adopt a behaviour for the occasion known as 'explosive mating'. When night falls on the first heavy shower announcing the start of the rainy season, they suddenly swarm in their hundreds to ponds and small lakes in a deafening chorus of croaks. They mate all night long and lay their eggs in the thousands. In the early hours of the morning their eggs carpeting the surface and bottom of the water are all that is left of their nocturnal frenzy.

Distribution: Argentina, Paraguay, Bolivia
Average length: 5 to 7cm (2 - 2¾n)

LEPIDOBATRACHUS LAEVIS [⋙]

Specifically aquatic. At first glance, this massive frog is just a large saggy body with a mouth and limbs added to it. It is closely related to the horny frog (*Ceratophrys*) and is an awesome predator with an enormous mouth, preying on everything that moves. Its jaw is equipped with two large, pointed teeth that inflict painful bites. It lives in ponds and marshes where its own larvae or members of its own species can end up as potential prey. Right before the winter season, it digs a burrow in the mud, in which it will stay for several months.

Distribution: Argentina, Paraguay and Bolivia
Average length: 10 to 12cm (4 - 4¾in)

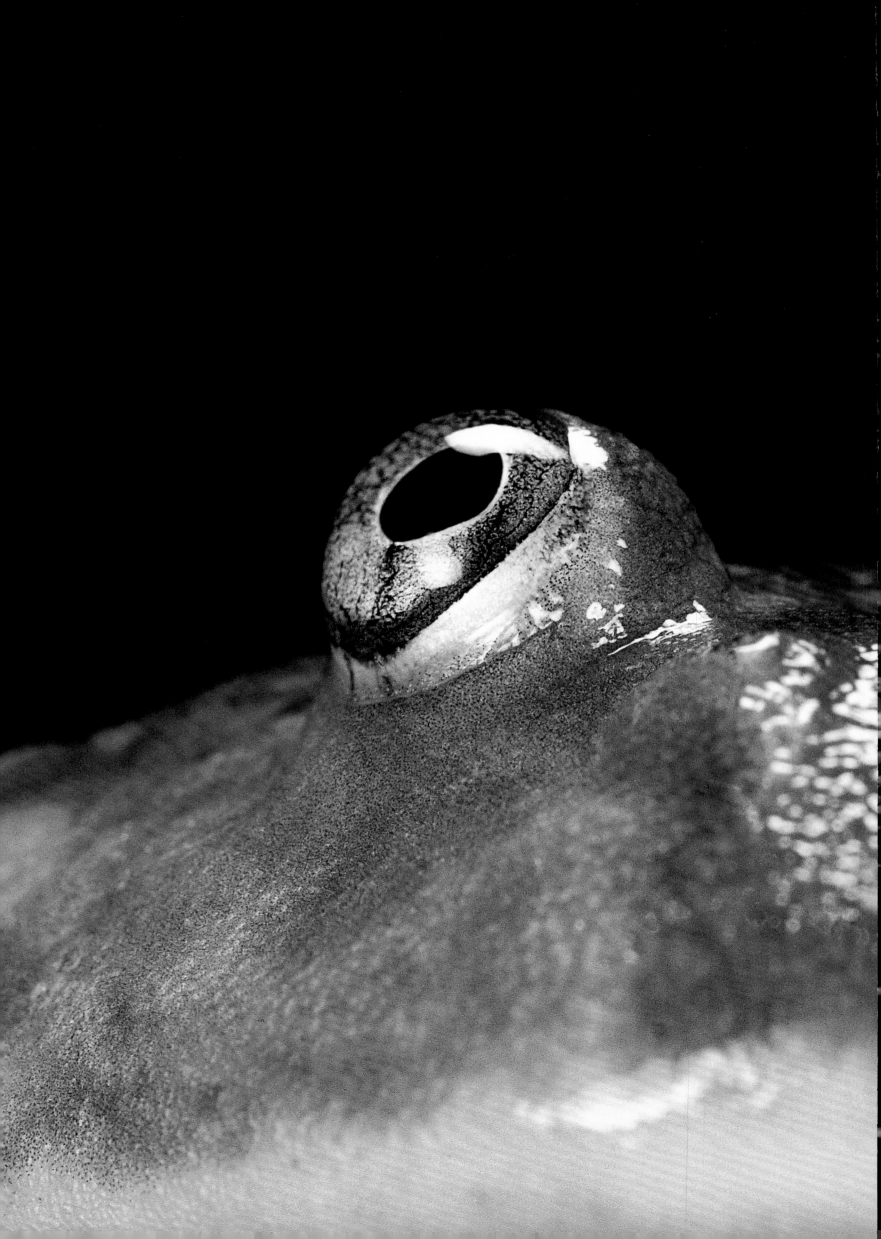

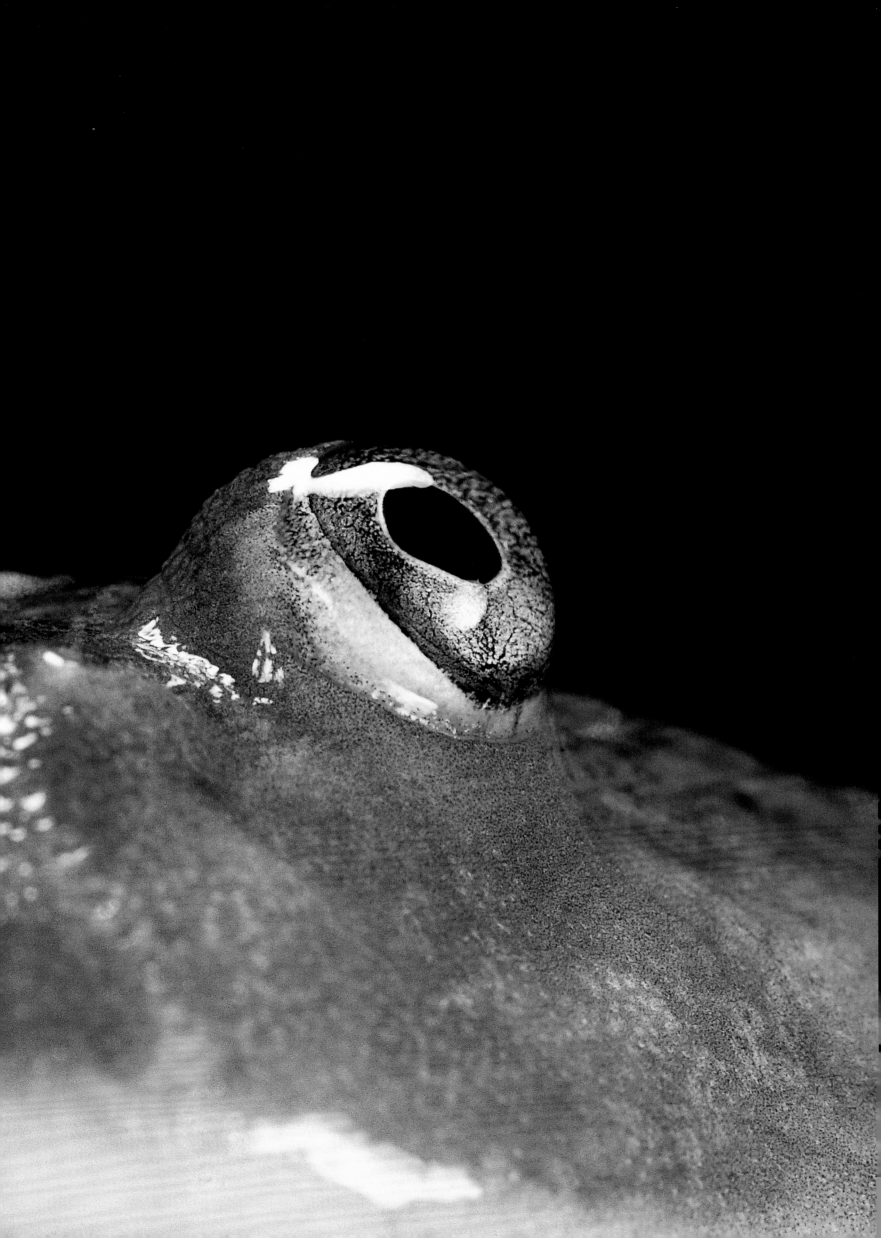

MICROHYLIDAE

Distributed over most tropical regions of the planet, they are particularly abundant in Oceania, Asia, Africa and South and Central America. In Papua New Guinea, about half of anurans are Microhylidae. This large family of around 430 species and 67 genera, consists of a few arboreal, as well as terrestrial burrowing species. They are small sized with a slender head and stocky body and short legs adapted for digging. Their very narrow mouth confines them to feeding on tiny prey such as termites and ants. Some species are relatively insensitive to the stings of these insects and will readily enter the insects' underground nests for a feast. Microhylidae are present in arid regions, where they protect themselves from drying out by seeking refuge in small cavities where there is a degree of moisture. They have multiple and varied reproductive patterns and their eggs hatch into either aquatic larvae or into young frogs that have developed inside the eggs.

BREVICEPS ADSPERSUS [▸]
This bulbous, flat-faced frog is a nocturnal burrower living in wooded areas with sandy soils. The significant size difference between male and females leads to an astonishing and unique mating behaviour: as the male is too small to grasp his partner by the waist, he 'sticks' himself to her back using a highly adhesive substance that resists rain and does not dissolve in water, which is secreted for this purpose. The female can walk around with the male on her back for three days while she digs the tunnel (backwards) and underground chamber to house their young.

Distribution: South Africa, Mozambique, Zimbabwe, Botswana, Swaziland, Namibia and Angola
Average length: 3 to 6cm (1⅛ - 2⅜in)

BREVICEPS MOSSAMBICUS [▸▸]
This exclusively burrowing frog with its angry 'sumo' look has the rare and distinctive feature of laying eggs in an underground chamber. Complete metamorphosis of the embryos occurs in the egg and gives rise to young, fully-developed frogs into the aquatic habitat. It lives in arid areas burrowed in the soil and will only venture out after a rain shower. It takes advantage of this humidity to fill up on small insects, ants or termites, the only prey its minuscule mouth will allow it to catch.

Distribution: eastern Africa, from the Democratic Republic of Congo to South Africa
Average length: 3 to 6cm (1⅛ - 2⅜in)

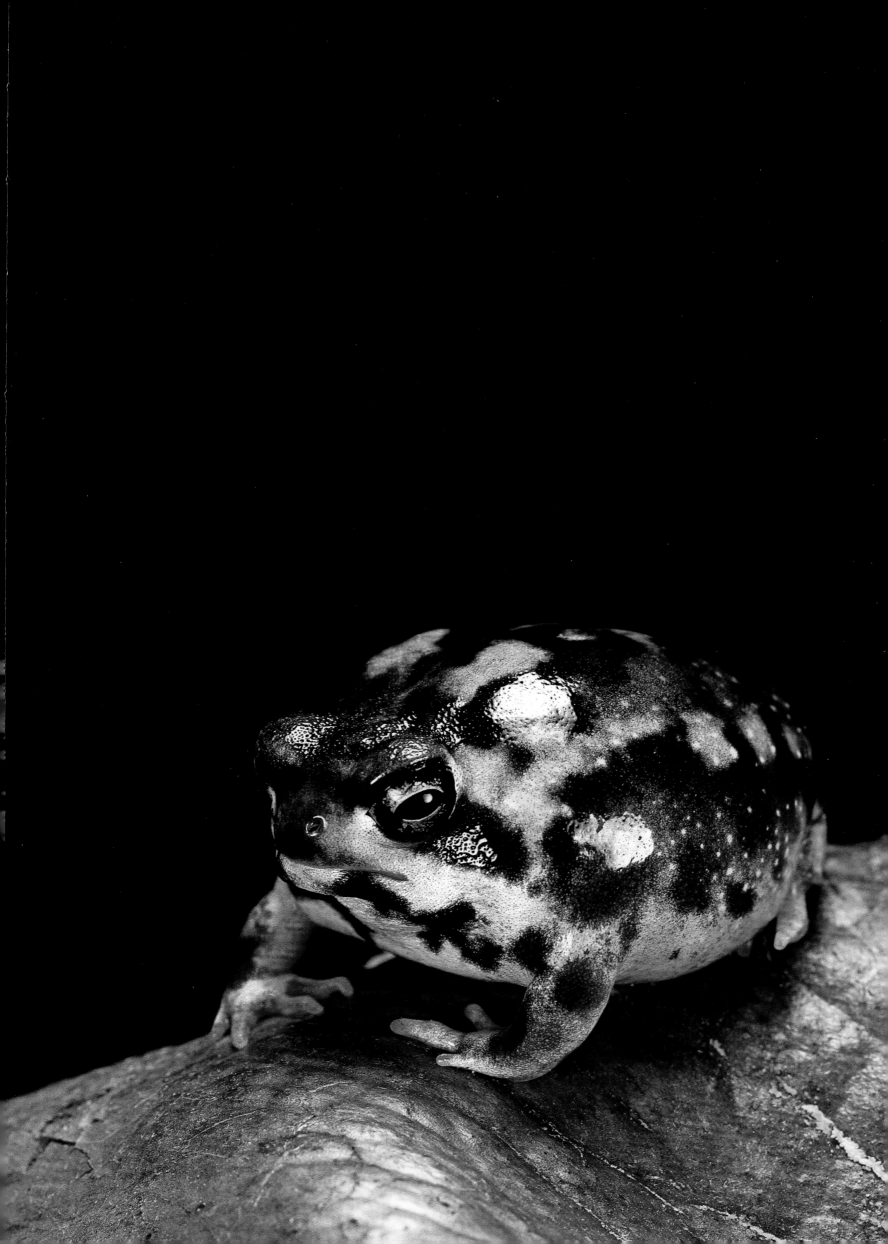

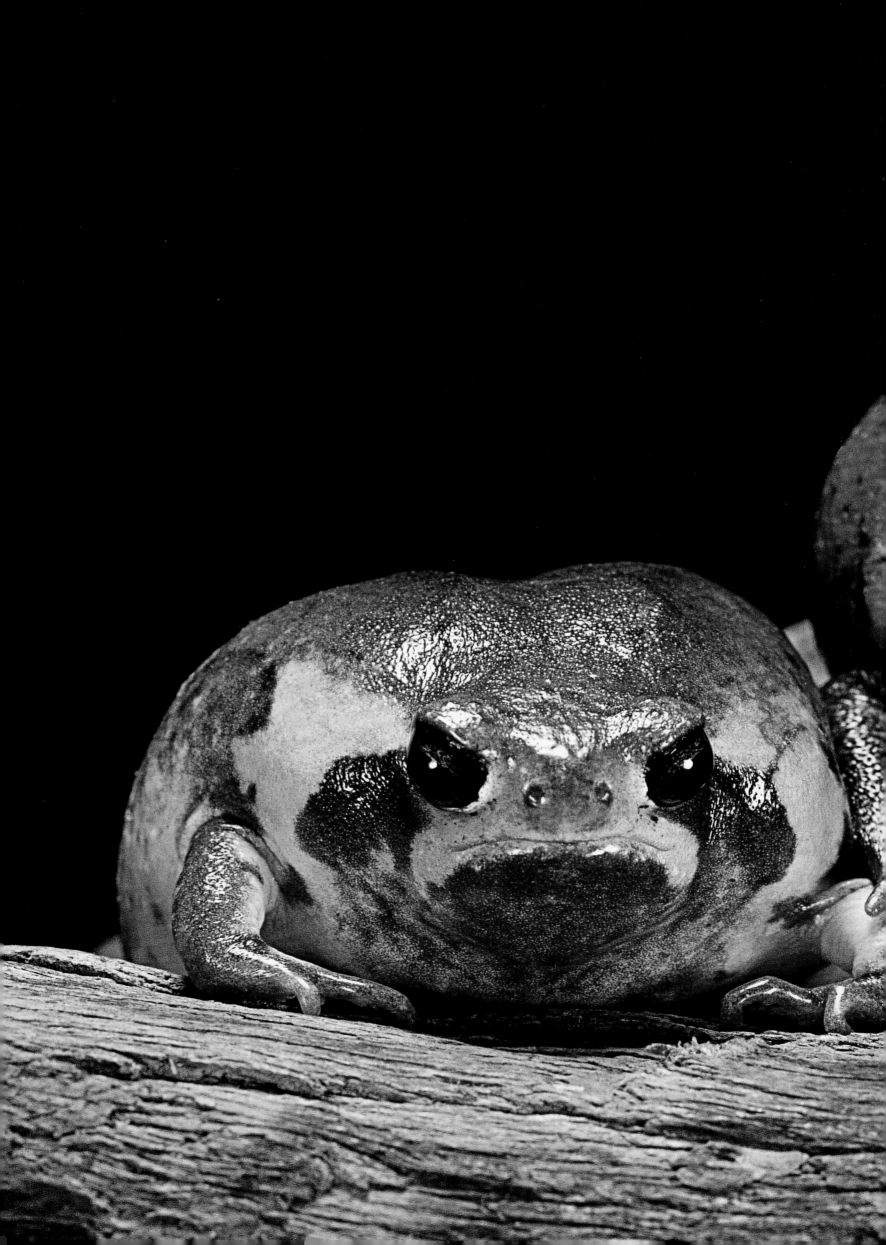

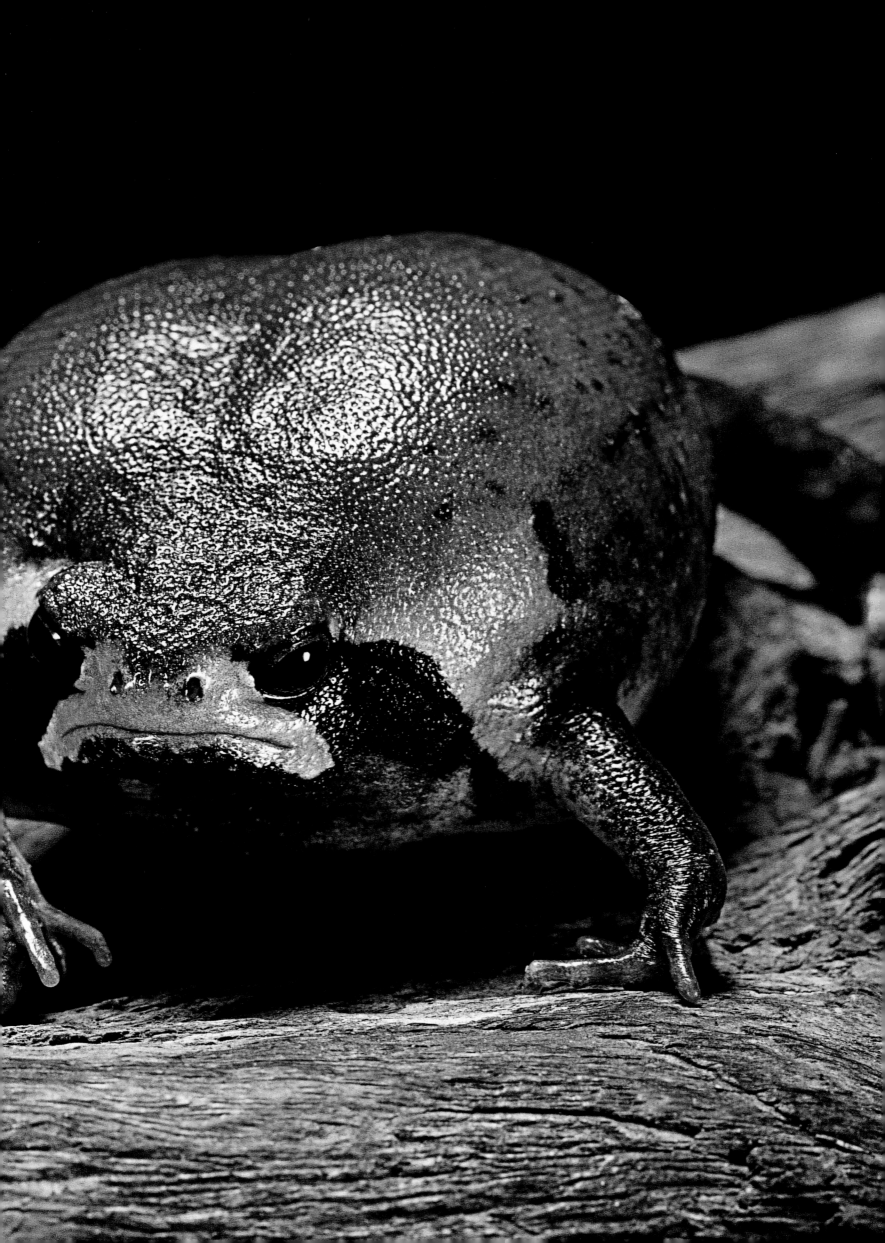

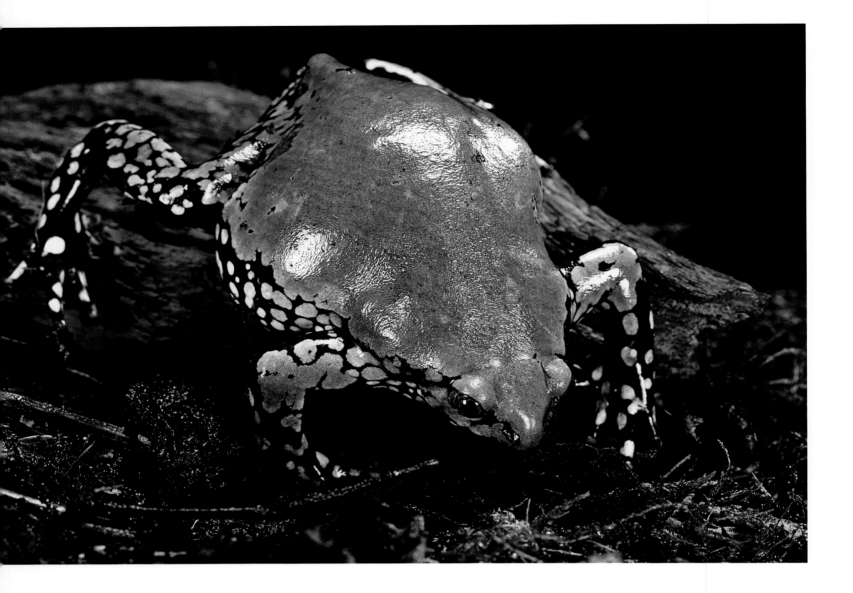

DERMATONOTUS MUELLERI [▲]

This species is principally a burrower and, along with *Hemisus marmoratus*is, is one of only two species known to have the ability to turn its head almost to a right angle while keeping the axis of its spine straight. This anatomical distinction enables it to forage in the ground easily with its head, which helps in its perpetual quest for insects. Inhabiting forests and dry tropical and subtropical savanna, it shows great skill in surviving an arid environment. It can fast for long months and store large quantities of water in its body. When handled against its will, its whole body starts to tremble – or rather vibrate.

Distribution: Argentina, Paraguay, and Bolivia
Average length: 5 to 8cm (2 - 3⅛in)

KALOULA PULCHRA [▶]

This very common burrower is easier to observe in residential areas than in nature. It is even mentioned in reference books as inhabiting parks, gardens and agricultural areas, rather than its natural habitat. Its bellowing croaks fill the silence of the night, especially during the rainy season, which coincides with its breeding period.

Distribution: South West Asia
Average length: 8cm (3⅛in)

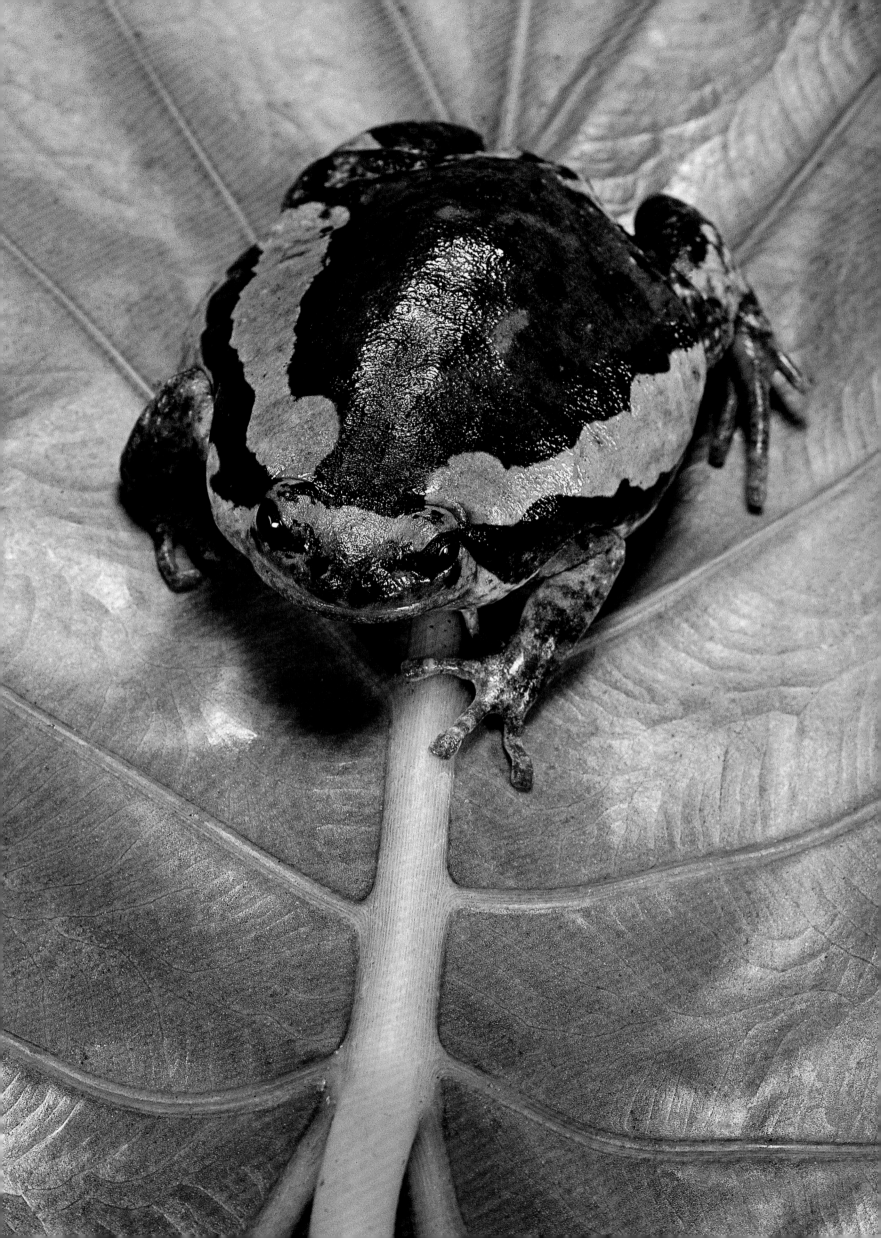

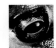

MEGOPHRYIDAE

This family includes 128 species in 11 genera distributed across South East and South Asia, part of India, Pakistan, Borneo, the Philippines and the Sunda Islands.

These timid and secretive animals are unmatched in their ability to become invisible on the forest floor. The genus *Megophrys* is the best known. Some members have supple horn-shaped dermal appendages on the upper eyelids and snout, cryptic colouring, and veined skin: the ideal camouflage in a tropical forest. When dusk falls their big eyes, with vertical pupils, open up wide and they set off on a long night of insect hunting. While their lifestyle is quite similar (camouflaged with the ground), *Leptobrachium* lack the anatomical protrusions. They are little known, and considered a relic species, a primitive group. Their way of moving about is unusual: they literally crawl on the ground.

In many species of the genus *Megophrys*, the female is much larger than the male and mating is quite a comical scene, with the male resembling a growth on the back of the female.

LEPTOBRACHIUM HASSELTII [▸]

Distribution: Indonesia, Malaysia, Thailand,
Myanmar (form. Burma), Philippines, India and
China
Average length: 5 to 7cm (2 - 2¾in)

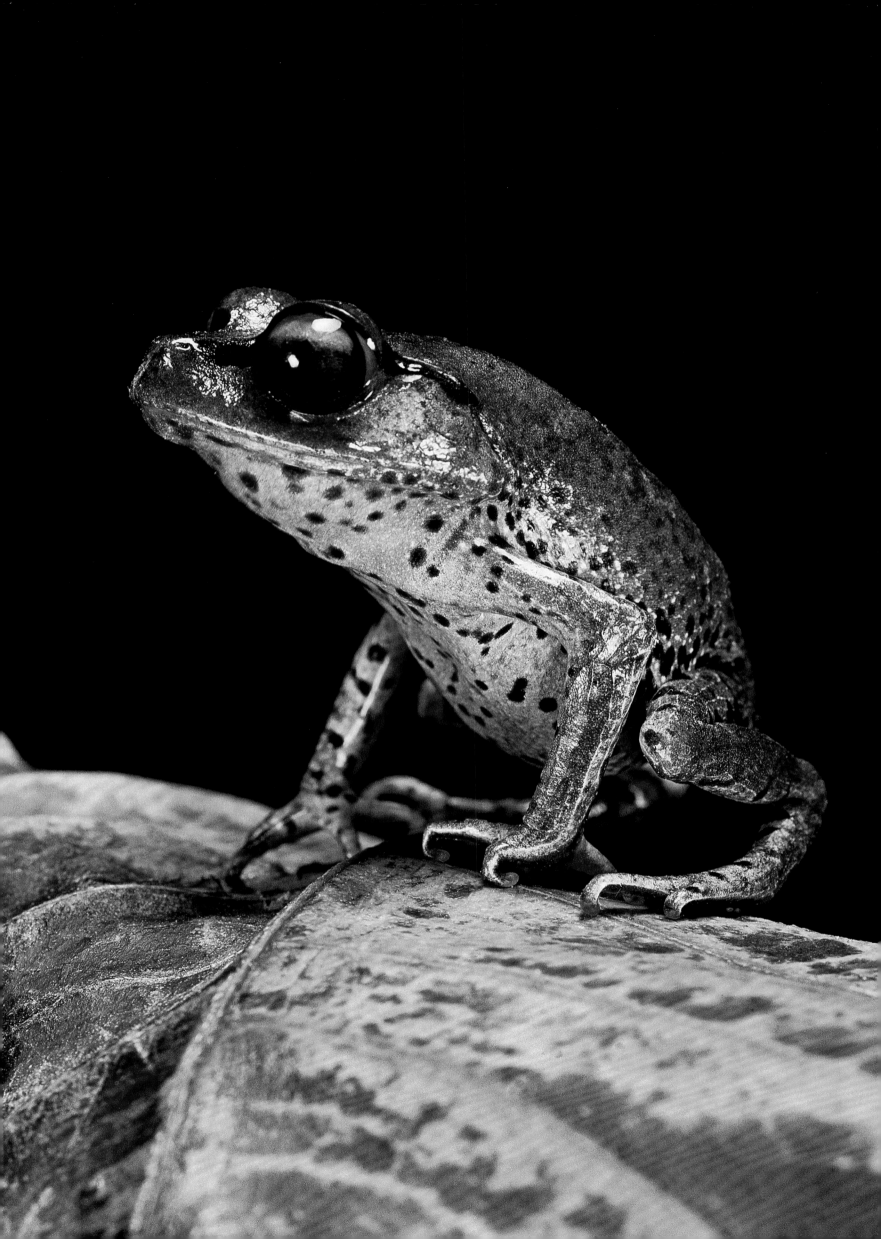

MEGOPHRYS LONGIPES [▸]

Distribution: Malaysia and the west of Thailand
Average length: 6 to 8cm (2⅜ - 3⅛in)

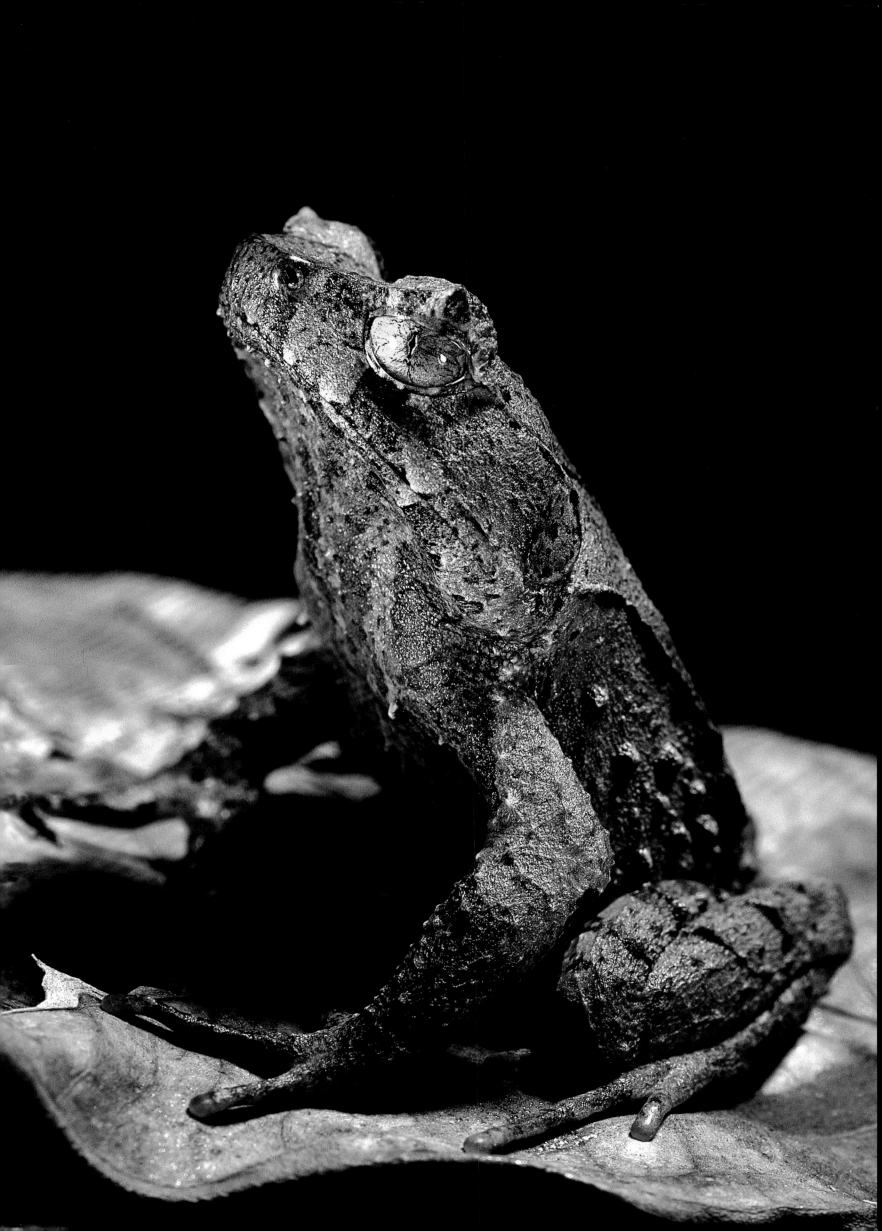

MEGOPHRYS NASUTA [▸ | ▸▸]

Distribution: Indonesia and Malaysia
Average length: 6 to 15cm (2⅜ - 6in)

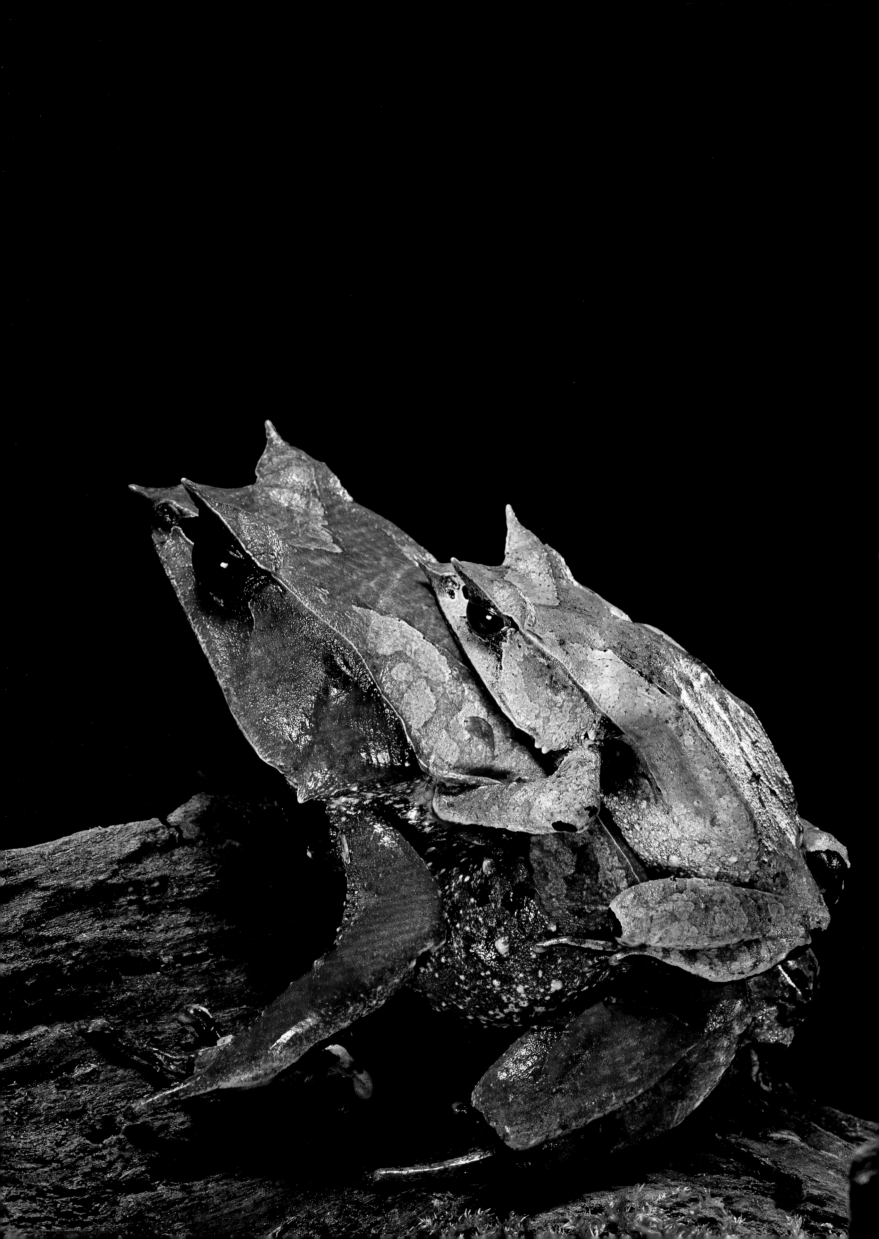

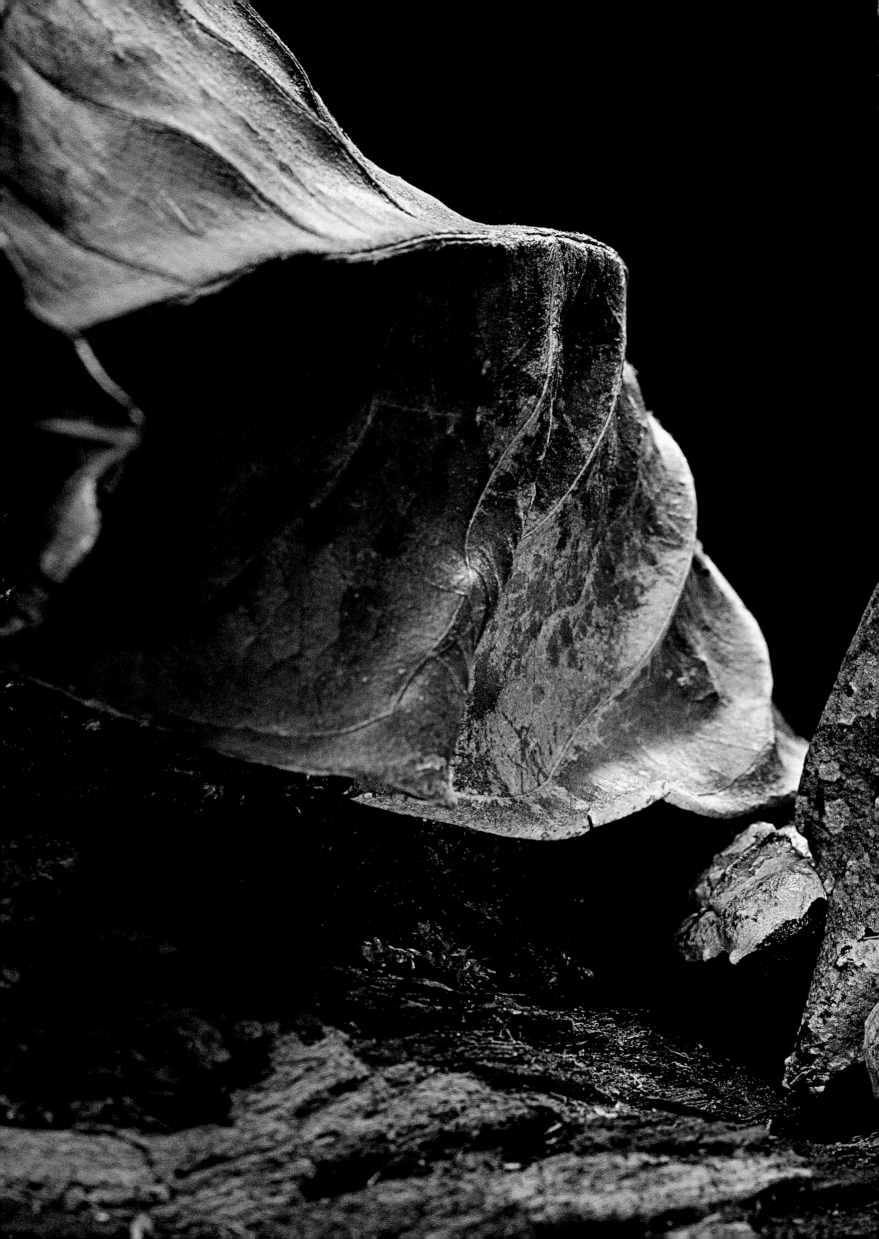

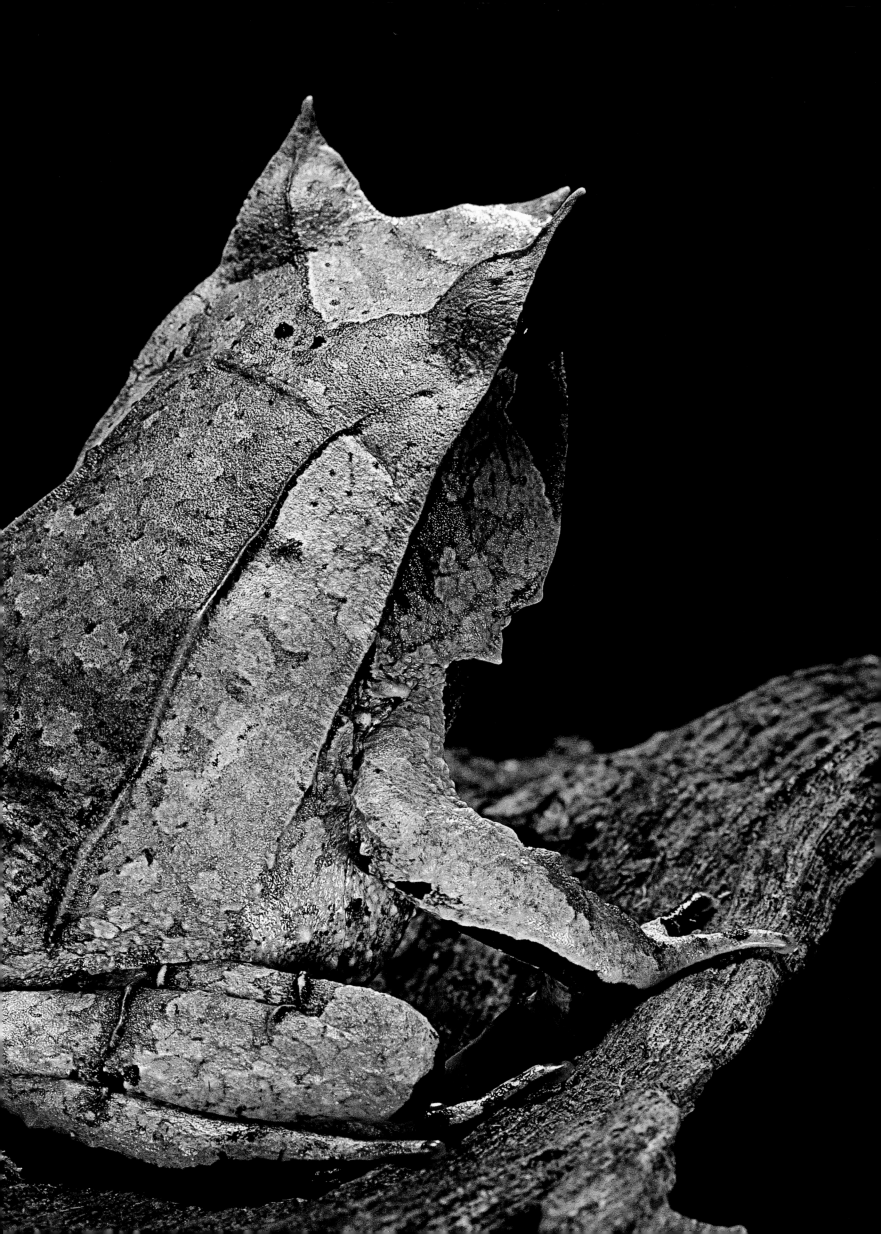

PELOBATIDAE

They are present in North America, western Eurasia and the northwest of Africa. There are only 11 species in 3 genera. Combining both primitive and evolved anatomical features, they are considered an intermediary between the so-called archaic families and the more advanced families. Their skin is covered in warts, which makes them look like small toads lacking parotid glands. They are burrowers and are particularly fond of sandy areas where they can put their remarkable digging skills to use. They are commonly known as 'Spadefoot' because of the horny spade-like projection on the side of each hind foot that they use to dig. They are known for their ability to live in very arid habitats, protecting themselves by taking refuge in deep burrows, which they only leave at night to hunt insects. If conditions are inadequate they may stay holed up underground for months. From the first rains they release themselves from the now hardened ground by breaking it with their head like a ram. Their eggs hatch into aquatic larvae that develop very rapidly in temporary pools.

SCAPHIOPUS BOMBIFRONS [▸]

Distribution: the centre west of the United States
Average length: 5cm (2in)

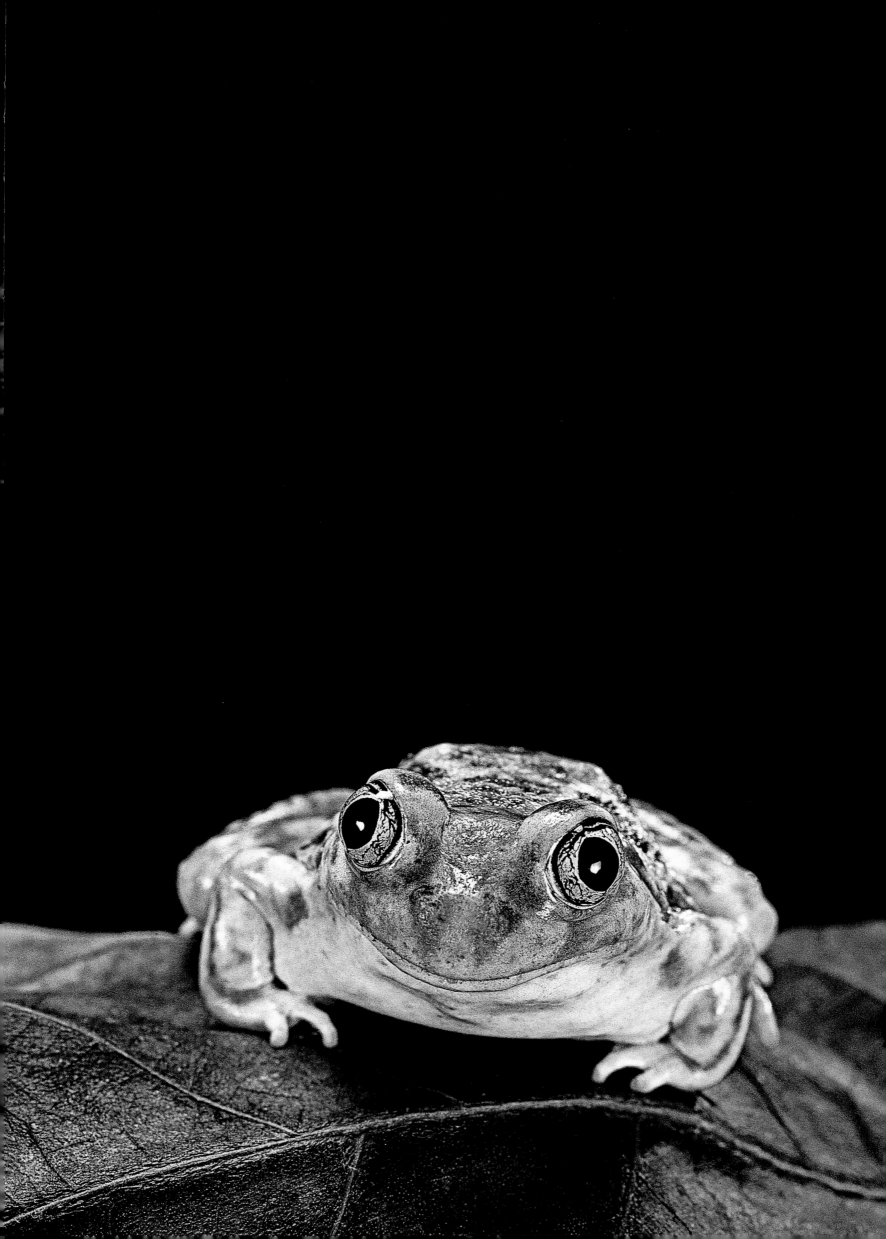

HEMISOTIDAE

This family is made up of 9 species encompassed in a single genus. Their distribution is limited to Africa, where they occupy sub-desert, tropical and subtropical areas. All have a stout and bulbous body, short but powerful legs, a pointed head with tiny eyes and an angular snout. Their extremely bony head allows them to dig into burrows head first, unlike other burrowing anurans. Their small, very active legs help them move along. These species spend their time in their burrows, often dug near a water spot. They feed exclusively on tiny insects: termites and ants. During the mating period, males come out on to the banks and call to the females by producing a strange humming sound. Mating occurs in an underground chamber. The male departs immediately after fertilising the eggs, leaving the female to attend to them. She cares for them until they hatch, coinciding with the beginning of the rainy season. To bring the tadpoles out from their flooded chamber, the female digs a small gallery through which she transports them to the pond.

HEMISUS MARMORATUS [▶]

Distribution: from West Africa to South Africa
Average length: 3 to 4cm (1⅛ - 1½in)

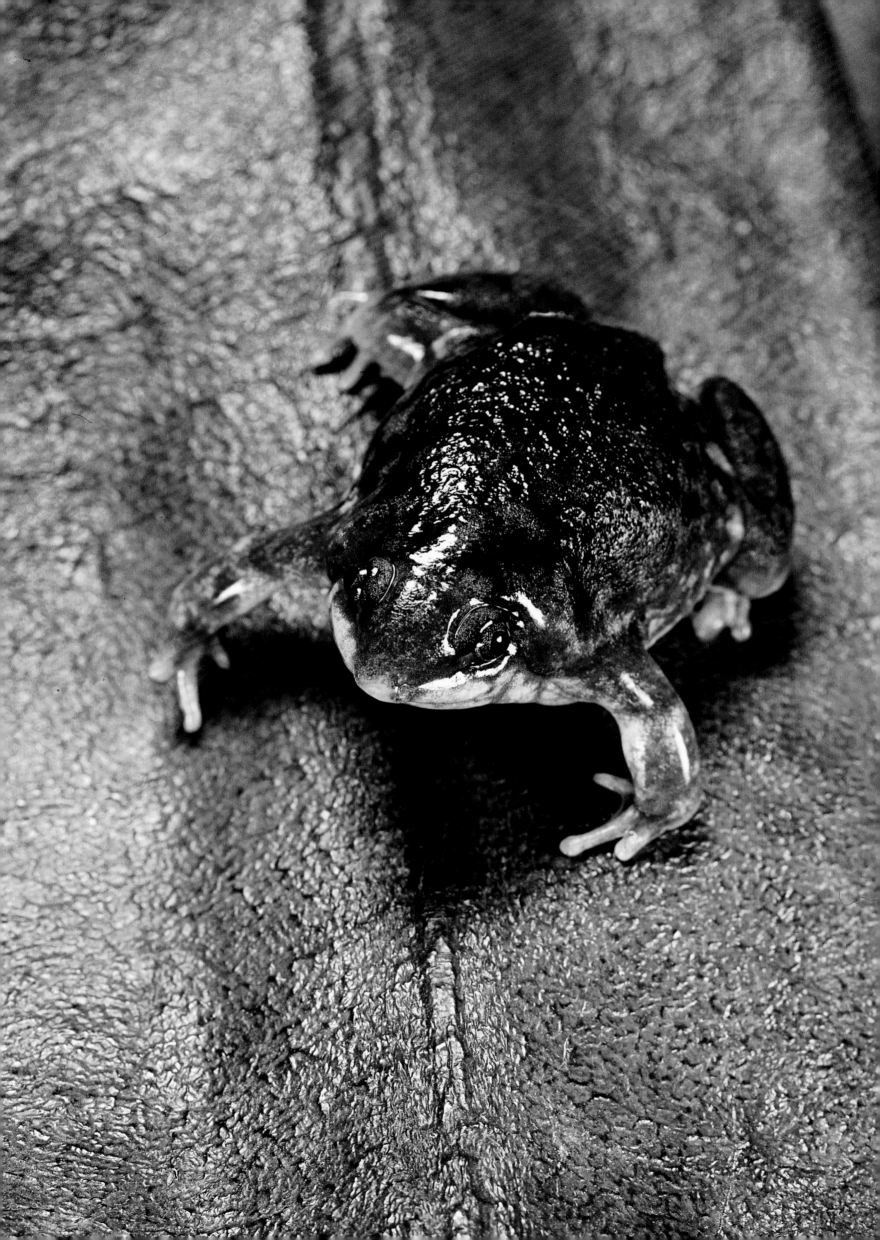

RANIDAE

Ranids group together a large number of species with a great variety of forms and lifestyles. They may be aquatic, burrowing or arboreal and are particularly fond of marshy areas or mountain streams. They show great diversity in reproductive patterns and development and their geographic distribution extends over the major part of the globe. This large family is made up of 50 or so genera for around 800 species. The systematics of this sizeable group are in constant evolution and will certainly be revised as new information challenges what was earlier thought. Widespread in Africa, the subfamily Dicroglossinae includes very interesting and unusual species such as *Conraua goliath*, the largest frog in the world, measuring 35cm (13¾in) when curled up and double that when it stretches its legs. The genus *Rana*, also called 'true frogs', are the best known and most represented in Europe. They are easily recognisable by their morphology – a streamlined body, a relatively pointed head, prominent eyes, conspicuous eardrums, long hindlegs and long fingers that may or may not be webbed – which is well suited to their aquatic environment: they are fond of marshy areas, ponds and shallow lakes. Some of them, however, haunt the grassy prairies and underbrush in the never-ending quest for food and only venture to the aquatic environment for breeding.

CERATOBATRACHUS GUENTHERI [▸ | ⇥]

A simple glance at the very particular appearance and anatomy of this insular species is enough to tell us that its habitat is the forest floor. As in *Megophrys* species, its eyelids are fitted with 'horns' that break up its appearance for better camouflage amongst dead leaves. The amazing colour range found in this species corresponds to a considerable diversity in habitat. It is nocturnal and a voracious predator. The bony protrusions are similar to teeth and equip its lower jaw to handle big prey such as lizards and other amphibians. During breeding it is one of the rare amphibians that do not opt for water. The female lays her large eggs in clusters on the ground, in a moist hole covered with plant litter. They hatch directly into miniature froglets.

Distribution: Solomon Islands and Bougainville Island
Average length: 6 to 8cm (2⅜ - 3⅛in)

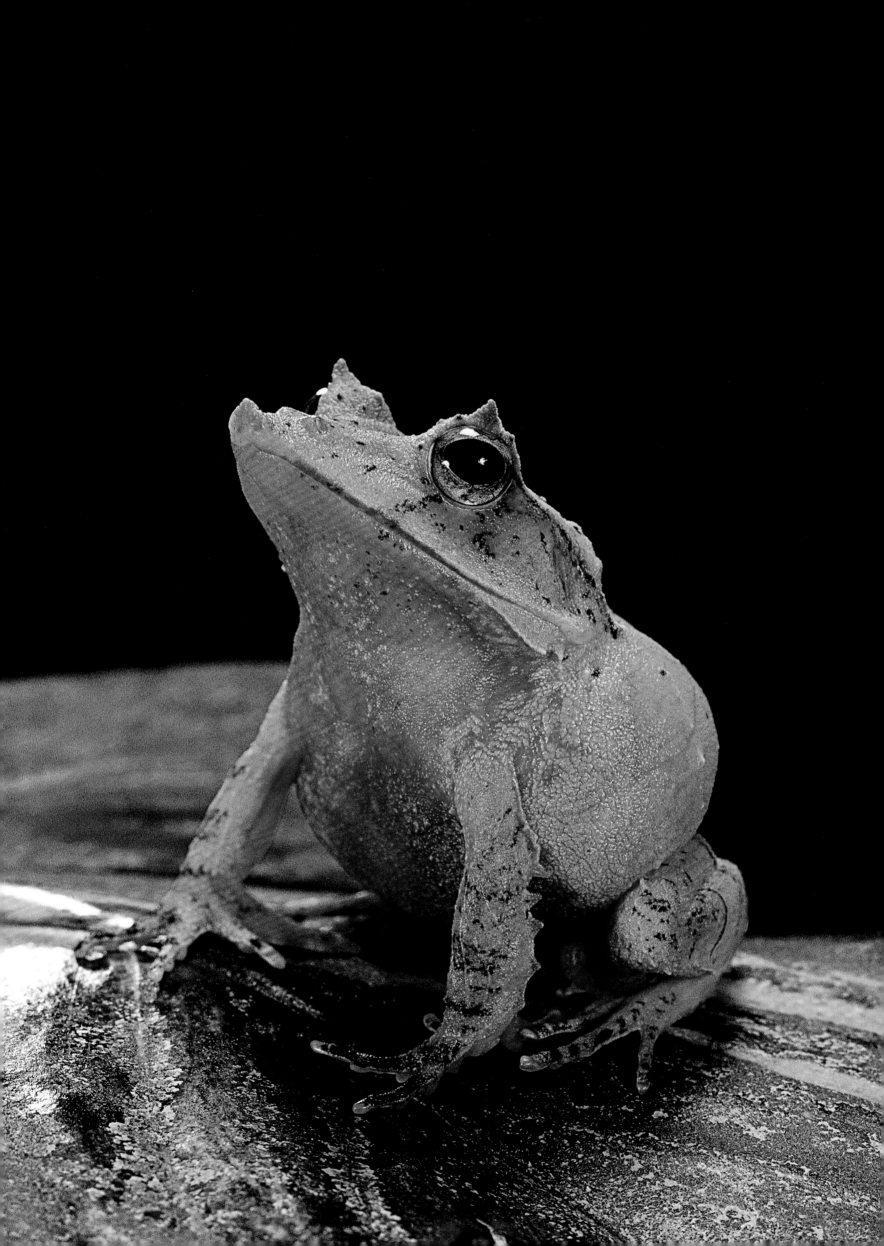

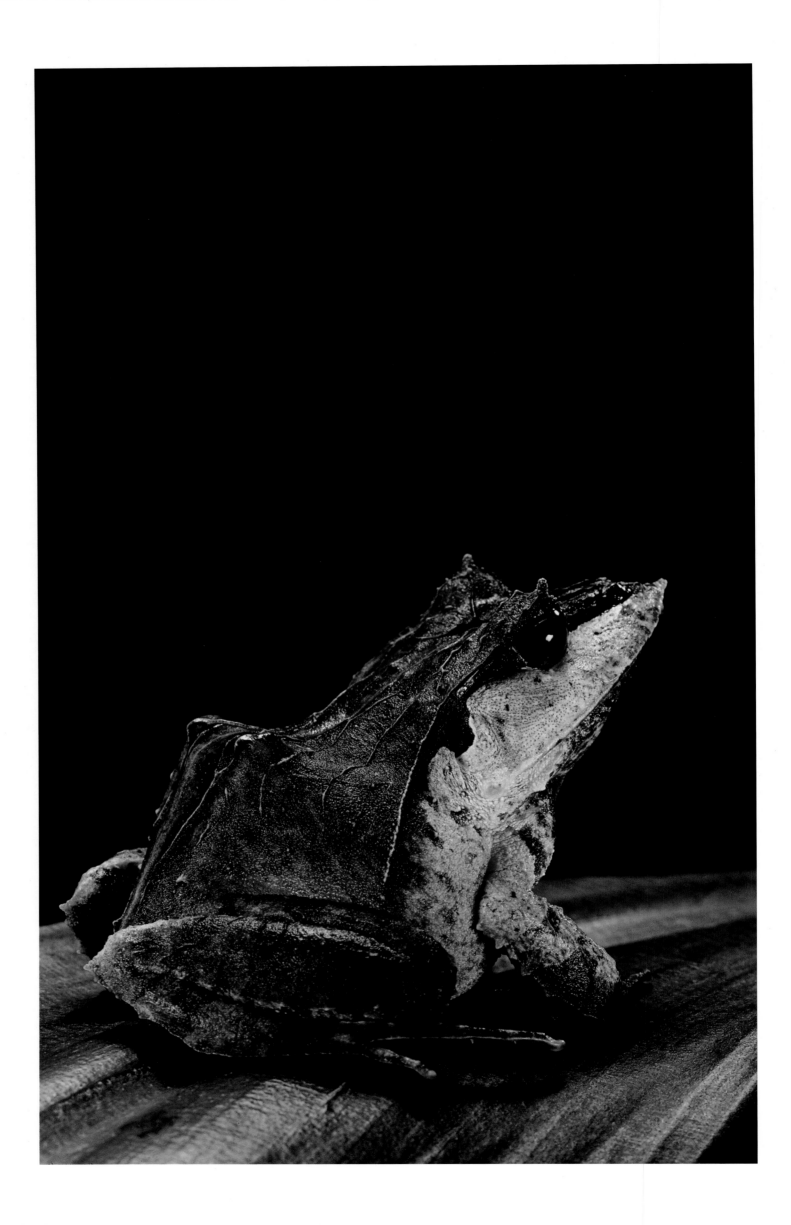

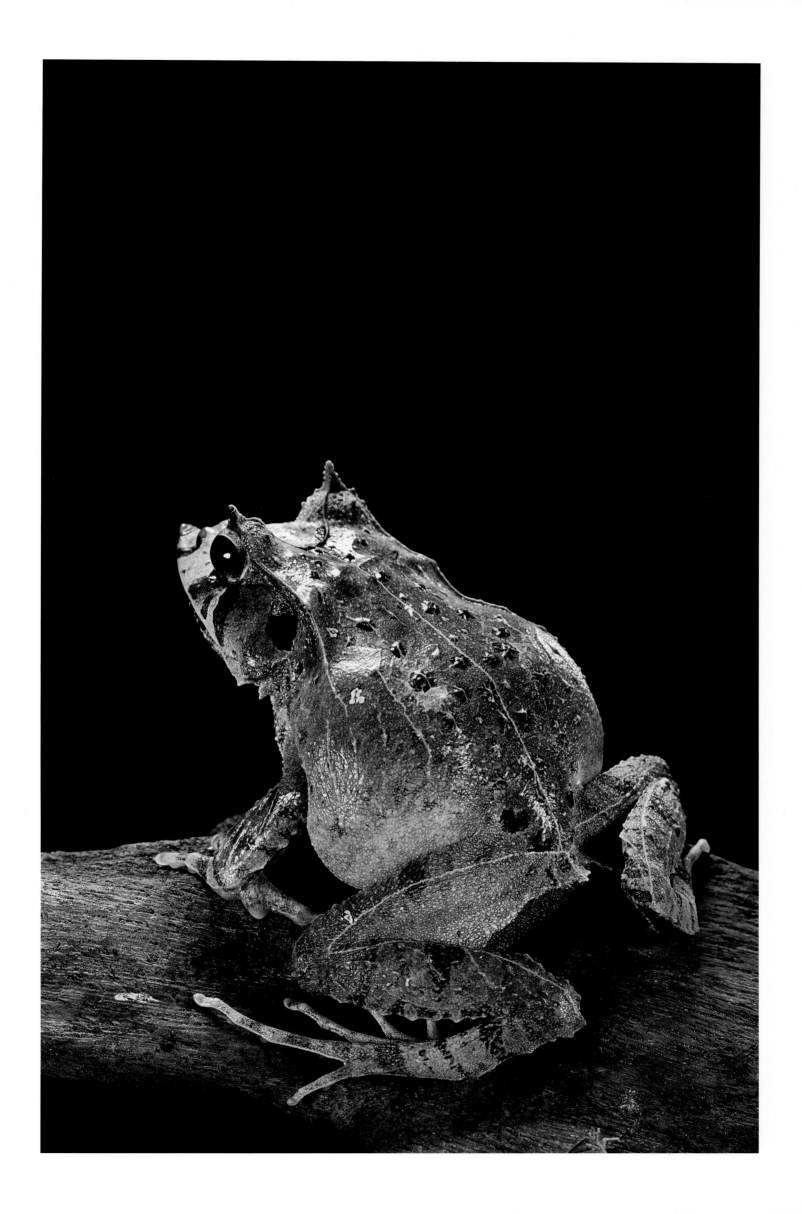

PYXICEPHALUS EDULIS [▸]

This fat frog is richly coloured and is as
formidable a predator as its big cousin
Pyxicephalus adspersu. Although modest in
size, it still displays very similar behaviour and
lifestyle. Like its cousin, it spends long months
or even several years burrowed in the ground
in a dried out pond. To reduce the risk of
drying out it produces a waterproof covering
by shedding the outer layer of its skin and
binding it with a mucous secretion, which
hardens to form a watertight cocoon.

Distribution: common in all of eastern Africa
and up to Angola
Average length: 10cm (4in)

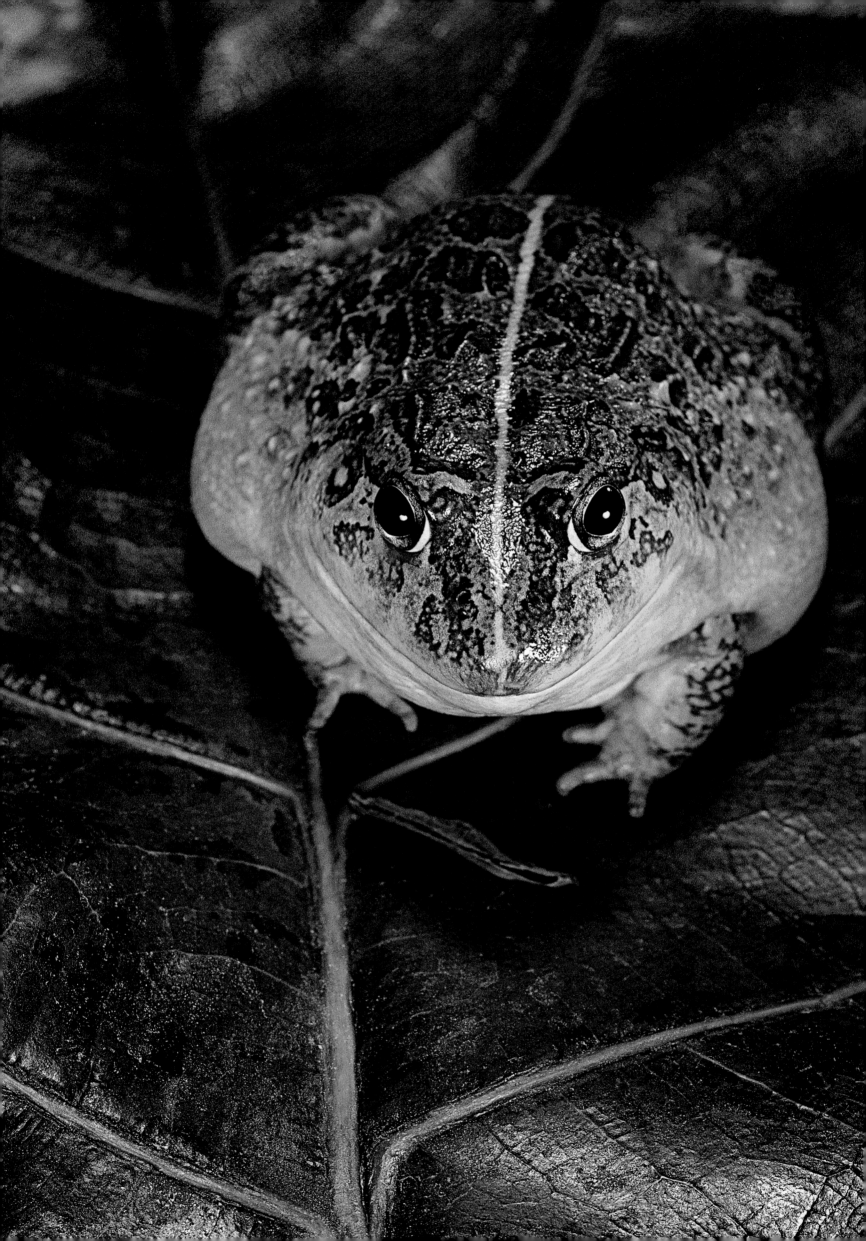

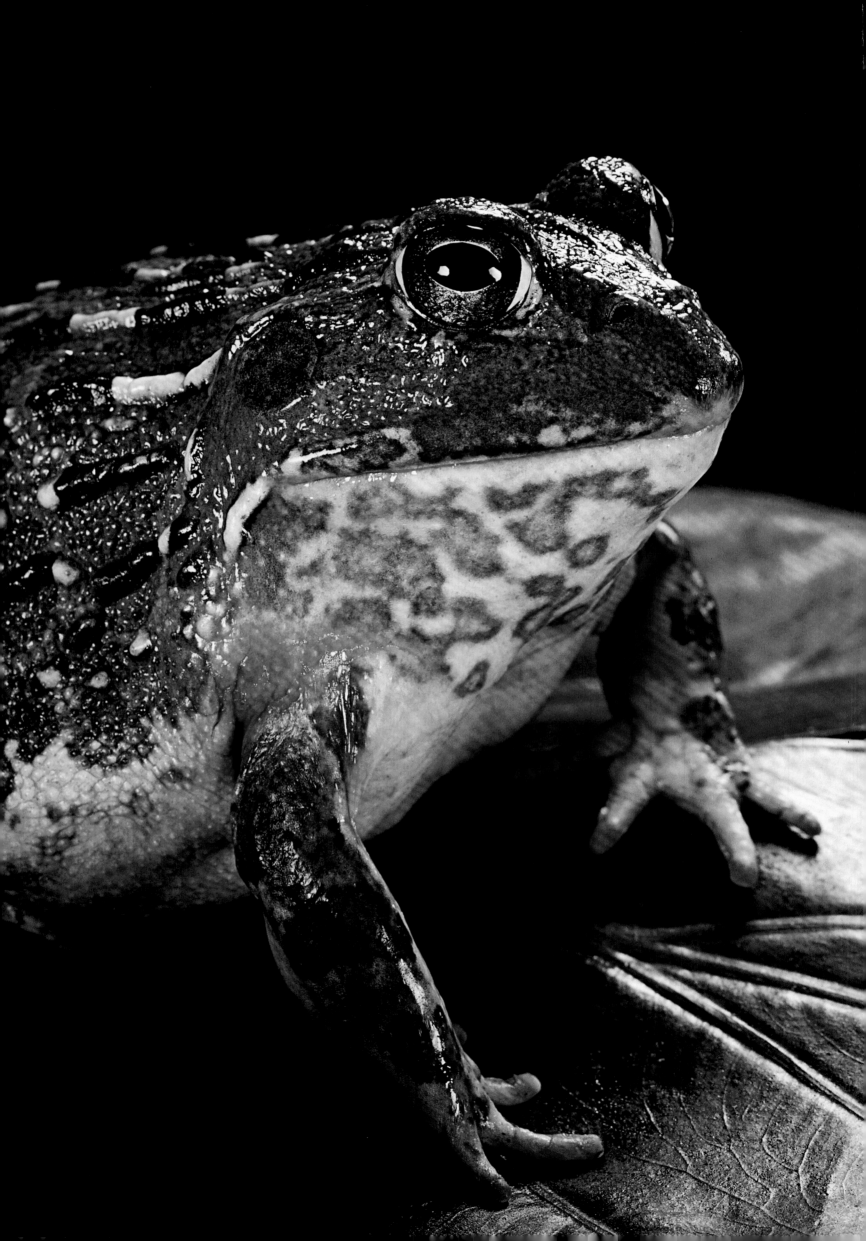

PYXICEPHALUS ADSPERSUS [◄]
(AFRICAN BULLFROG)

This is a giant among African anurans. It is renowned for its recklessness and ferocity, as well as for its paternal instinct. After having spent several months (or even several years) burrowed in dried out ponds, these frogs surface on the first rains, with an irresistible desire to procreate. During this period, males fight bitterly, using their bodies like rams and inflicting deep wounds with their terrifying fangs. After mating, care for the young is an exclusively male task. The males are totally devoted and remain constantly beside the eggs, protecting them from predators as well as from their own species. The pond where the tadpoles hatch can quickly dry out, in which case doting fathers will start digging channels to carry the larvae to larger stretches of water.

Distribution: common in all of eastern Africa and up to Angola
Average length: 8 to 23cm (3⅛ - 9in)

CONRAUA GOLIATH [▶▶]

With a size that can reach 35 centimetres (13¾inches) when curled up and a weight that can exceed 3kg (6lbs 10oz), it is undeniably the largest and fattest frog in the world! Now scarce and very localised, this legendary creature haunts fast-flowing rivers and waterfalls and lives protected by a lush setting of tropical forest. It is diurnal, keeping watch from rocks that emerge from rapids, and has an incredible leaping ability – over 3 metres (approx. 10ft) – to capture flying insects, caught by surprise at this prodigious jump. Crustaceans, anurans and some reptiles are also part of its diet. It is renowned for being very elusive and has excellent eyesight to anticipate unwanted intruders and escape with great leaps, which generally end in the water. Another significant peculiarity is that the males do not vocalise during the mating period as they have no vocal sacs.
Its situation today is quite alarming. While some local populations have always hunted this animal, the trend has seen a disturbing rise in the last few years as this frog is believed to have all sorts of miraculous virtues. Its rarity and so-called magical properties have made it a sought after (and forbidden) delicacy served by some local restaurant owners, who pay the earth for these legendary animals. Add to this the destruction and pollution of its last habitats, and it is possible we are witnessing the very rapid disappearance of the largest frog in the world.

Distribution: Cameroon and Equatorial Guinea
Average length: 17 to 35cm (6¾ - 13¾n)

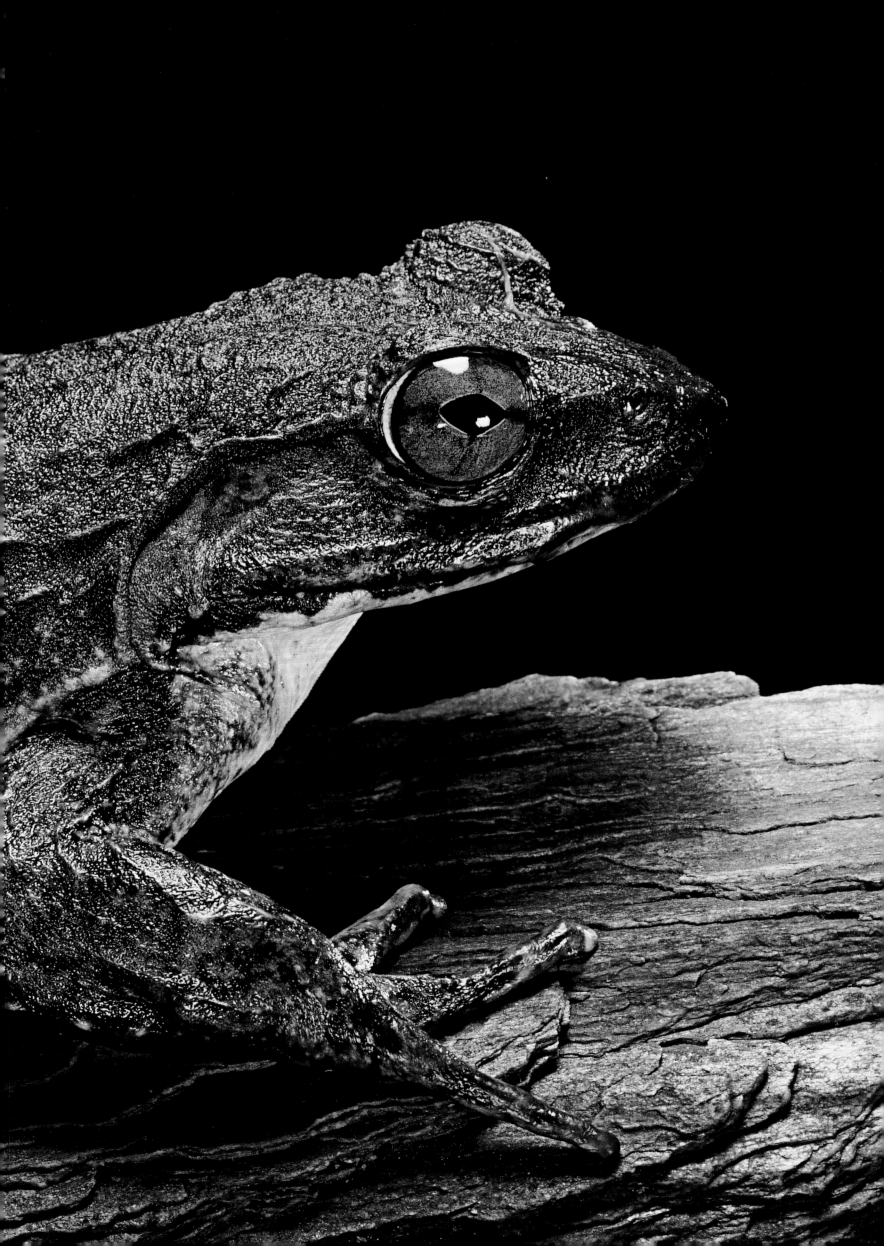

RANA PIPIENS [▶]

(LEOPARD FROG)

This species bears an obvious similarity to European 'green frogs' but its lifestyle is visibly more terrestrial. It has a preference for prairies, forest zones and even golf courses! Thanks to its long, muscular hindlegs, it can perform spectacular leaps, often including sudden turns and bewildering zigzags. It is diurnal and is prey to a great number of species: large wading birds, birds of prey, snakes and all kinds of small carnivorous mammals such as raccoons. They are very common and can often be seen in residential areas. Sadly, it is still being captured in large numbers and used for dissections in biology classes.

Distribution: United States and Canada
Average length: 9 to 13cm (3½ - 5⅛in)

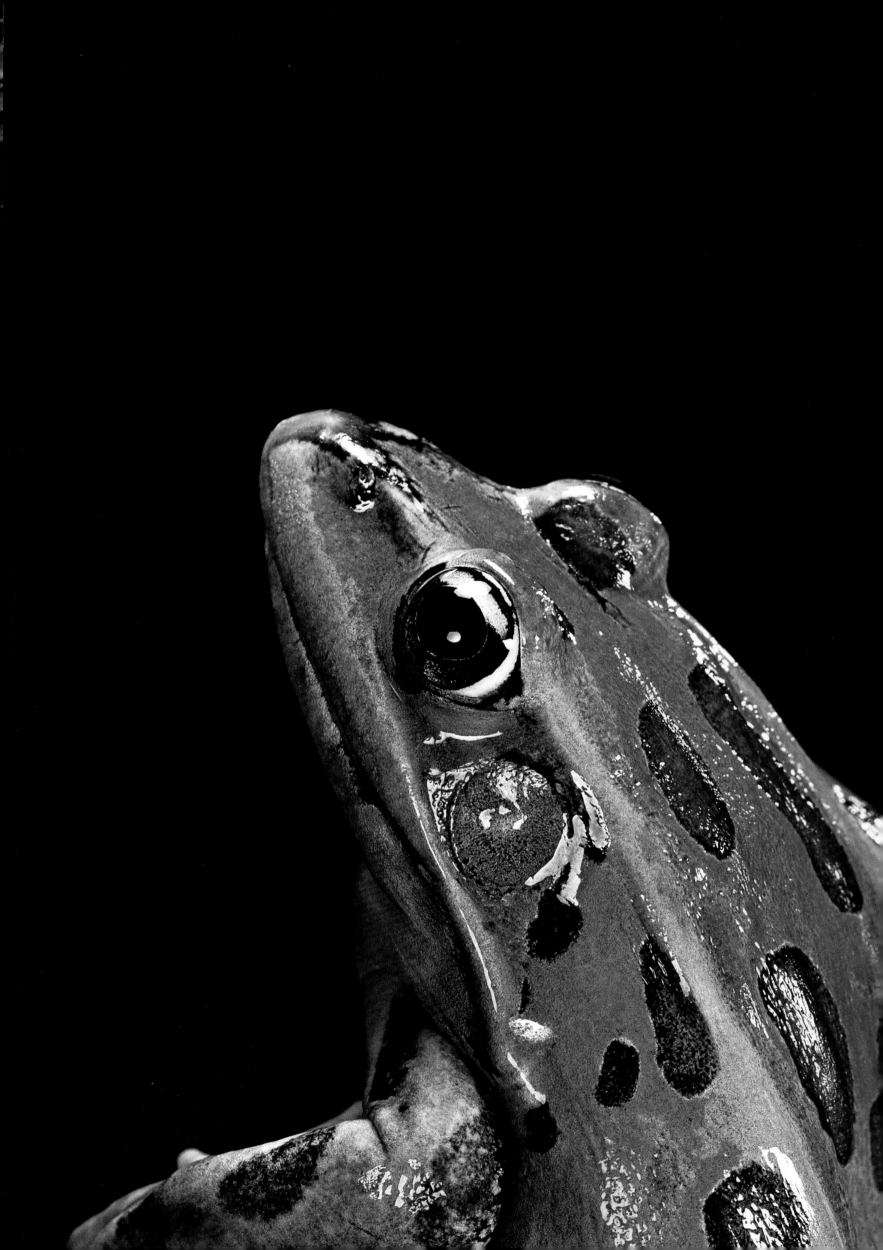

ASLYLOSTERNIDAE

This family is represented by 5 genera with 29 species and is only present on the African continent, mainly localised in Cameroon and its bordering countries. These species often have atypical morphologies and unusual habits. The most astonishing and famous of all is the legendary Hairy Frog. It is the only representative of its genus and is by far the most unusual. Its 'hairs', which are actually skin filaments, are exclusively male attributes that only appear during the breeding period. They are heavily vascularised to enable gas exchange with the aquatic environment and this provides it with much greater autonomy under water. When threatened it will not hesitate to inflict a painful sting on its assailant, using its retractable claw located on a toe of the hind feet. Fast-flowing waters in protected, mid-altitude primary tropical forest are the only locations where it is still possible to observe this amazing animal.

TRICHOBATRACHUS ROBUSTUS [▸]
(HAIRY FROG)

Distribution: Nigeria, Guinea, Cameroon
Average length: up to 15cm (6in)

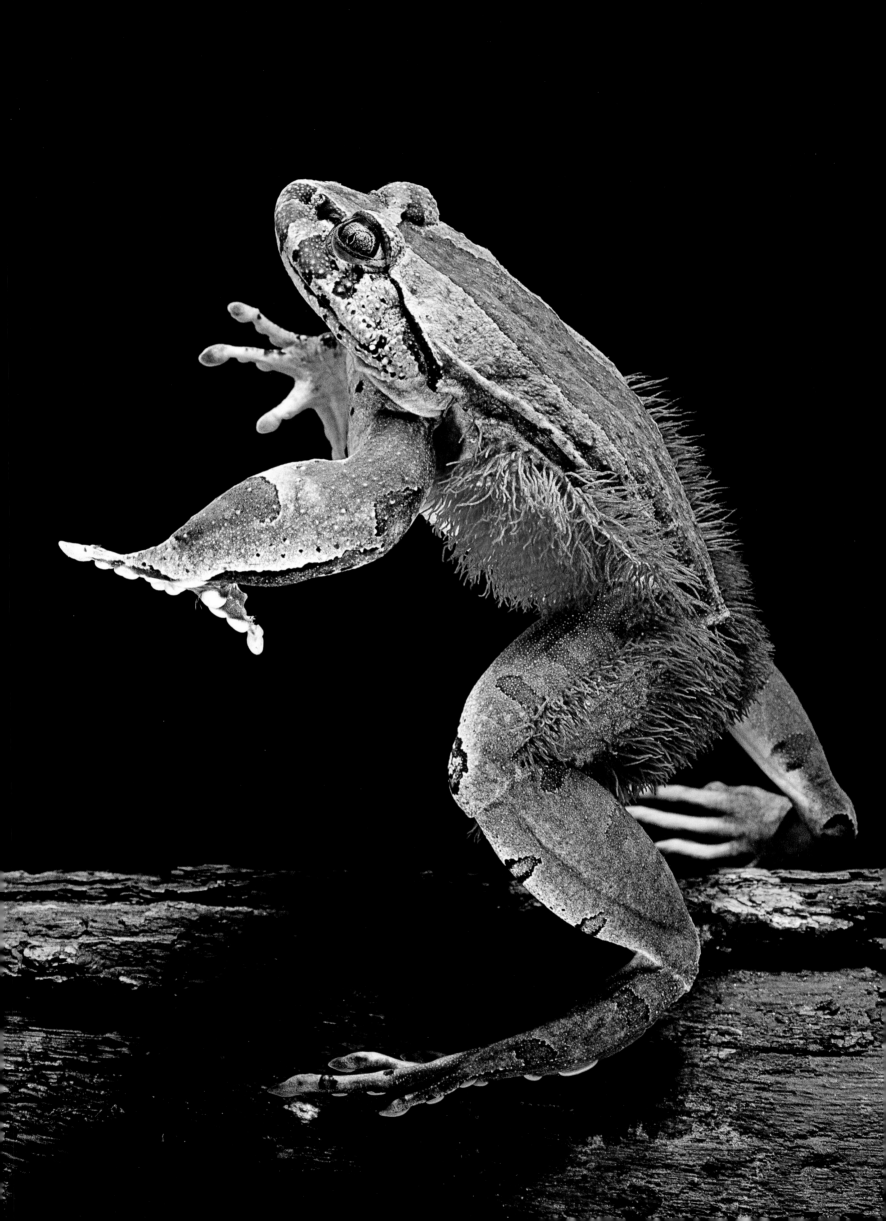

ARTHROLEPTIDAE

The Arthroleptidae family includes 51 species from 8 genera that are mostly common and well represented in their habitat. They live exclusively in Africa and are only absent from the southwest of the continent and desert areas. This family is principally made up of species from the genus *Arthroleptis*. These tiny terrestrial frogs are mostly distributed across tropical forests, where they live in leaf litter on the forest floor, camouflaged in dead leaves. In some regions where they are particularly abundant, they can be seen littering the ground by the hundreds. A distinguishing feature is that during the breeding period eggs are laid in rudimentary nests in the middle of the vegetation – under a bush or between the roots of a tree – and then hatch into miniature juvenile frogs.

ARTHROLEPTIS VARIABILIS [▸]

Distribution: from Guinea to Cameroon, and on to Uganda
Average length: 1.5 to 2.5cm. (½ - 1in)

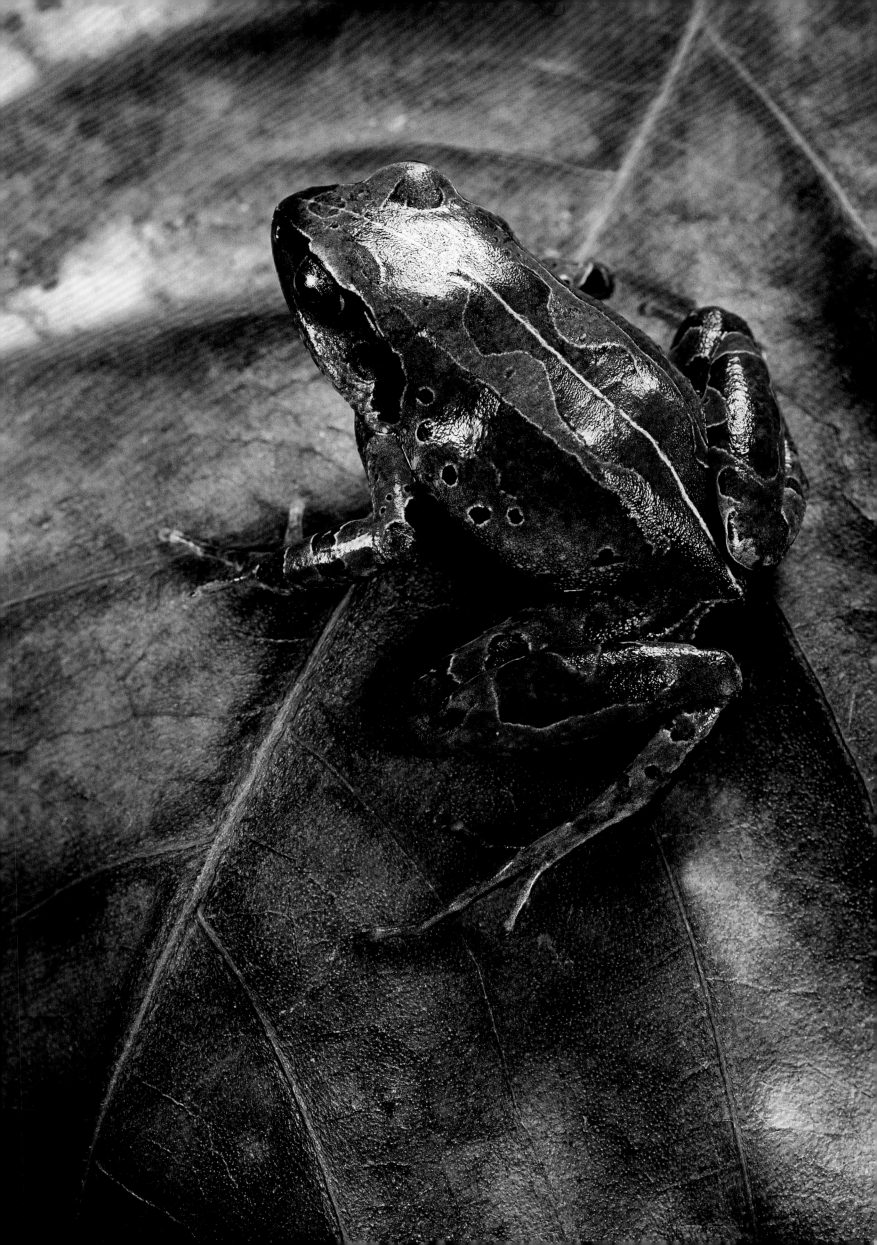

RHACOPHORIDAE

Under constant revision, this family includes around 270 species in 10 genera. They are prevalent in Asia and South East Asia with a few representatives in Africa. Many new species have been discovered over the last few years, notably in Sri Lanka. These anurans are mainly arboreal and their big eyes have horizontal pupils that give away their nocturnal lifestyle.

These species owe their astounding diversity to the great feats of adaptation they have achieved to specialise in climbing. Some have developed webbing between the fingers and toes to glide from tree to tree. Others have opposable fingers and toes to better grasp branches and twigs. Specific to this family is the construction of a foam nest to protect the eggs after hatching. These are built on high branches above water, though a few rare species prefer to lay their eggs on the ground. Their eggs are rich in yolk and hatch into fully developed froglets.

RHACOPHORUS REINWARDTII [▸ | ▸▸]
(JAVA FLYING FROG OR GREEN FLYING FROG)
Unquestionably the most atypical and most fascinating of all arboreal frogs. Of course, this frog doesn't actually fly in the literal sense but rather glides from tree to tree. Its fingers and toes have large webbing that it spreads out to the maximum during its gliding flights. When threatened or hunted it can jump impressive distances into the air – up to 15 metres (approx 50ft) – all the while controlling its course. It is an agile climber and lives in the branches of the tallest trees in dense forest, guzzling countless insects every night.

Distribution: Indonesia, Malaysia, Thailand, Laos, Vietnam, India and China
Average Size: 5 to 8cm (2 - 3⅛in)

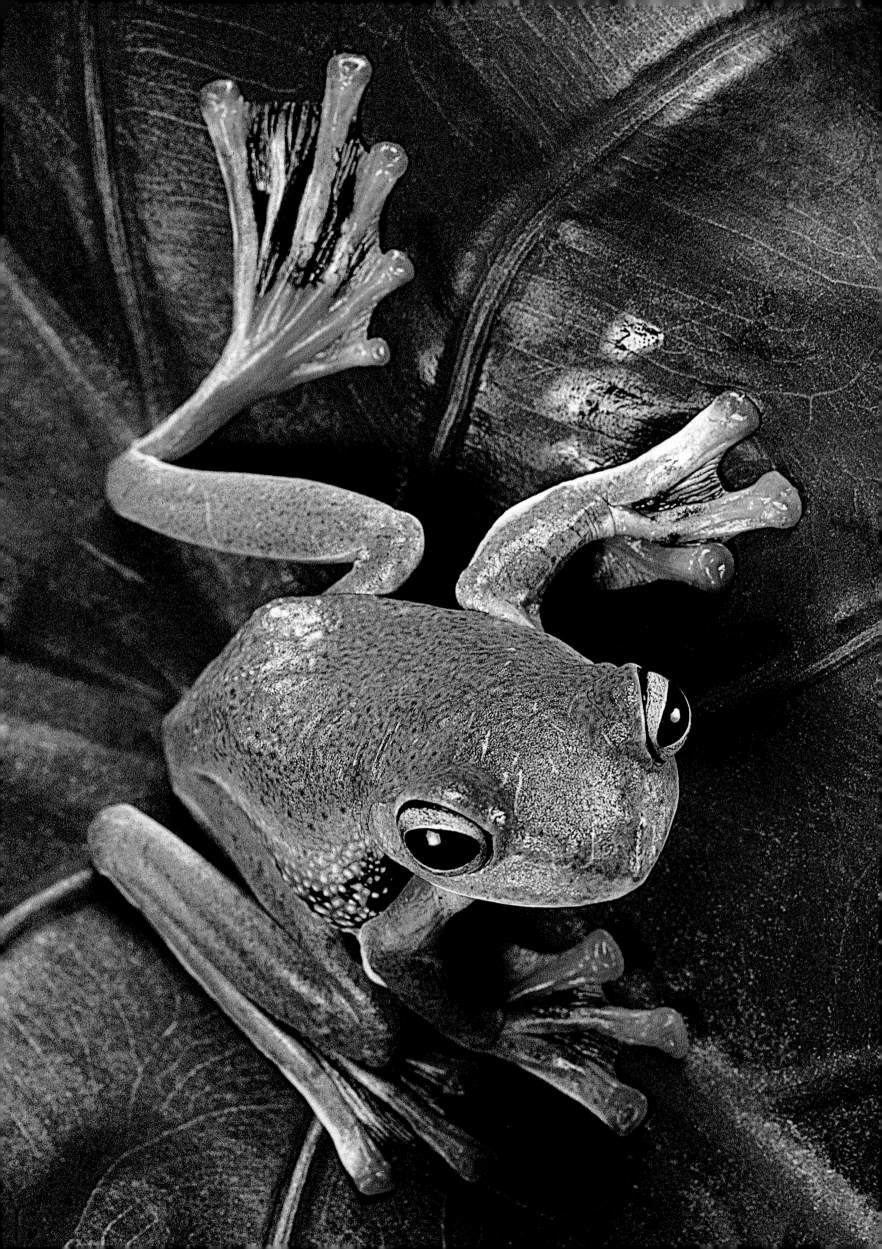

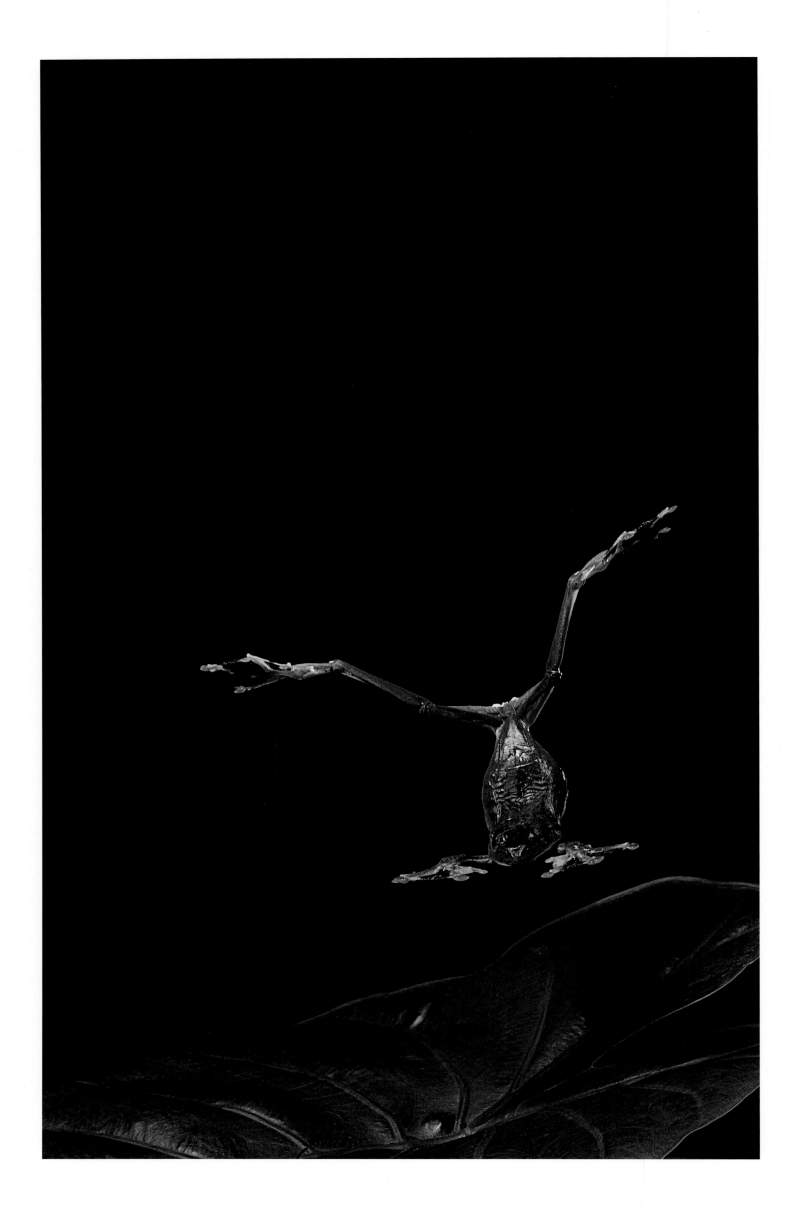

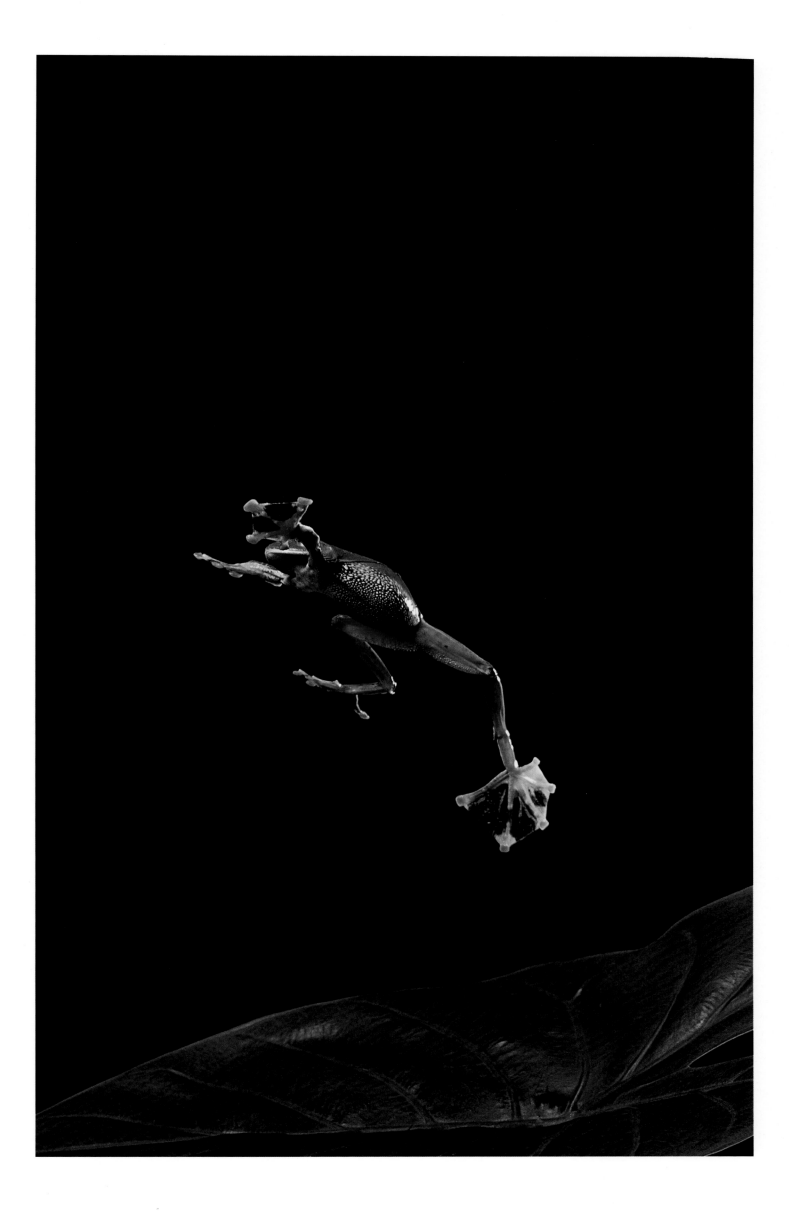

RHACOPHORUS PROMINANUS [▸]

The incredible shading of the skin, which is blurry and transparent, allows the animal to blend marvellously into its environment. This creature may appear fragile on the outside but come nightfall it becomes an extraordinary acrobat, mastering the art of climbing and gliding from tree to tree to perfection. It is so named because of its very prominent cloaca.

Distribution: Indonesia, Malaysia and Thailand
Average length: 4 to 5cm (1½ - 2in)

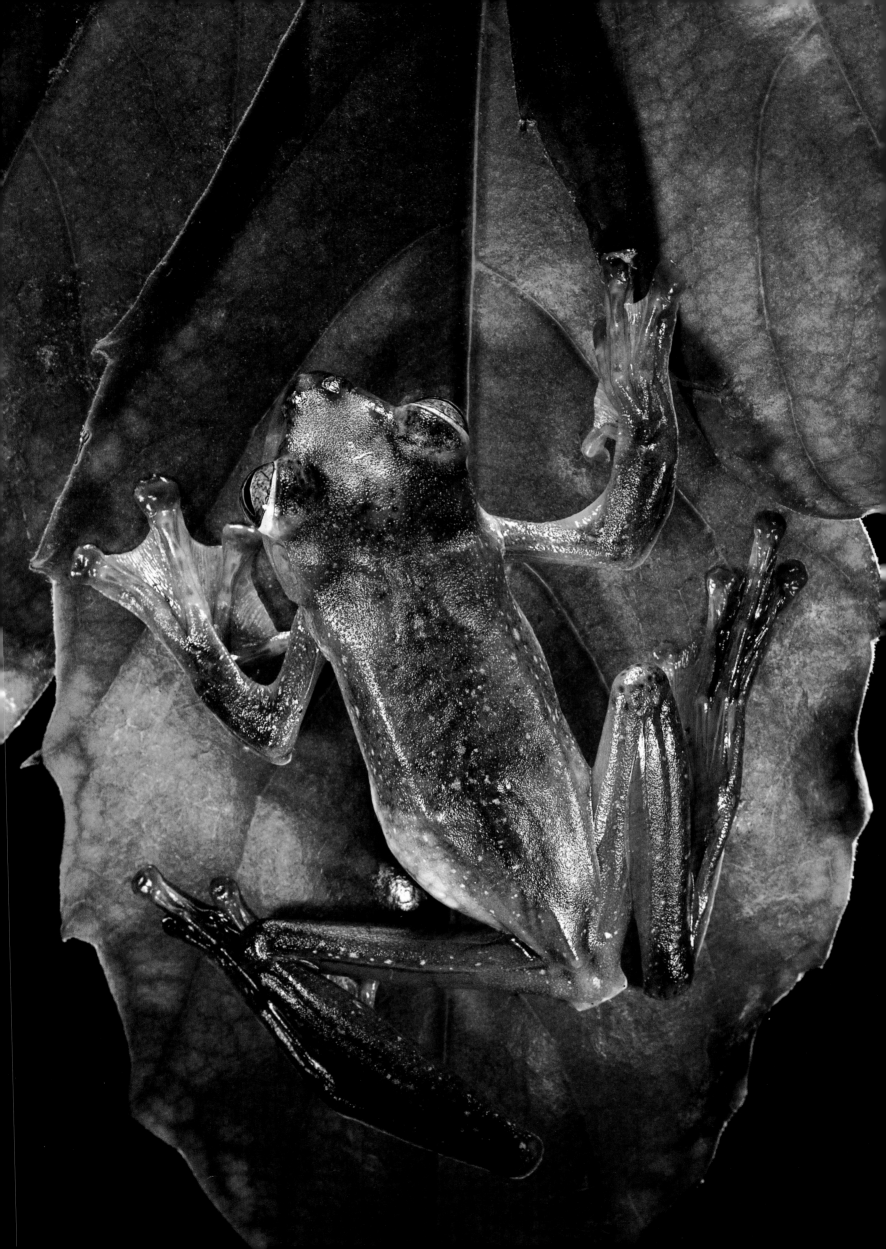

CHIROMANTIS RUFESCENS [▸]

Its disguising colouring comes in many shades
and it is remarkably well adapted to the tree
branches and trunks on which it rests during
the day. It lives in the forest and is excellently
suited to tree dwelling, showing off its
acrobatic talents exclusively at night. Like its
close cousin, *Chiromantis xerampelina*, it builds
large nests of foam in the foliage, always above
a pond or even a temporary pool or puddle
such as a large elephant print filled with
rainwater.

Distribution: western Africa, from Sierra Leone
to Uganda
Average length: 4.5 to 6cm (1¾ - 2⅜in)

THELODERMA CORTICALE [▸▸]

Its prominent moss and lichen coat is
testimony to the marvellous creativity of
nature when she is inspired. This atypical
colouring makes the frog practically invisible in
an environment of very rich vegetation. This
animal is secretive and spends its days
sheltered in water-filled cavities, mainly in tree
trunks and even in rock fissures in caves. This
species had not been observed for very many
years until it was rediscovered in 1995 in
primal high-altitude forests, still protected by
the difficult access.

Distribution: in the Tam-Dao region north of
Hanoi in Vietnam
Average length: 6 to 7cm (2⅜ - 2¾in)

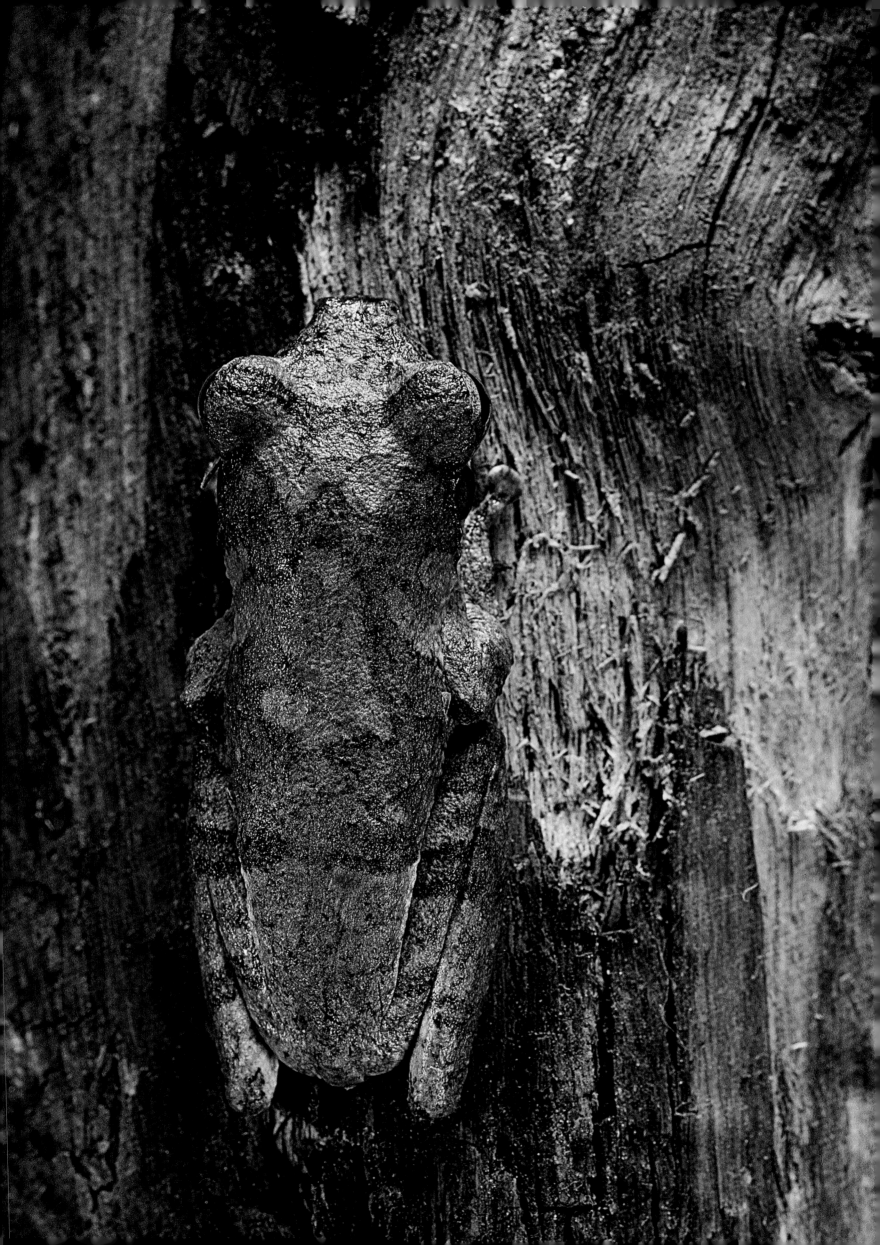

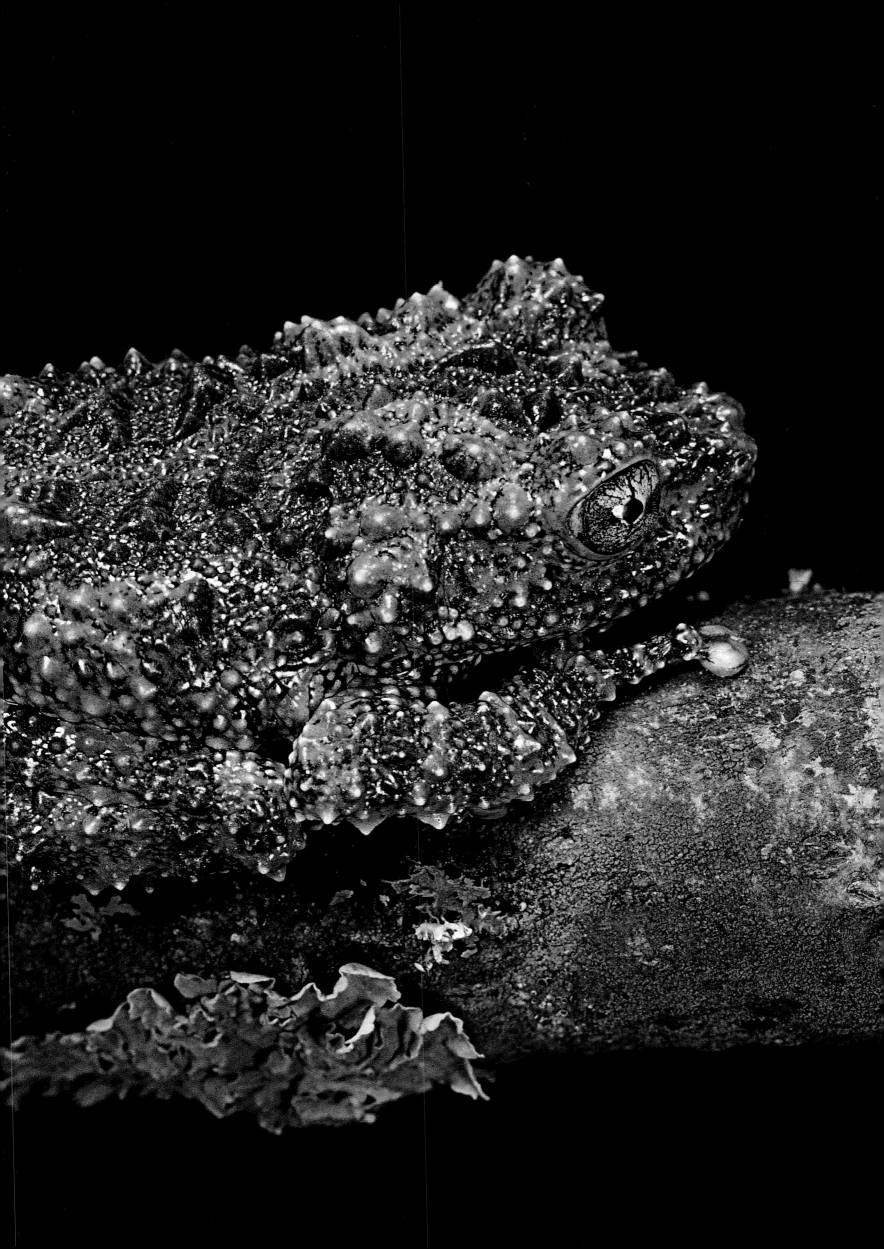

MANTELLIDAE

Present only on the main island of Madagascar, the recent classification of this family of 150 species is still in debate. It is currently made up of 5 genera including terrestrial, arboreal and semi-aquatic species. Mantellas, the most famous members of this family, are often compared to Dendrobates; in terms of their ecology, colouration, morphology and toxicity they have followed a remarkably similar evolutionary path to their New Mexican cousins. Like these, they show a considerable diversity of species with incredibly coloured attire. The little known genus Boophis, includes both arboreal and nocturnal species, of a generally good size. They are specialists in camouflage, with a great wealth of colours and patterns.

MANTELLIDAE

BOOPHIS MICROTYMPANUM [▸]

The designs on its beautiful coat seem almost as if they have been drawn on by hand and can only be admired in the low foliage of mountain forests. This species has been observed up to 2,200 metres (7,200ft) in altitude, living in clear-running streams and waterfalls where it lays its eggs. It always intermingles its eggs with twigs partly submerged by the whirling waters.

Distribution: centre east of Madagascar
Average length: 3 to 4cm (1⅛ - 1½in)

BOOPHIS MADAGASCARIENSIS [▸▸]

Curiously, this arboreal and nocturnal species does not camouflage itself in branches by day, but rather stays on the forest floor. This large brown tree frog has dermal flaps on its elbows and heels that break the visual lines specific to anurans and accentuate its mimicry of dead leaves. This singularity, along with its perfect immobility makes it practically invisible. When night falls it returns to the foliage where only its big eyes caught in the glow of torchlight can betray its presence.

Distribution: eastern part of Madagascar, from the north to the south
Average length: 6 to 8cm (2⅜ - 3⅛in)

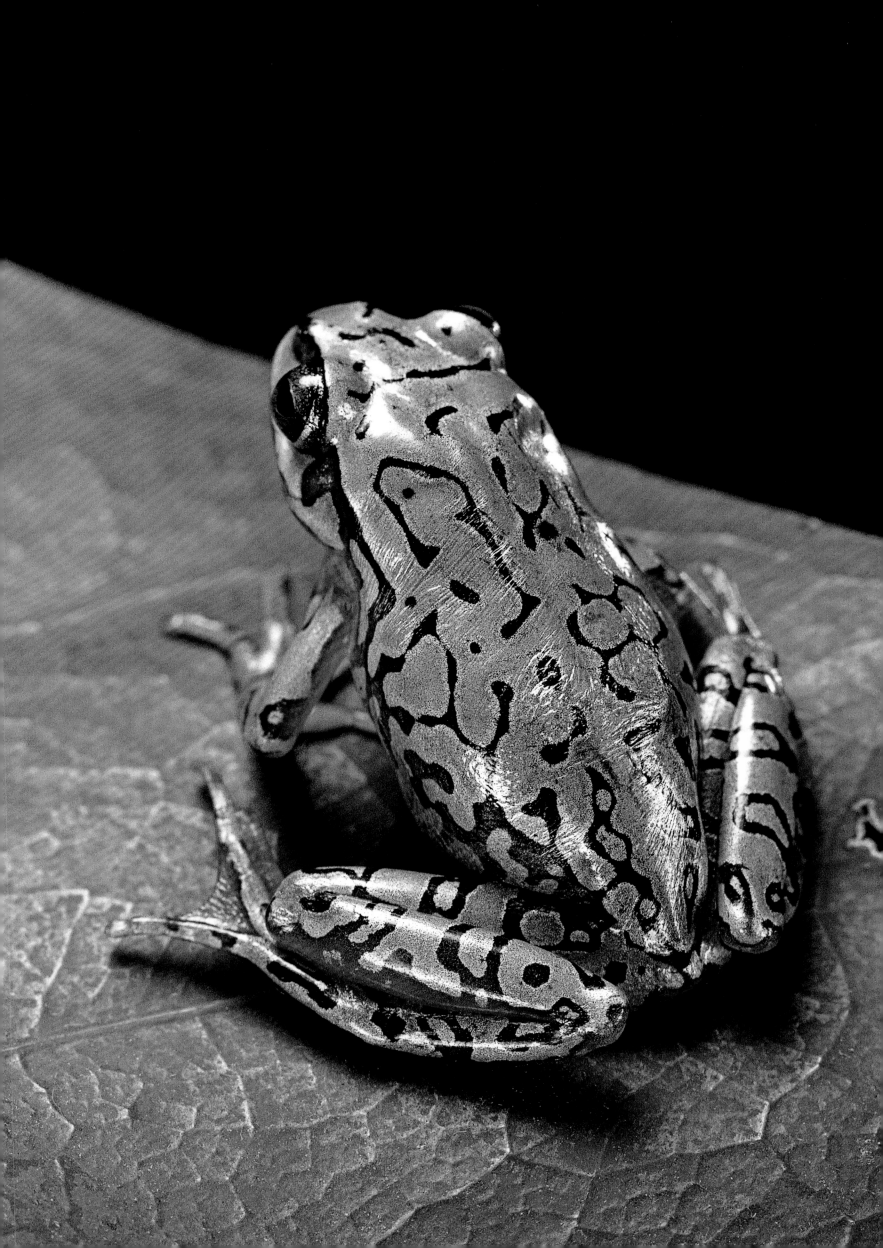

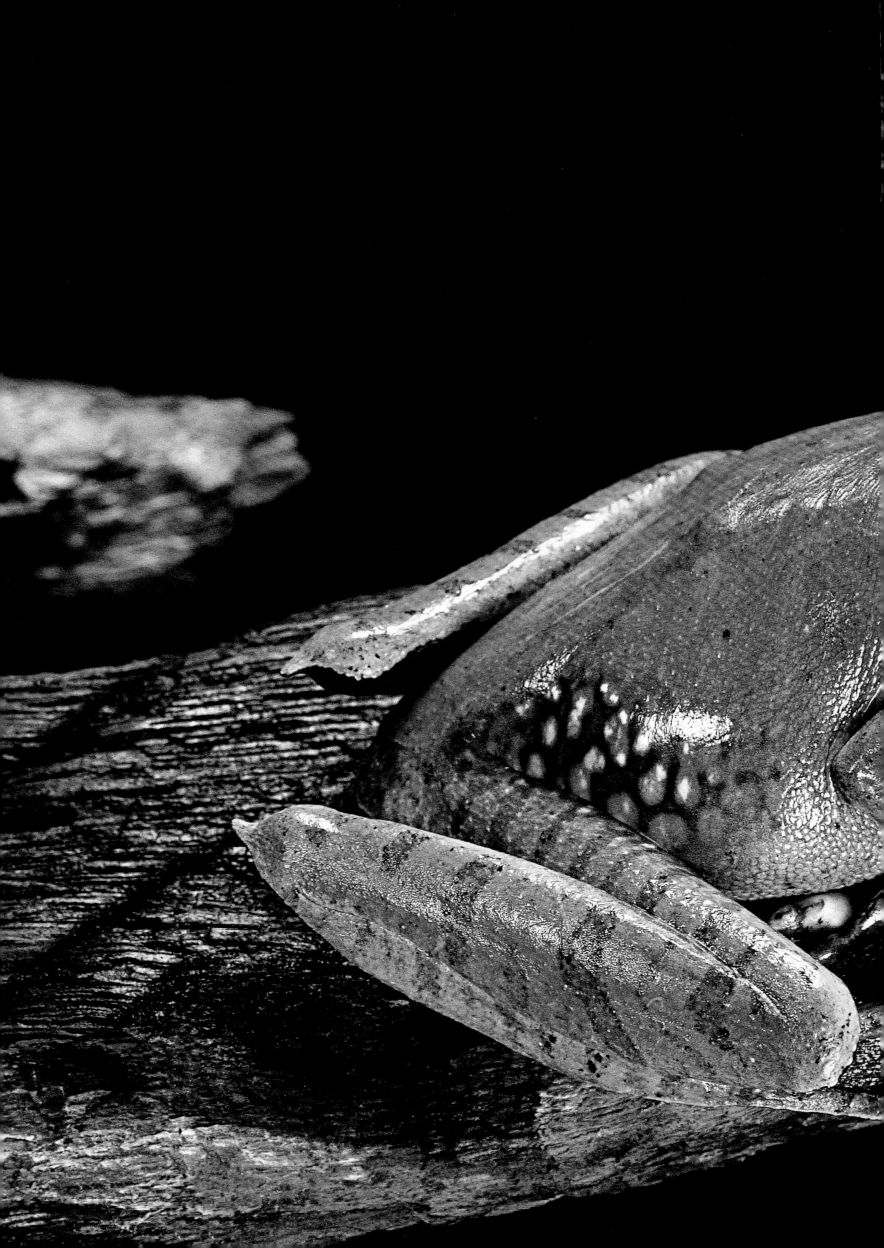

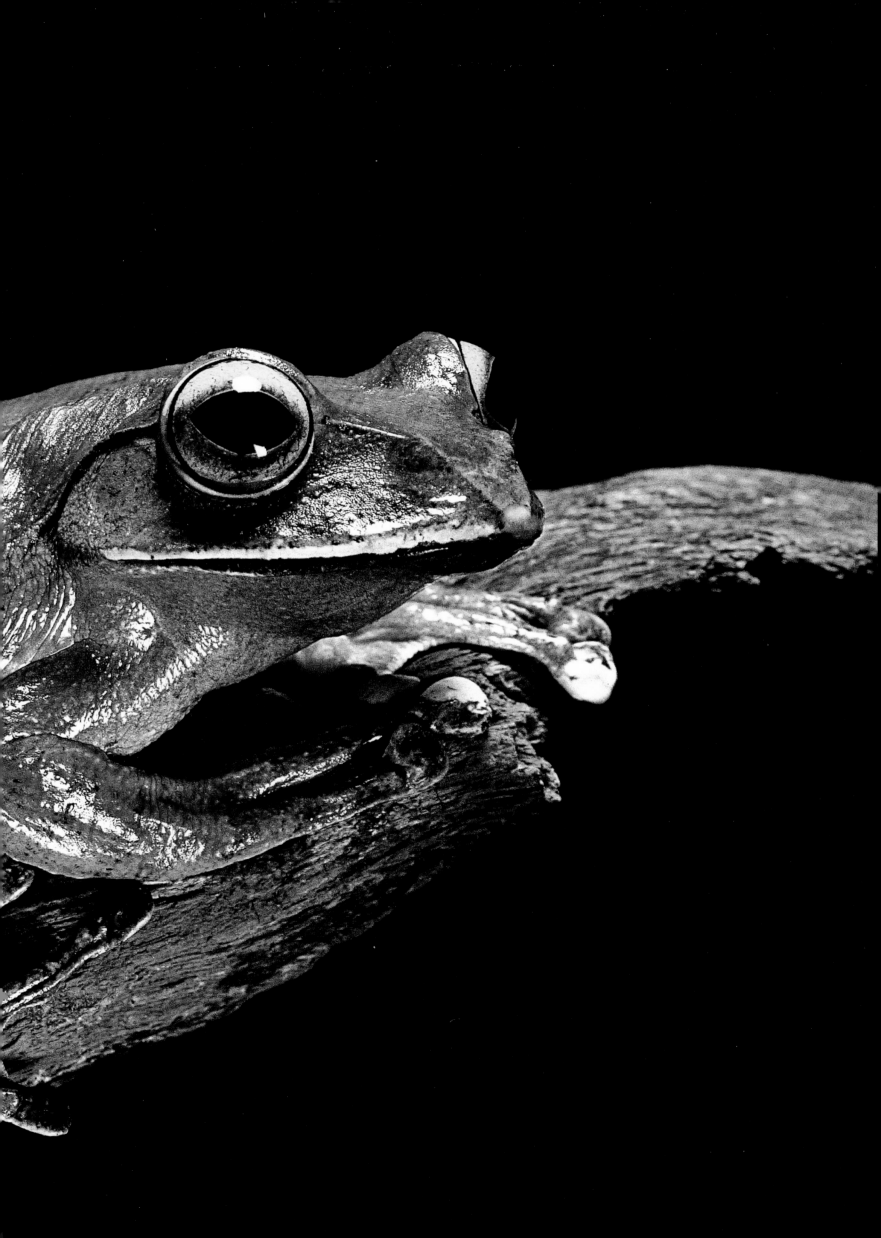

URODELANS

Considered as the most closely related animals to ancient terrestrial vertebrates, the urodelans (salamanders and newts) of today comprise over 550 species in 10 families. The largest of these are the *Plethodontidae* and the *Salamandridae*. They are found almost exclusively in the northern hemisphere: Europe, Northern and Central Asia, North Africa, North America and Mexico.

Urodelans generally have a cylindrical body, slightly flattened laterally, with four short legs. Their long tail, which they keep after metamorphosis (their name comes from the Greek *ouros* = 'tail' and *dêlos* = 'visible'), makes them look somewhat like a lizard without scales. Most species live in wet areas and come out only at night, when the air is cooler and less dry. Others share their time between water and land, or are exclusively aquatic. Their movements are slow, awkward and snake-like.

Their slowness renders them vulnerable. To compensate, urodelans employ several different means of protection, including a defensive posture known as the 'Unken reflex', where the head and tail are raised to reveal the brightly-coloured underside. Like anurans, the skin of urodelans contains numerous toxic glands, located principally behind the eyes, on the tail and the sides of the back; their bright colouring serves as a warning to inform predators of their toxicity. The Iberian Ribbed Newt (*Pleurodeles waltl*) has an additional secret weapon: long sharp ribs. When the animal is threatened, its ribs puncture through the skin, covered in venom, and are capable of disabling a predator.

Urodelans are fascinating for the diversity of their forms and colours, and the wealth of environments in which they flourish. Many have unusual qualities, such as the impressive *Andrias japonicus*, a giant salamander from Japan, that can measure up to one-and-a-half metres long and live up to fifty years, or the Axolotl, an aquatic salamander adorned with incredible red feathery gills.

They are less known to the general public than anurans and are often the forgotten amphibians. Yet these creatures from another time come in the most extraordinary varieties and are well worth further exploration.

Triturus marmoratus (Marbled newt)
Distribution: western and southern France, Iberian Peninsula
Average length: male - 11 to 14cm (4⅜ - 5½in), female - 13 to 16cm (5⅛ - 6¼in)

AMBYSTOMATIDAE

This family comprises about 30 species in a single genus and can be found from the south of Canada down to Mexico, including the United States. They are very similar to European salamanders, generally large and robust with a large head and smooth skin. They are principally burrowers and invade rodent burrows, where they remain hidden for most of the time, venturing out only at night or on rainy days to feed. In the spring breeding period they migrate in swarms to water spots. Females can lay up to 200 eggs. Some species of this family have a tendency to exhibit neoteny (the adult form retains features from the larva), like the famous Axolotl (*Ambystoma mexicanum*), which keeps its larval external gills.

AMBYSTOMA MEXICANUM [▸]

(AXOLOTL)

ALBINO FORM

This salamander demonstrates a typical example of neoteny, a larval stage form of maturity. Although it is rare to come across an axolotl in its natural habitat, it is commonly bred in captivity by amphibian breeders and in laboratories, where it is used for research experiments. The parameters enabling its transformation to a terrestrial salamander, 'Ambystoma', or an aquatic one, 'Axolotl' have in fact been mastered for a long time. An increase in iodine levels in the water stimulates the thyroid gland and sets off the metamorphosis in to a terrestrial salamander.

Distribution: Lake Xochimilco, in Mexico
Average length: 20cm (8in)

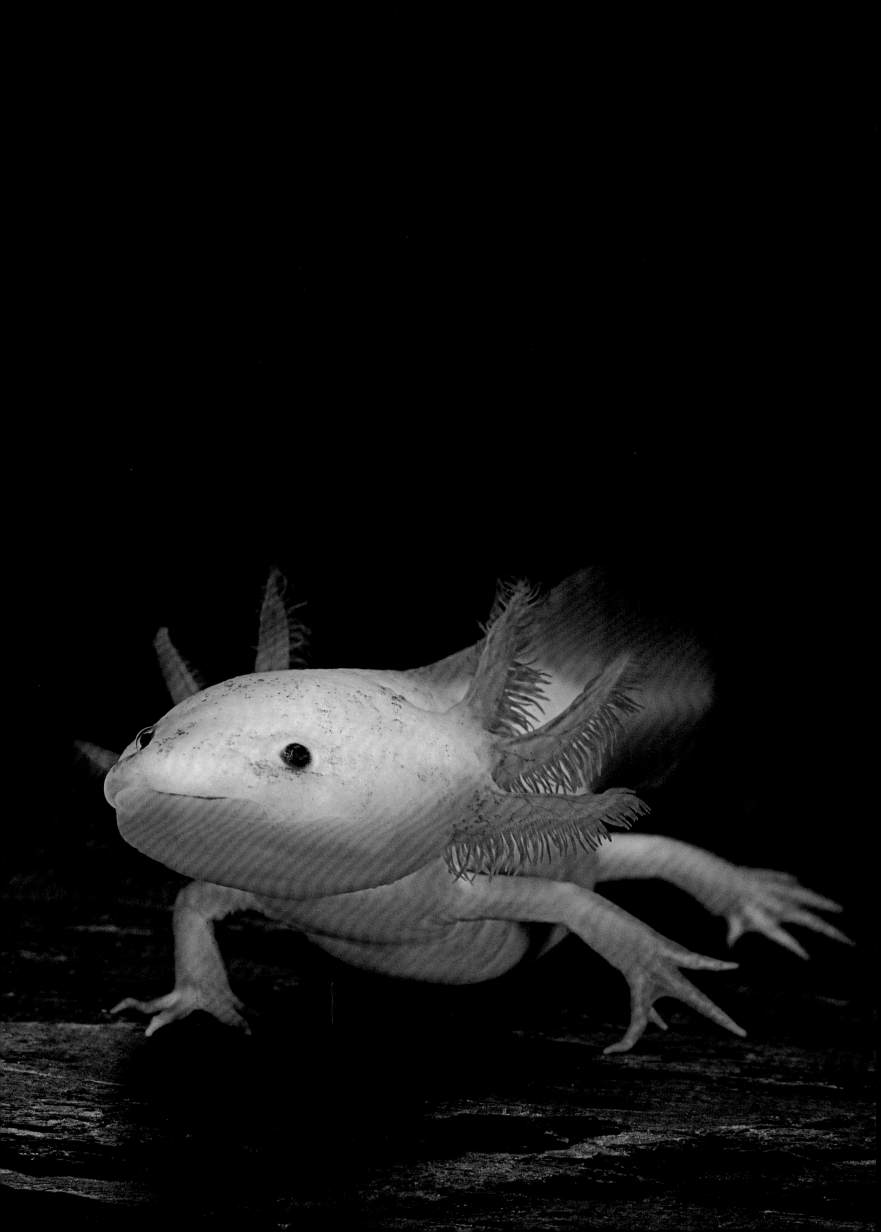

AMBYSTOMA TIGRINUM TIGRINUM [▸]

The largest of terrestrial salamanders has a wide geographical range and has therefore settled in all sorts of environments: mountain forests, arid plains or wet meadows. It spends the greatest part of the day sheltering under plant debris or in an abandoned burrow. The large smile seemingly etched on its face hides its ferocious appetite for all sorts of prey, including insects, slugs, snails and even micromammals.

Distribution: North America, from Canada to Mexico

Average length: 18 to 25cm (7 - 10in)

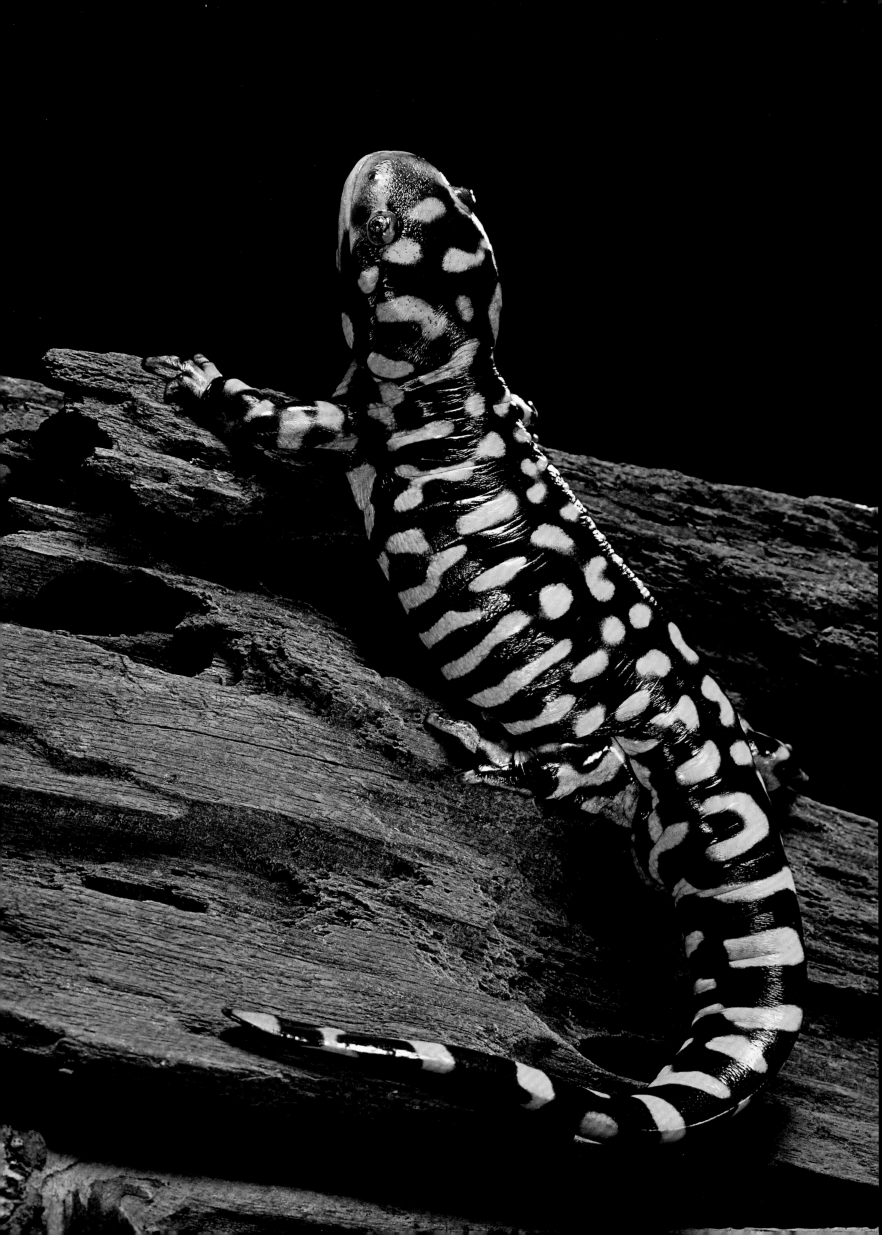

PLETHODONTIDAE

Over 370 species and 27 genera make up this family. They lack lungs and breathe through the skin or mouth. However, they are hardly disadvantaged by this singularity and form one of the most prolific amphibian groups in terms of numbers and are the largest family of urodelans. They are elusive, secretive animals and proliferate in the north east of the United States, where their biomass is superior to that of birds and even mammals! Their respiratory system constrains them to stay constantly moist and they live in or near flowing water or in boggy forests. A few species have the ability to lose their tail voluntarily to escape predators. Others are equipped with a protractile tongue, which they flick out at prey to catch them. Plethodontidae are found from North to South America and some species live in Europe, in the western Mediterranean.

PLETHODON GLUTINOSUS [▶]
(SLIMY SALAMANDER)
This salamander owes its name to the venomous and sticky substance secreted by its skin. When threatened, it secretes a poison that sticks like glue. Many an anuran predator has succumbed to this poisonous meal. It appreciates the tranquillity of the moist underbrush, hidden in the humus, moss or in the crevices of a rock face. The eggs are laid on the ground and the young are born in their adult forms.

Distribution: east coast of the United States
Average length: 15 to 18cm (6 - 7in)

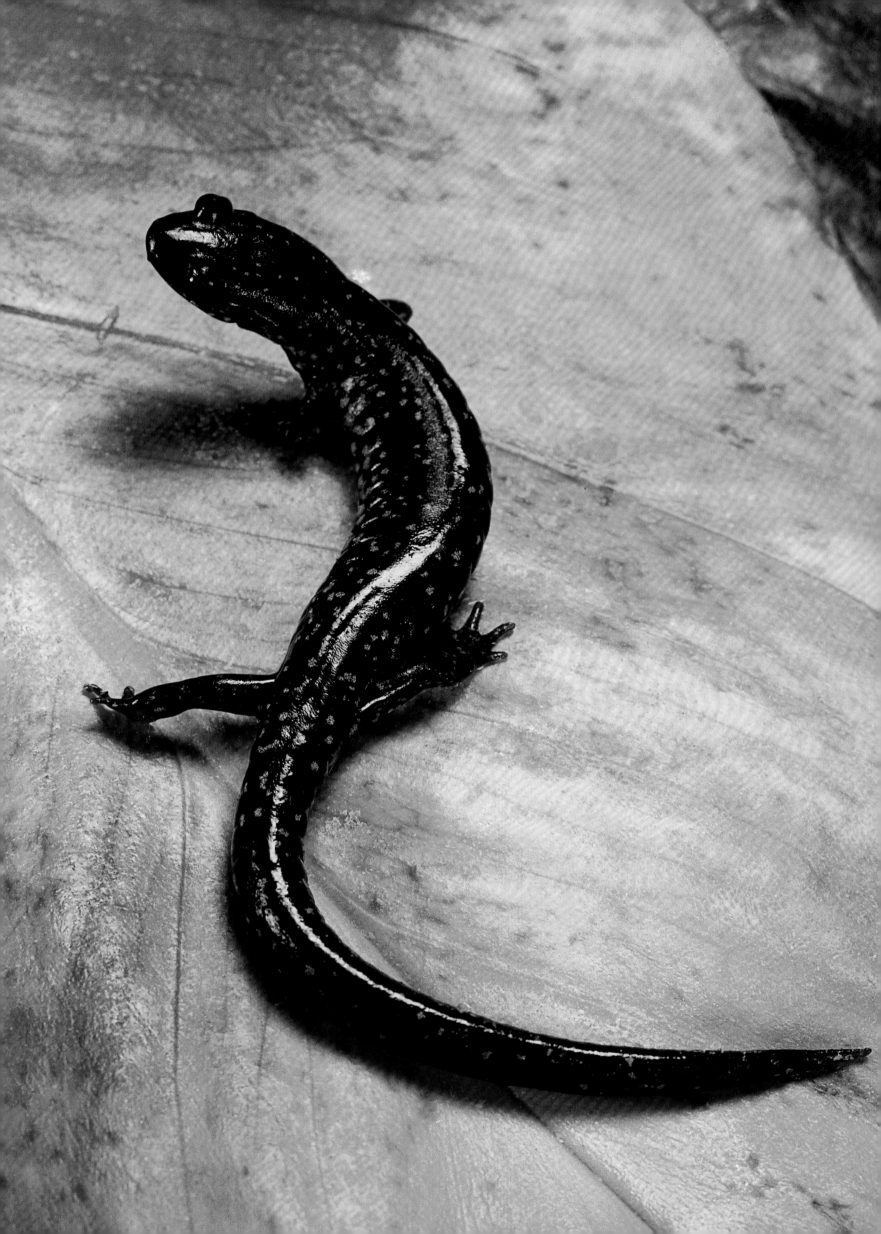

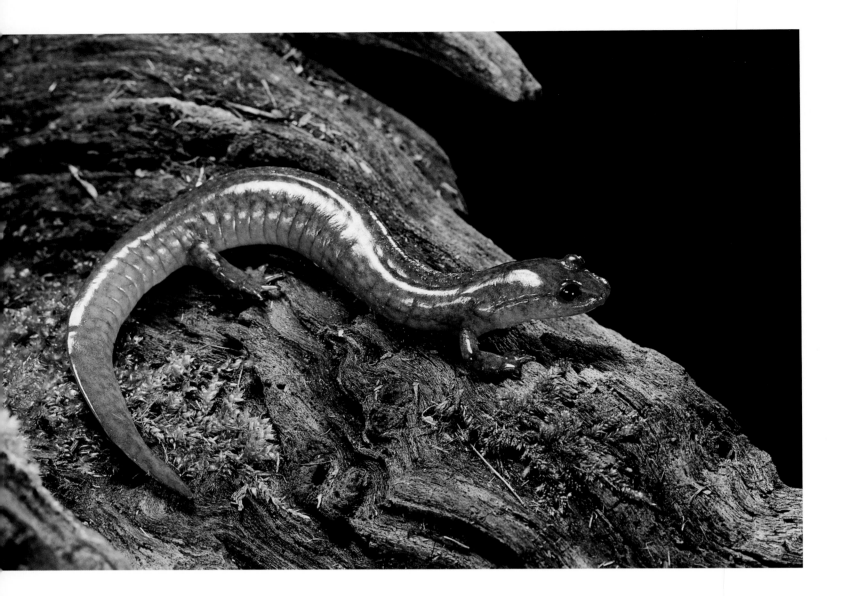

GYRINOPHILUS PORPHYRITICUS [▲]

This large salamander is renowned for its cannibalism but also preys on other urodelan species. It is mainly aquatic, living in the clear, moderate-flowing icy waters of mountain brooks and streams. Its cylindrical body has a long tail that is compressed laterally and acts as a fin to enable it to move about freely on the rocky bottom in search of food. It occasionally leaves the water to venture out into the forest.

Distribution: United States, Canada
Average length: 20cm (8in)

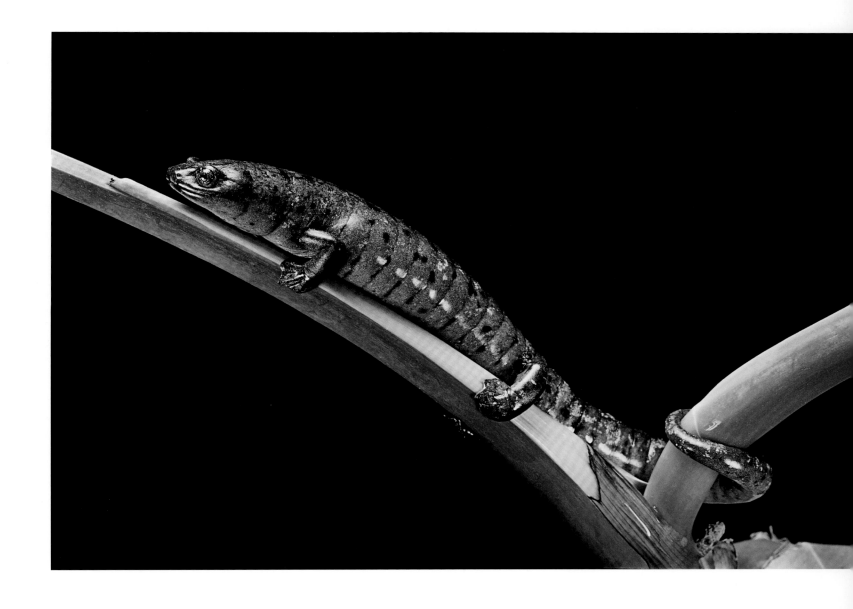

BOLITOGLOSSA DOFLEINI [▲]

This astonishing salamander has adapted
remarkably well to an arboreal life in the high
canopy of tropical rainforests. Most of its year
is spent in this biotope, where mossy trunks,
epiphyte plants, lichens, mosses and fungi
make up a rich, luxuriant suspended garden.
Its robust, prehensile tail allows it to grip on
to thin branches, and it uses its large hands
and feet with adhesive cushion pads to move
about like a tightrope artist. During the dry
season, it abandons its territory for solid
ground, in search of moist areas: mossy soils
or low vegetation on the edges of ponds. It
has a timid temperament but is all the while a
fearsome hunter and uses its projectile
tongue like a whip, catapulting its prey at
lightning speed.

Distribution: Guatemala, Belize, Honduras
Average length: males - 8cm (3⅛in),
females -15cm (6in)

SALAMANDRIDAE

Salamanders and newts are unquestionably the best-known urodelans. Spread across Europe, North Africa, Eurasia and North America, they are the second largest family of urodelans with around 70 species in 20 genera. They include terrestrial, aquatic, mixed and neotenic species. Their internal fertilisation reproductive pattern is also very diverse: oviparous (producing eggs that hatch outside the female), ovoviviparous (producing eggs that hatch inside the female) and even, in a few rare cases, viviparous (producing embryos that develop inside the female). During the breeding period, some of them return to aquatic forms and develop a dorsal keel. Juveniles and adults have lungs. Their skin is rough and, in some of them, rich in toxic secretions. In European terrestrial salamanders the venom is concentrated in protruding glands located behind the eyes.

NEURERGUS KAISERI [▸]

This Middle-Eastern newt is a true gem. Its splendid colouring is amazingly bright and showy for a rather secretive animal. It inhabits a very restricted range, in a mid-altitude mountain area, including rather arid forests and prairies, in a semi-desert zone. During the breeding period it lays its eggs in temporary ponds, unlike the other three species in its genus, which prefer mountain streams. These newts are critically endangered, the damage caused to, and pollution of, their water spots has led to an alarming decline in their population.

Distribution: Zagros Mountains in Iran
Average length: 10cm (4in)

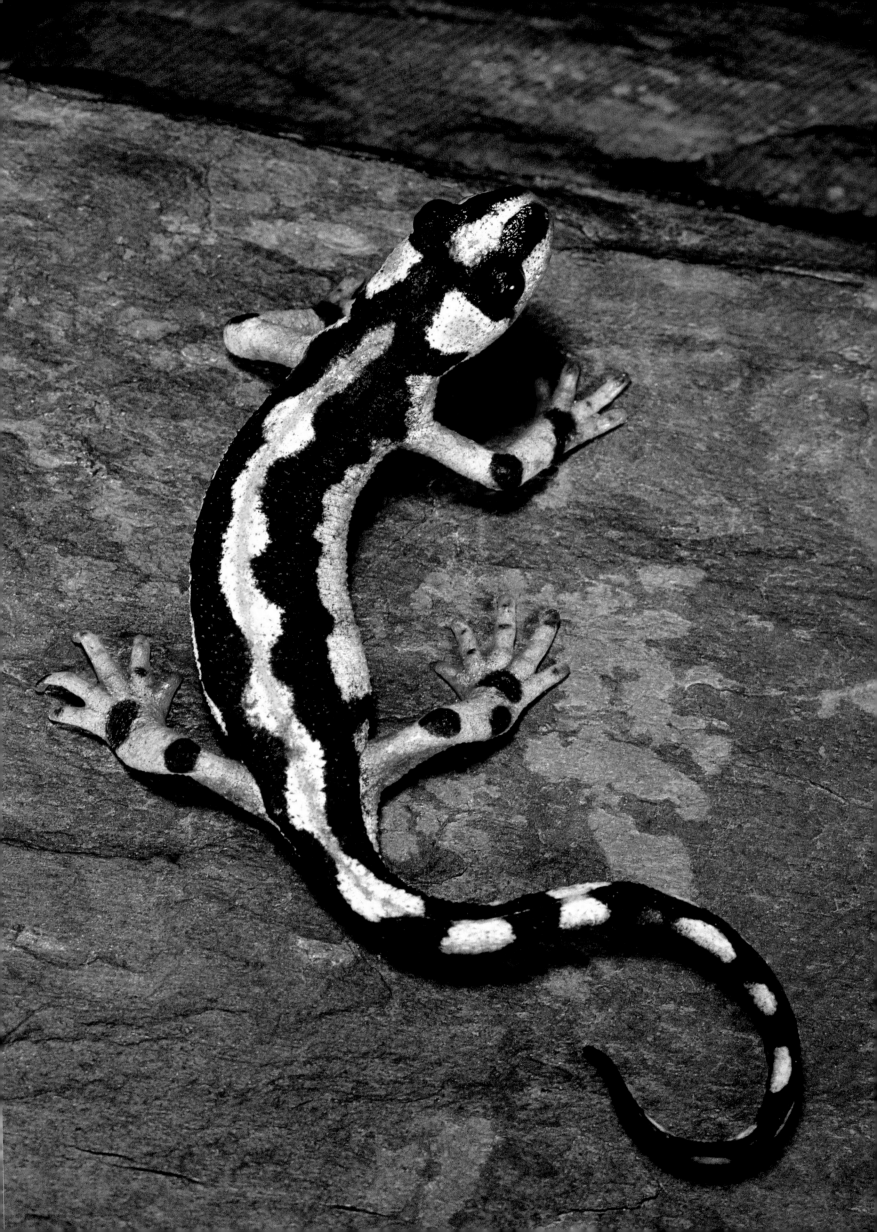

PACHYTRITON BREVICEPS [▸]

This sublime aquatic newt is often confused
with other very similar species. It is principally
found in mountain streams and rivers. It is
mainly nocturnal and hides during the day in
aquatic vegetation or at the bottom of the
water in rocks or stone crevices. Its superb
red and orange ventral markings are a warning
to any animal attempting to add it to its menu.
Males are known to have a highly-developed
territorial instinct and they are extremely
aggressive towards each other.

Distribution: China
Average length: 15 to 18cm (6 - 7in)

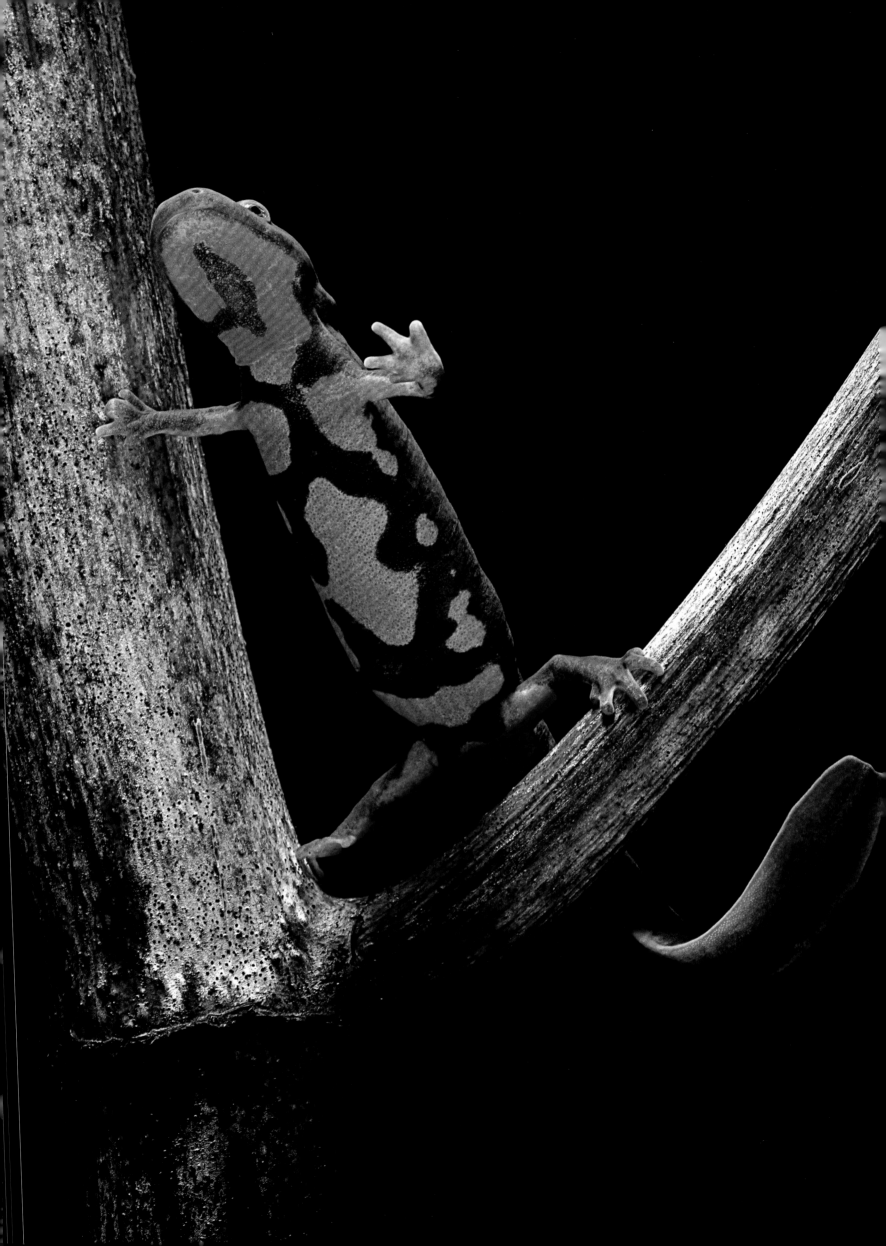

SALAMANDRA SALAMANDRA TERRESTRIS [▸ | ▸▸]
(EUROPEAN FIRE SALAMANDER)
In the Middle Ages this animal was regarded
as a symbol of indestructibility and it was
believed that it could live in flames. The
paintings and tapestries of the time often
depict it in the middle of a blazing house. This
salamander likes to live in the heart of cool
and moist forests, on the edges of clear rivers,
where it camouflages itself under mossy bark
or lush ferns. When night falls, it sets out on its
hunt: worms, slugs and small beetles are its
favourite prey. Its magnificent red, black and
yellow coat is a highly effective weapon of
dissuasion: the glands situated behind the eyes
and on two rows of either side of its mid-
dorsal line secrete a powerful venom.
However, handling it is harmless for humans,
although it is recommended to wash your
hands thoroughly after touching one.

Distribution: central and southern Europe
Average length: 20 to 28cm (8 - 11in)

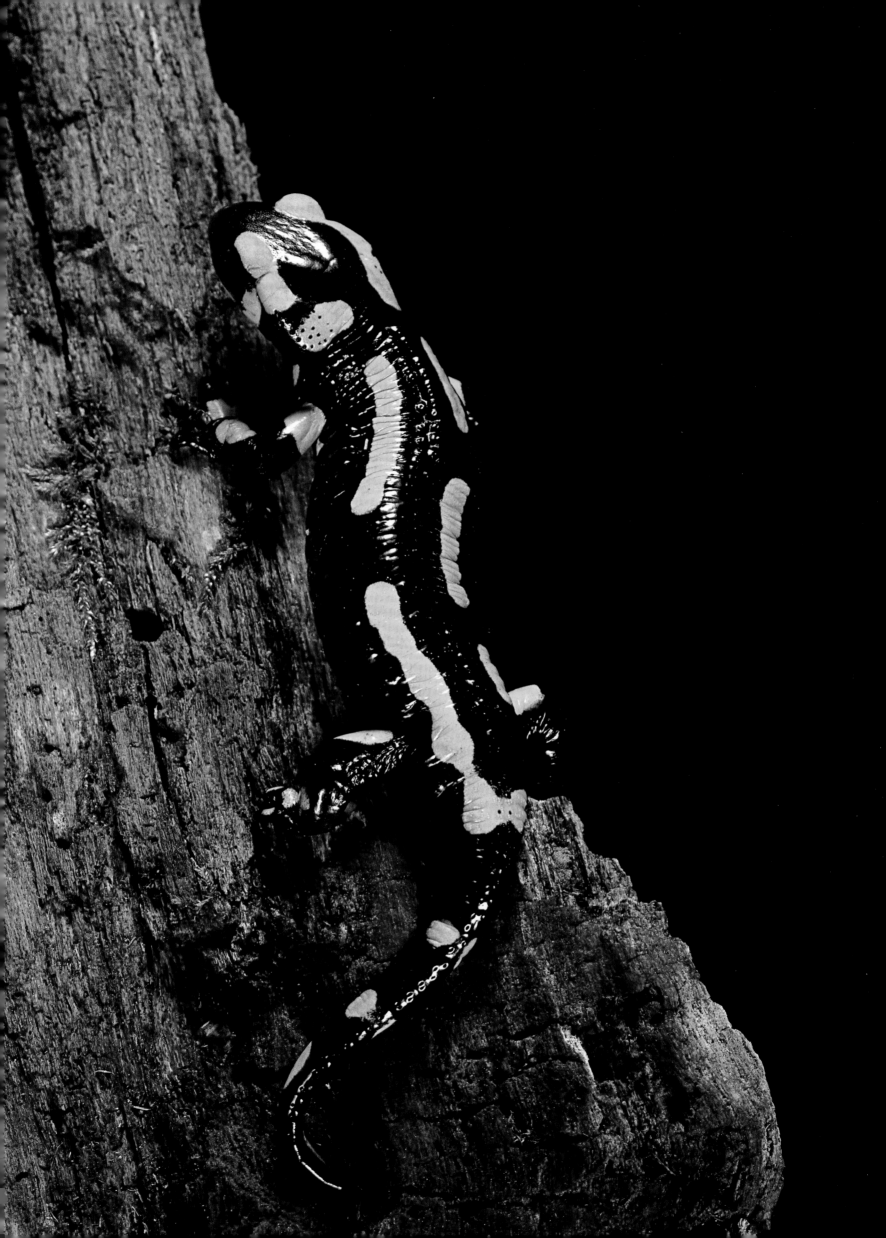

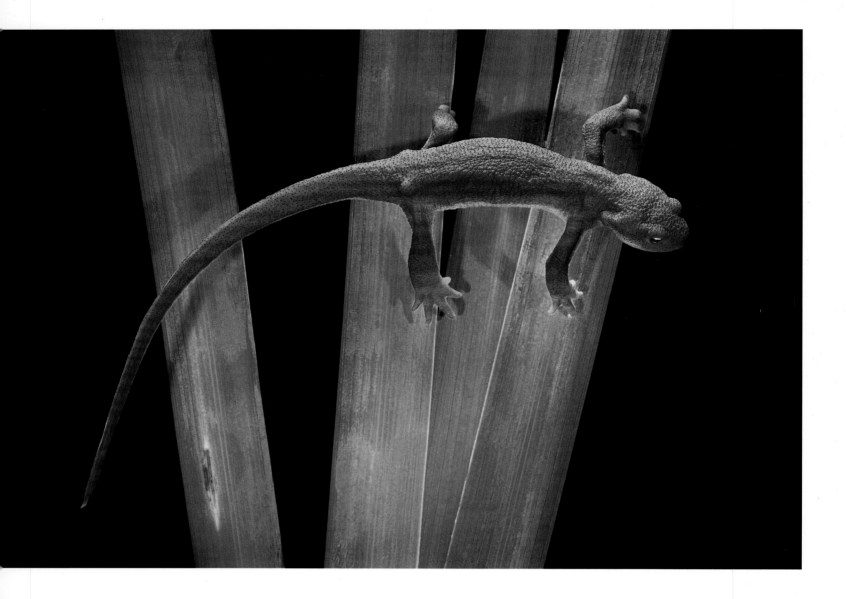

TARICHA GRANULOSA [▲]

This is by far the most toxic newt in North America. Its neurotoxins are devastating to most vertebrates. If ingested it may be fatal to humans. When it is threatened, it adopts a defensive posture known as the 'unken reflex': it braces itself, arches its back and turns up its tail above its head to form an arch exposing the distinctive bright orange colour of its belly. A few rare predators such as the Ribbon Snake, for example, have specialised in hunting this animal by developing resistance to its poison.

Distribution: all of the west coast of the United States, from southern Alaska to California
Average length: 12 to 22cm (4¾ - 8½in)

TRITURUS MARMORATUS [▶]
(MARBLED NEWT)
Undoubtedly one of the most beautiful newts in Europe. In its terrestrial phase, it exhibits a brilliant green display divided in two by an elegant red-orange dorsal line. During mating, which takes place in water, males develop a large dorsal crest making them look rather like a magnificent submarine. When the breeding season is over, it gradually loses its courtship attire and diurnal lifestyle to return to terrestrial and nocturnal life.

Distribution: western and southern France, Iberian Peninsula
Average length: male - 11 to 14cm (4⅜ - 5½in), female - 13 to 16cm (5⅛ - 6¼in)

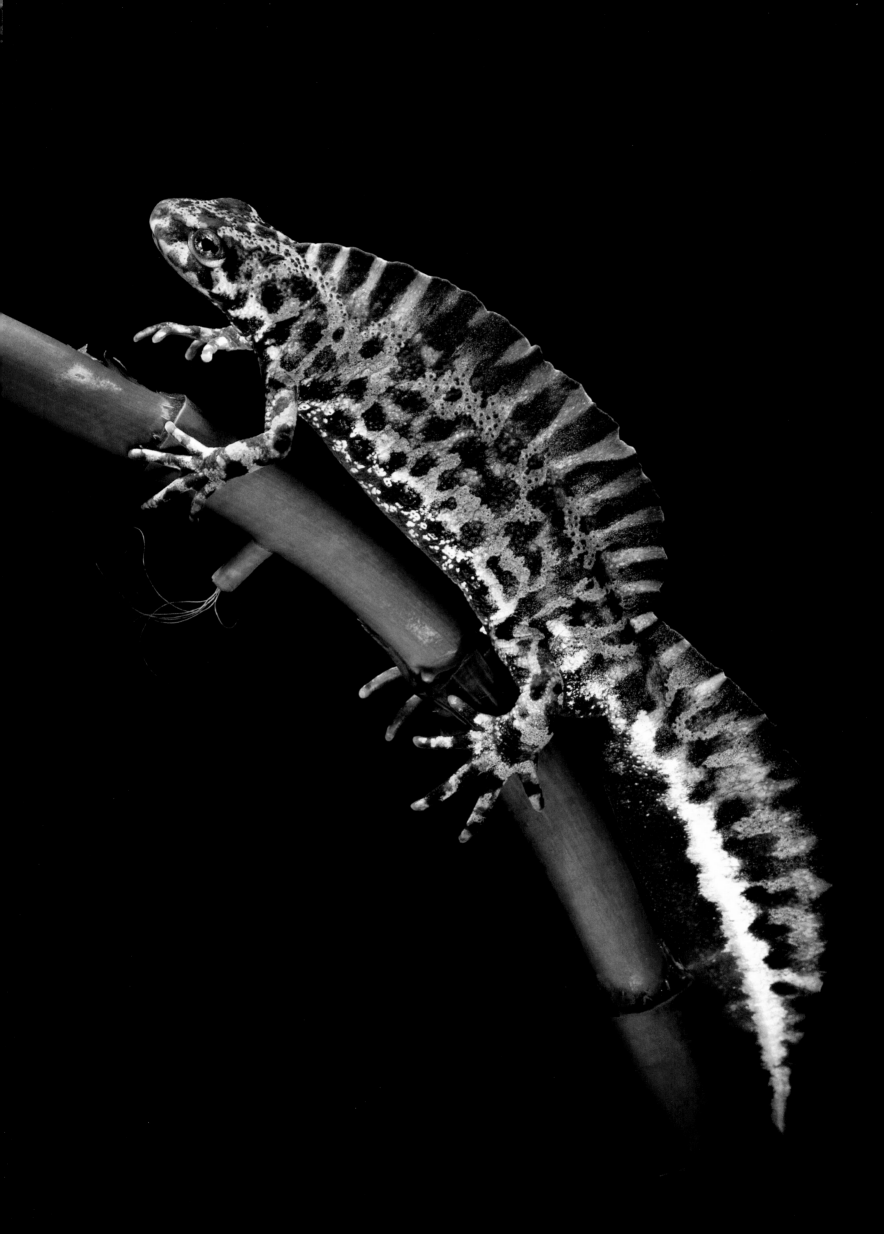

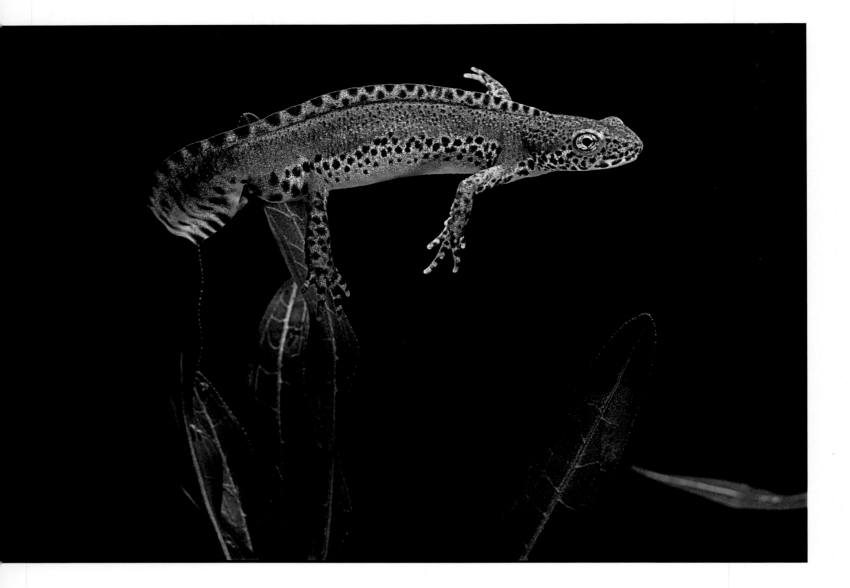

TRITURUS ALPESTRIS [▲]

(ALPINE NEWT)

Despite its name, it can be found in plains where it colonises a great variety of habitats: lakes, ponds, stagnant pools of water and streams. This magnificent animal is still restricted to aquatic environments up to 3,000 metres in altitude. During the breeding period, the attire of the male passes for one of the finest among European newts.

Distribution: almost all of Europe
Average length: 10cm (4in)

TRITURUS VITTATUS [▶]

During the breeding period, there is rivalry between males (chases, fights, various intimidation tactics) to claim their spot. They assert themselves as suitors through undulations of the tail, engaging in a courtship display to win over their mate. Eggs are not laid until after a few months and hatching occurs about twenty days later.

Distribution: Asia Minor, Syria, Lebanon, and Israel
Average length: 8 to 13cm (3⅛ - 5⅛in)

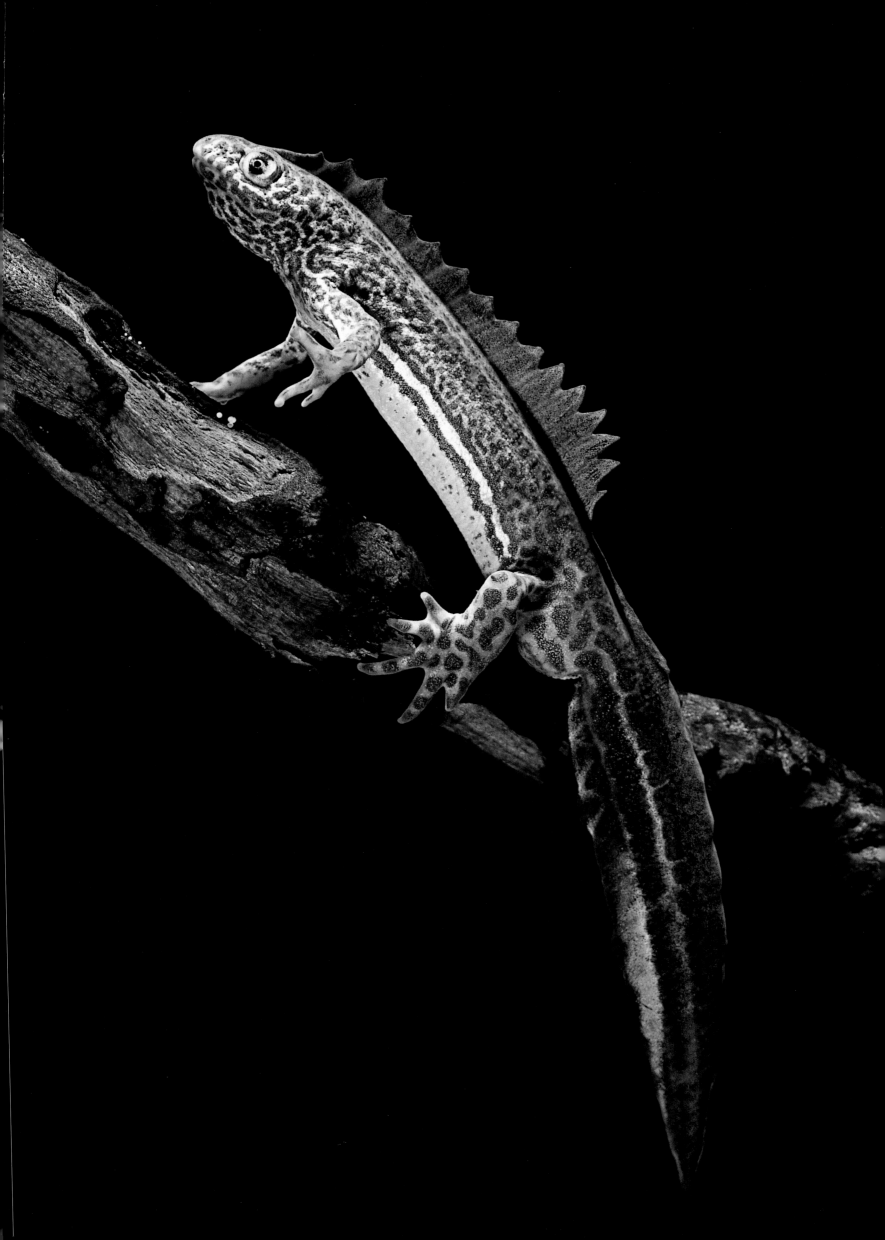

TYLOTOTRITON TAILANGENSIS [▲]

With its beautiful ink black exterior, bright orange coloured fingertips and prominent parotid glands, this animal can be recognised at first glance. Unfortunately, its amazing beauty is difficult to admire, as it lives in mountainous regions of 2,000 to 3,000 metres (approx. 6,600 - 9,800ft) in altitude. This newt is secretive and terrestrial, living on the edges of ponds, rice fields and streams where it breeds. Although now rare in the wild, it is still used in traditional Chinese medicine.

Distribution: China
Average length: 15 to 20cm (6 - 8in)

CYNOPS PYRRHOGASTER [▶]

Its beautiful coat and adaptation to life in captivity have made this semi-aquatic newt a popular animal among breeders of amphibians and specialised pet stores. Along with its Chinese cousin, *Cynops orientalis*, it is the most commonly bred newt in the world. Its fiery red belly, which makes it so attractive, warns predators of its toxicity, providing it with a degree of protection in its natural habitat. It inhabits clear or stagnant temporary pools, ponds and ditches on the side of the road. Males are difficult to differentiate from females except during the mating period when they can be distinguished by the small filament prolonging the tail.

Distribution: Japan
Average length: 10 to 17cm (4 - 6¾in)

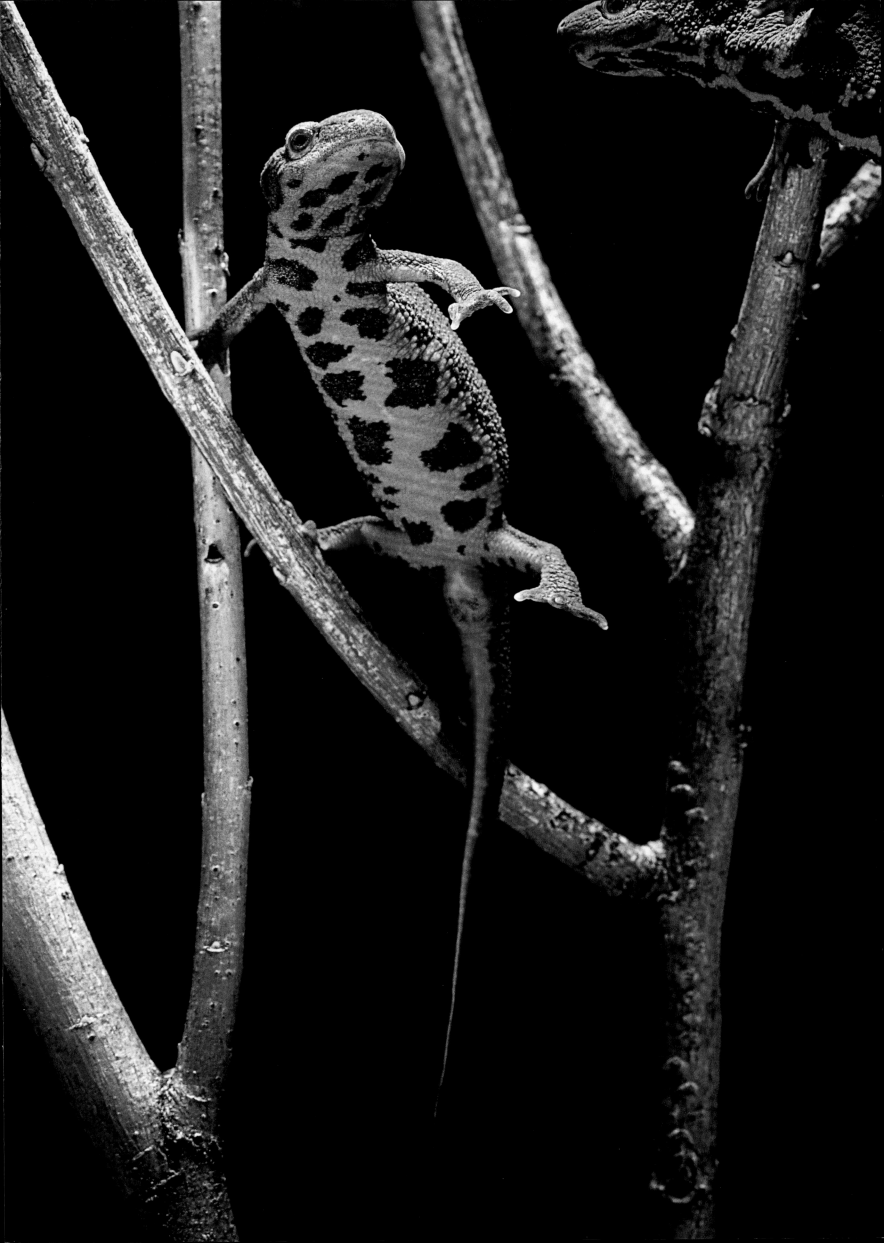

HYNOBIIDAE

These primitive looking urodelans have a distinctive feature: they are the only ones with external fertilisation.

This family includes small to medium sized terrestrial and aquatic salamanders. There are about forty species in 9 genera and all are unique to Asia, with the exception of the Siberian Salamander (*Salamandrella keyserlingi*). *Pachyhynobius shangchengensis* is extremely rare and inhabits a very small region in China near the town of Shancheng, hence its name. Its habitat is principally aquatic and like the majority of members in this family is a formidable predator, preying as much on other urodelans as anurans and their larvae. Mating occurs in the water. The female lays capsules containing between 30 and 70 eggs each, which are then fertilised by the male.

PROTEIDAE

This tiny family has only two genera and six species. These aquatic salamanders have an eel-shaped body with four limbs to walk about underwater on the riverbed, a long truncated head, a powerful caudal fin and three large pairs of bright red gills. These secretive, robust neotenic animals frequent flowing waters rich in aquatic plants, from the south of Canada to the Gulf of Mexico. In the United States they are known as 'Waterdogs' or 'Mudpuppies', as they are erroneously believed to make barking sounds. In fact, they are only able to emit brief high-pitched sounds. The only European species in this family is *Proteus anguinus* or olm. It is a rare and strange animal, devoid of pigmentation due to the absence of light, and lacking in eyes because of its cave-dwelling lifestyle. It has a white, translucent appearance with red feathery gills, moving around underground rivers, staying alert for the slightest movement that betrays the presence of the small invertebrates on which it feeds.

PACHYHYNOBIUS SHANGCHENGENSIS [▸]

Distribution: China
Average length: 16 to 20cm (6¼ - 8in)

NECTURUS MACULOSUS [▸▸]

Distribution: south of Canada, central and eastern United States to Louisiana
Average length: 25 to 48cm (10 - 19in)

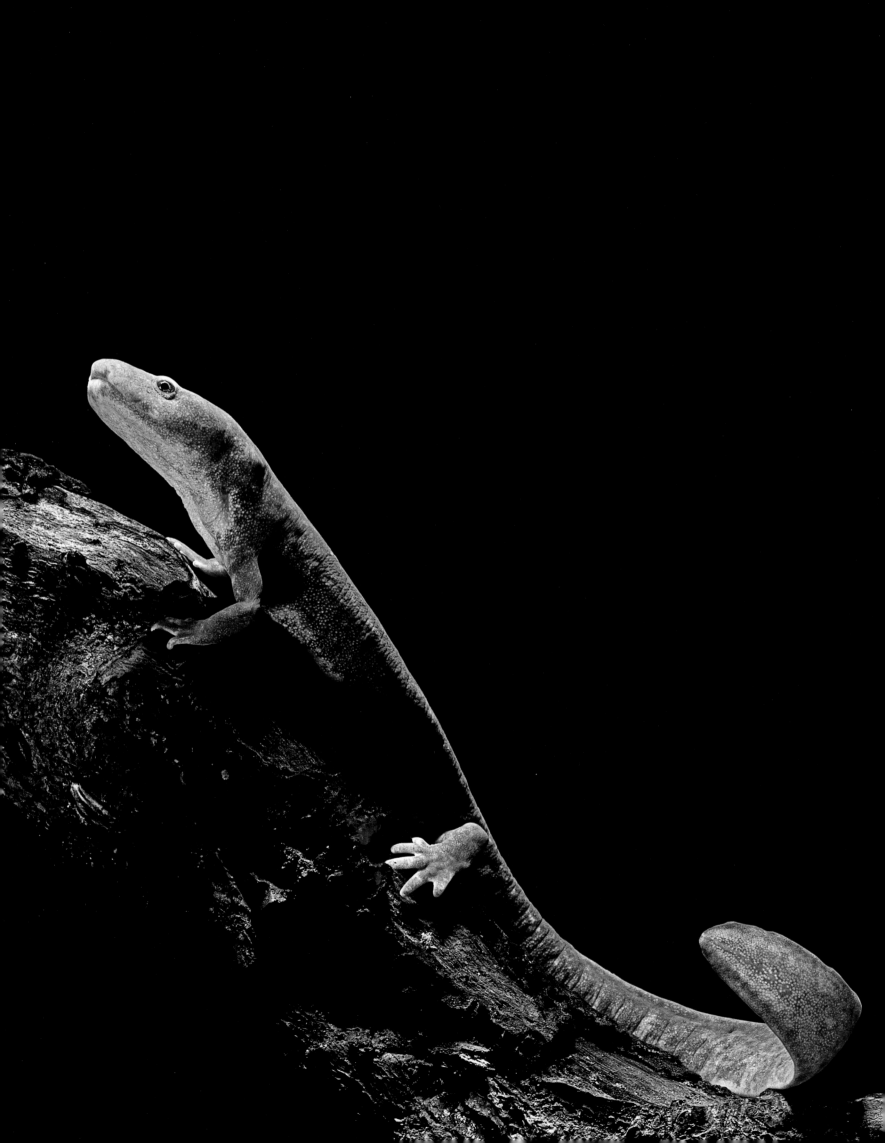

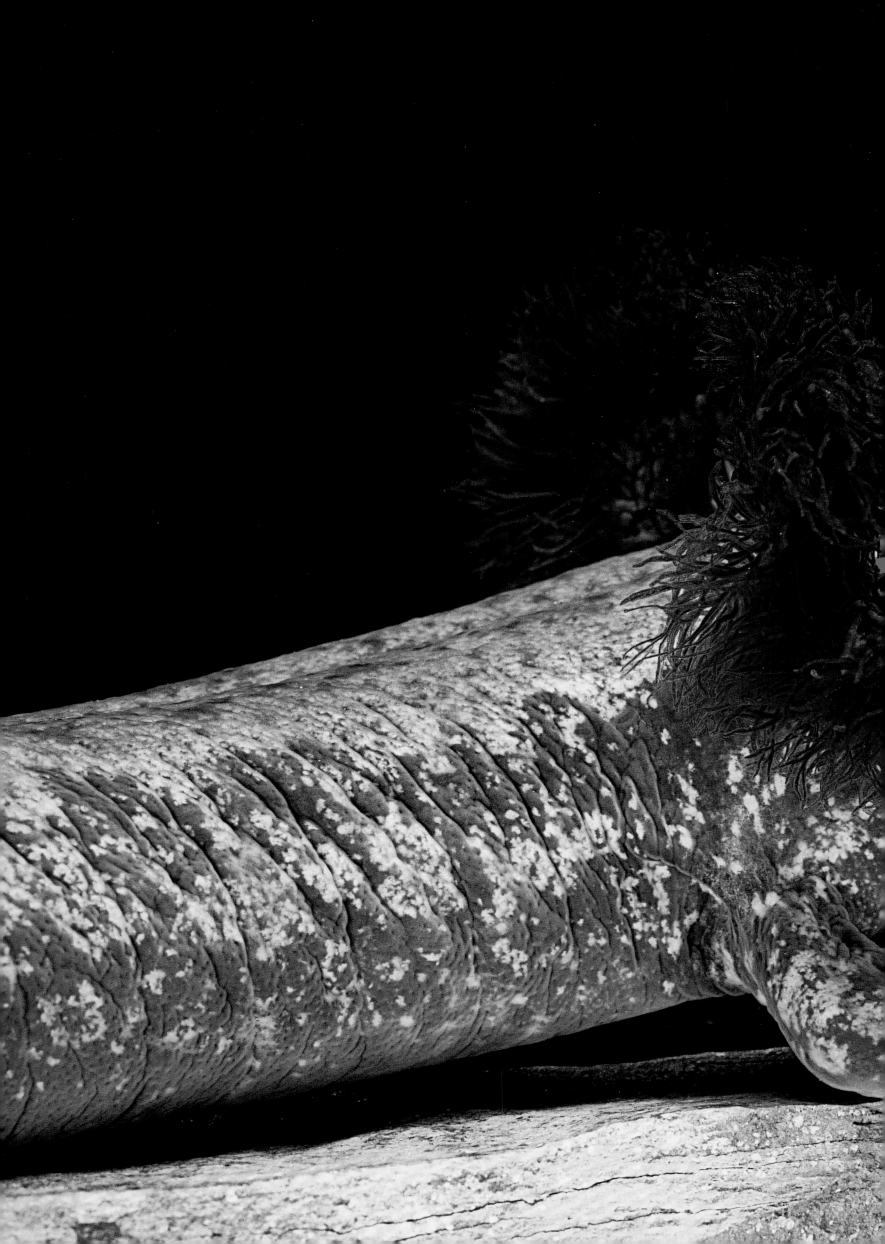

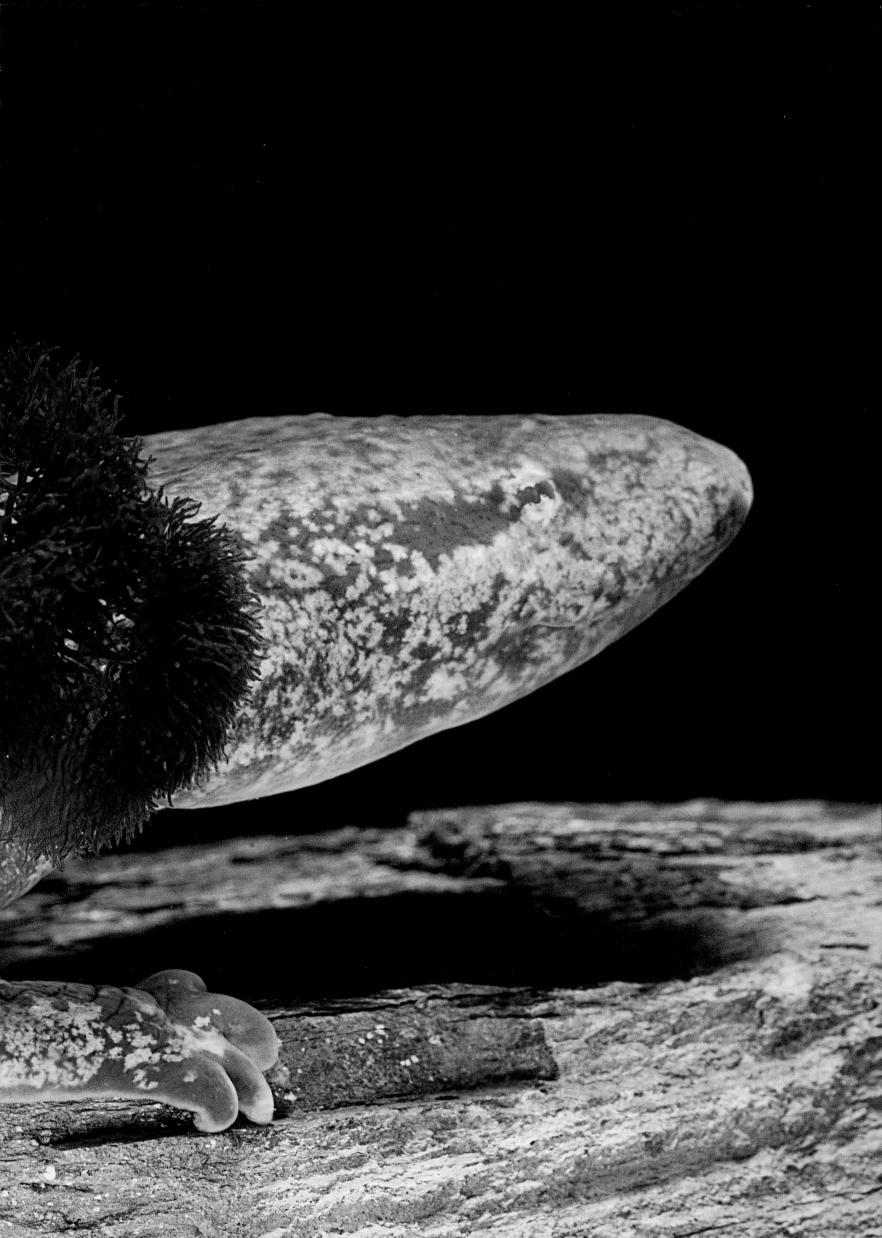

SIRENIDAE

With 4 species from just 2 genera, their range extends from the United States to the north of Mexico. These long salamanders are exclusively aquatic, and look somewhat like an eel with large external gills. They live in shallow waters, burrowed in mud or sand, in lakes, rivers or ditches. When night falls, they venture out in search of insects, crustaceans, worms, snails and even shrimp. Their nocturnal lifestyle provides some protection from their predators: mainly carnivorous fish, wading birds, snakes and aquatic turtles. Lacking in hind limbs, Sirenidae have short and thin forelimbs behind the gills. If oxygen levels are depleted, their gills shrink to no more than stubs. They can then leave the water and crawl a short distance to another more oxygenated pool, after which they regain their gills. They are oviparous and the female can lay up to 300 eggs. Sirens reach sexual maturity after two to four years.

SIREN INTERMEDIA [▸]

Distribution: United States, Canada
Average length: 20 to 70cm (8 - 27½in)

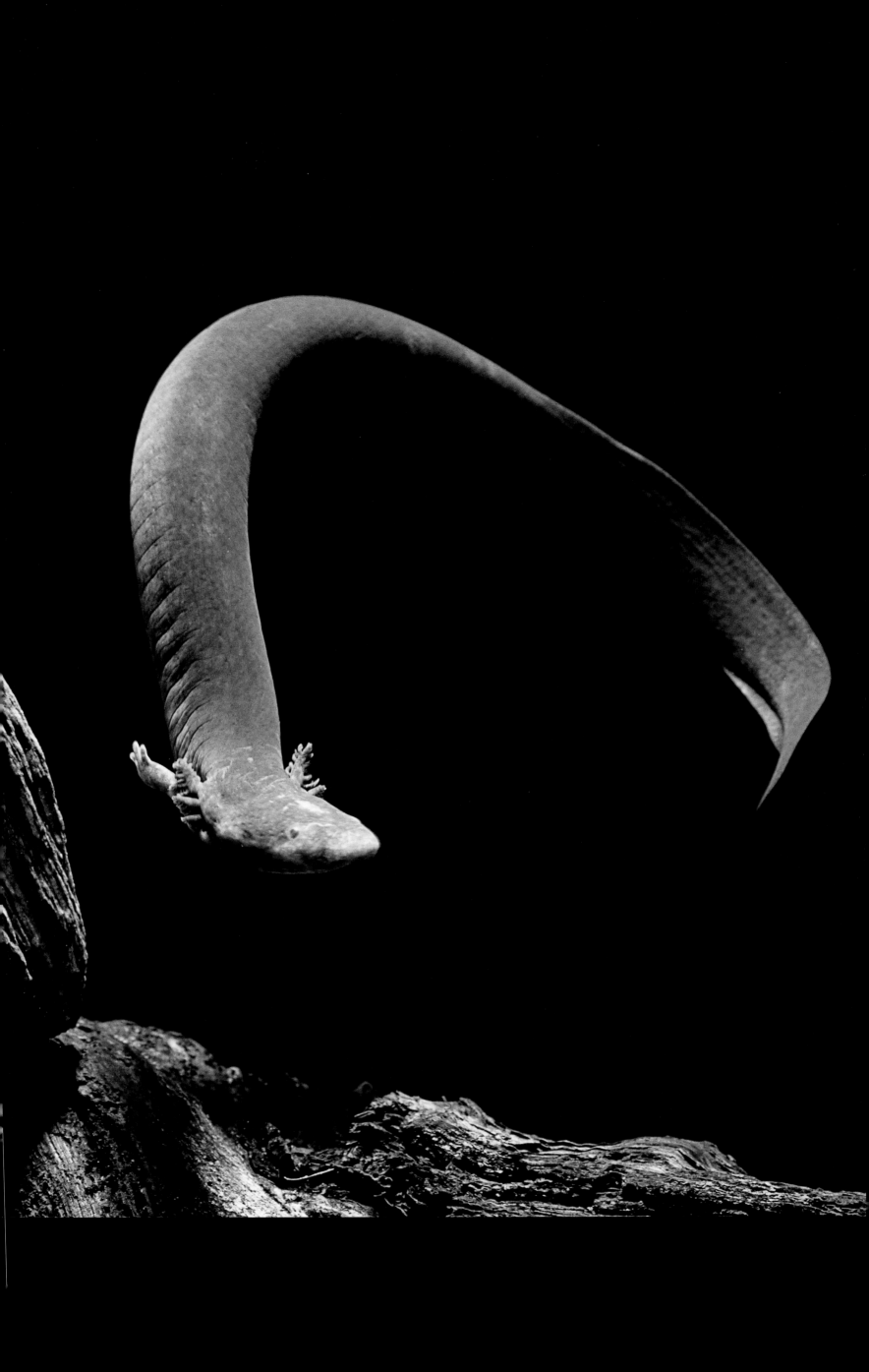

INDEX OF ILLUSTRATIONS

ACKNOWLEDGEMENTS

I should like to express my gratitude to the following people for their invaluable help in the preparation of this book:

First of all my companion, Gorette Dos Santos, for her presence and support, as well as my daughter, Lou, who, for the long period of writing this book had to make do with a father who was often unavailable.
A big thank you to Karim Daoues, who gave me the opportunity to do this book through La Ferme tropicale, for her sensible and relevant advice.
Thank you also to Jean-Charles Poupart, for his great kindness and availability and for the animals he lent me.
Stéphane Martin, for his friendship, support and so very stimulating advice.
Fanny Le Hen and Frederic Harlall for their encouragement throughout this project and for their animals.
Claude Delaire for her extreme kindness and unfailing support.
Jérôme Danan, Christophe Réaux, Thierry Natiez and Hélène Veilleux for kindly lending me their animals.
Benjamin David and Ludovic Bedu for their help in identifying some anurans.
Anne-Marie Ohler and Renaud Boistel from the Muséum d'Histoire Naturelle for their invaluable advice.
And last, but not least, the team at La Ferme Tropicale for their help with the photographic shoots. Thank you all!

LA FERME TROPICALE - 54 rue Jenner, 75013 PARIS –
Telephone: +33 (0) 1 45 84 24 36 - Fax: +33 (0) 1 45 84 25 69
www.lafermetropicale.com